Resurrecting Easter

ALSO BY JOHN DOMINIC CROSSAN

RESURRECTING
EASTER

HOW THE WEST LOST AND THE EAST KEPT
THE ORIGINAL EASTER VISION

✠ ✠ ✠

John Dominic Crossan *and* Sarah Sexton Crossan

HarperOne
An Imprint of HarperCollinsPublishers

HarperOne

RESURRECTING EASTER. Copyright © 2018 by John Dominic Crossan
and Sarah Sexton Crossan. All rights reserved. Printed in the United States of America.
No part of this book may be used or reproduced in any manner whatsoever without
written permission except in the case of brief quotations embodied in critical articles and reviews.
For information, address HarperCollins Publishers, 195 Broadway, New York, NY 10007.

HarperCollins books may be purchased for educational, business, or sales promotional use.
For information, please email the Special Markets Department at SPsales@harpercollins.com.

FIRST EDITION

Designed by Ad Librum

Library of Congress Cataloging-in-Publication Data is available upon request.

ISBN 978–0–06–243418–0

18 19 20 21 22 LSC 10 9 8 7 6 5 4 3 2 1

To Eastern Christians,
who suffer greatly,
live dangerously,
and survive precariously,
in the original heartland
of Christianity

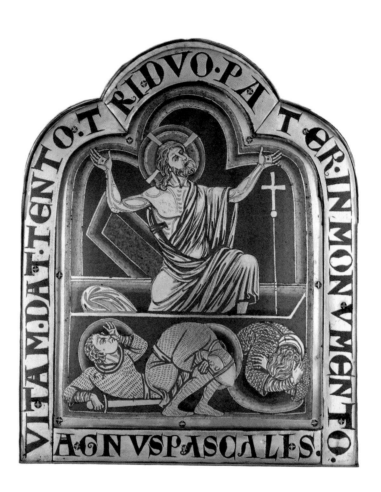

Contents

Resurrecting Easter

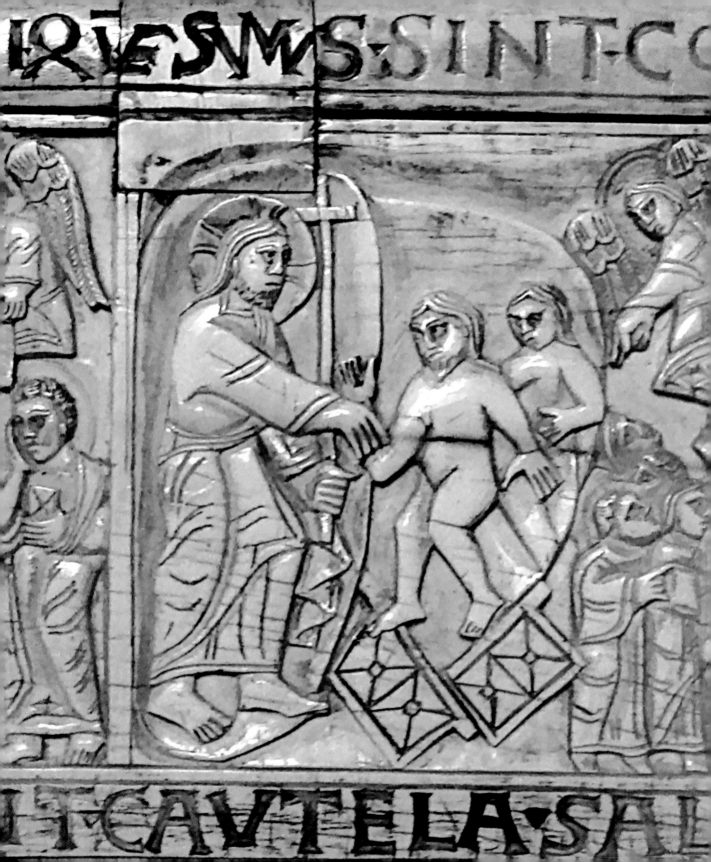

Prologue

A Tale of Two Visions

*If Christ did not rise for us, then he did not rise at all, since he had no
need of it just for himself. In him the world arose, in him heaven arose,
in him the earth arose. For there will be a new heaven and a new earth.*

St. Ambrose of Milan,
On the Death of His Brother Satyrus, 2.102 (379)

Resurrecting Easter is a debate about ideas and images or, better, a debate about ideas presented in and by images. It is a tour through thought and theology, an expedition across geographical space and historical time, and, finally, a passage from religious tradition to human evolution. It concerns a struggle between two visions of Christ's Resurrection, studies a conflict between two images of Easter's icon, and asks what is here at stake both inside and outside Christianity. This is how the problem unfolds.

The major events in Christ's life and therefore the major feasts in the church's liturgy— from the Annunciation to the Ascension—are *described* in Gospel stories and so can be *depicted* in any medium. Biblical artists illustrate visually and creatively what they read verbally and traditionally. That is why, despite brilliance in artistic imagination and genius in technical invention, those images remain easily recognizable across the centuries by those who know either the Gospel story or art history.

We just mentioned "Annunciation to Ascension," but there is one exception in that overall sequence, one event in the life of Christ that is never described in any Gospel story. Furthermore, this is not some minor happening, but the

1

most important and climactic one of them all. This is the moment of Christ's Resurrection as it is actually happening. This—unlike all other Gospel events—is never described in itself. But if it is never described in the text, how can it ever be depicted in an image?

Maybe, you say, the Resurrection is simply too mysterious, too far above human comprehension for any possible description. But there are many other mysterious events in Christ's life—the Transfiguration, for instance—and they all get quite adequate descriptions. Is the Resurrection any more mysterious than the Ascension? No, yet the latter is described twice, in Luke 24:50–51 and Acts 1:9–11. So why is there no description of the Resurrection, and then how do you depict something that isn't described anywhere?

☩ ☩ ☩

A distinction is crucial here between *direct* and *indirect* portrayals of an event. You can either describe and depict an event directly in itself, for example, the Crucifixion in all its explicit details; or you can describe and depict it only indirectly in its effects, for example, the Pietà, which shows Mary holding the executed Christ on her lap. The choice is always there: directly describe and depict the event or indirectly describe and depict the effect, the result, the consequence, of that event.

Of Christ's Resurrection there are so many *indirect* descriptions that their sheer exuberance masks—deliberately or not—the absolute absence of any direct report of the event itself as it was actually happening. The description of so many consequences obscures the fact that there is no description of the event itself. These multiple aftereffects fall into two major trajectories of post-Resurrection Gospel stories.

One is the *empty-tomb tradition*, in which female or male disciples discover the vacant tomb on Easter Sunday morning. This involves one (John 20:1–2), two (Matt. 28:1), three (Mark 16:1), or more women (Luke 24:10). It can also involve males in some competition with one another (Luke 24:12; John 20:3–10).

The other is the *risen-vision tradition*, in which female or male disciples see the risen Christ. This can involve one woman (John 20:11–18), two women (Matt. 28:9–10), or a married couple (Luke 24:13–32). Locations can be in Jerusalem, in a room (Luke 24:36–49; John 20:19–29) or on a hill (Luke 24:50–53; Acts 1:12); in Galilee, on a mountain (Matt. 28:16–20); or by the lake (John 21:14).

These two traditions are—and ever remain—powerful but *indirect* solutions to the Gospel's lack of any direct Resurrection story. Still, the question presses. From the Nativity through the Crucifixion, we have the events in Christ's life presented directly as they happened. How can the Resurrection, the most important event of them all, be the only one lacking a direct presentation? It is comparatively inconsistent and thus clearly unacceptable that Easter alone be depicted indirectly, even if profusely so.

It is not surprising, therefore, and was

probably inevitable, that Christian imagination eventually created a direct image of Christ's Resurrection—just like all those other direct depictions of events in Christ's life. But it is certainly surprising that it created two different images, two stunningly divergent images. No such duality, and certainly no such competing duality, ever happens for any other event in the life of Christ or in the sequence of major church feasts.

The first direct image of the Resurrection appeared by the year 400. We consider it part of the *individual resurrection tradition*, because it focuses on Christ alone. It imagines Christ rising in splendid, triumphant, and transcendent majesty, but also in splendid, triumphant, and transcendent isolation. This first Easter image is derived from the story of the guarded tomb found only in Matthew's Gospel (27:62–66; 28:2–4, 11–15). How, why, and where this happens is a first major theme in *Resurrecting Easter*.

The second direct Resurrection image was created by the year 700. We term it part of the *universal resurrection tradition* because, instead of arising alone, Christ raises all of humanity with him. He reaches out toward Adam and Eve, the biblical parents and symbols for humanity itself, raises them up, and leads them out of Hades, the prison of death. This second Easter image is *not* derived from the story of the emptied tombs found only in Matthew's Gospel (27:51b–54). How, why, and where this happens is a second major theme in *Resurrecting Easter*.

Think for a moment about those two images and about the different theological visions behind them. Reread what Ambrose, the sainted archbishop of Milan, wrote in the epigraph to this chapter: "In him the world arose, in him heaven arose, in him the earth arose." He wrote it about the same time that the image belonging to individual resurrection tradition appeared, and yet it seems a far better description of the universal resurrection tradition's depiction.

What happens between those two traditions across the millennia of Christianity? Will one, the other, or some combination of both ever become the single, official, and traditional Easter icon? If both remain, how will that dualism endure within the same religion? Those issues are a third major theme in *Resurrecting Easter*.

✠ ✠ ✠

We have, in summary, two major traditions each for both the indirect and the direct depictions of Christ's Resurrection across the millennia of Christianity's existence (Fig. 0.1). Our focus in this book, however, is not spread evenly across those four categories. We may mention now and again those indirect traditions of "empty tomb" and "risen vision" (in 1 Corinthians 15:5–8, by the way, Paul has only the latter tradition), but we will concentrate on the direct traditions. Further, although we will spend time with both of the direct traditions, we are primarily concerned with the *universal* rather than the *individual* resurrection tradition. There are two reasons for this emphasis.

One is that the individual version becomes, by the second millennium, the official Easter

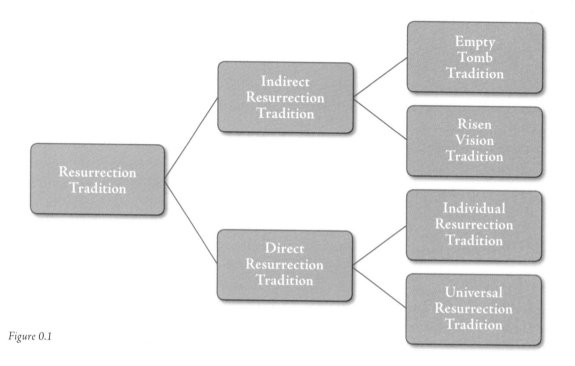

Figure 0.1

icon of Western Christianity. As such, it is the one we know best as Westerners, and we may even presume, mistaking part for whole, that it is the only one present throughout Christian history. In this book, therefore, the emphasis is on universal over individual iconography for Christ's Resurrection as remedial education for Western Christians. During the last fifteen years, it has been precisely that for us.

Another—and much more important—reason for emphasizing the universal resurrection tradition is based on these two final questions as the fourth and fifth themes of *Resurrecting Easter*. We emphasize them here and now, and we ask you to keep them in mind throughout the book, but we will only answer them at the very end of the book.

First, is the individual or universal vision in closer continuity with the New Testament's understanding of "Resurrection" and in better conformity with the Gospels' conception of Easter? For example, when Paul speaks of Christ's Resurrection, is he imagining it as individual or universal? Or, again, when 1 Corinthians 15:20 and Matthew 27:52 refer, using the same Greek term, to the resurrection of "those who have fallen asleep," who exactly are those sleepers?

Second, whether you understand Christ's Resurrection as a historical event or a theological interpretation; whether you accept it as myth

or parable, symbol or metaphor; and whether you accept it religiously or reject it absolutely, what does it claim and what does that mean? How can someone or something that happens once at a certain time and in a specific place influence or change the whole human race—not just forward to the end of time, but backward to its start?

We can at least *imagine* a certain catastrophe, a certain group, or even a certain individual affecting the future—or lack of future—for the whole human race. (Hollywood depicts such events regularly.) But how can anyone or anything influence the human past of our entire species, somehow change the past all the way back to "Adam and Eve" as personifications of our primordial origins? What does it mean, whether or not it is credible, to depict Christ's Resurrection as humanity's liberation from death—all humanity, past, present, and future?

<center>✠ ✠ ✠</center>

Resurrecting Easter derives from twenty research trips, spanning fifteen years, to the museums and libraries, the monasteries and churches—the past glories and the present hopes of Eastern Christianity. We went to these places above the Mediterranean: Spain, France, Germany, Italy, Serbia, Greece, Romania, Turkey, and Russia; in the Mediterranean: Sicily, Cyprus, and Crete; and around the Mediterranean: Syria, Israel, Egypt, and Tunisia.

The result is not texts illustrated with images, but images discussed by texts. In other words, imagery and iconography rule the presentation. These images are quite simply visual theology, and they challenge verbal theology to explain them—if it can. Learned scholars once justified Christian imagery as the "Bible of the illiterate," as if imagery were a secondhand substitute for literacy, an inferior form of script for those unable to read. Such condescension does not explain why the Greeks had illustrated copies of Homer, the Romans had illustrated copies of Virgil, Christian monks had illustrated—copiously illustrated—copies of the Psalter (which we will see in Chapters 7 and 8), and Christian bishops had illustrated—magnificently illustrated—copies of the Easter Vigil Exultet scrolls (see Chapters 9 and 10).

As an antidote to any presumed ascendancy of text over image, we recall the very opposite claim: "A most excellent rule of the wisest ones is that material images are stronger, more faithful, and mightier by far than verbal arguments and biblical quotes." This is from the *Hodegos*, or *Guide for the Way*, by St. Anastasios of Mt. Sinai in the 680s or 690s. Anastasios, by the way, comes from *anastasis*, the Greek word for "resurrection."

Our species evolved through sight and sound, through the visual and the verbal, before we ever graduated to image and text. If you had to lose sight or sound, which would you—even if regretfully—choose to abandon? Or again, when TV pharmaceutical commercials verbally describe the horrible potential side effects of a drug but visually depict users frolicking happily

in the park or on the beach, does sight or sound, image or text, rule the process?

Be that as it may, this book's dialectic of image and text is the result of Sarah's on-site camera and visual-image work and Dominic's travel log and verbal text, yet we always work in tandem and always present as "we"—think of us as SarDom. Also, if and when, even after Sarah's digital therapy, our own images were inferior to ones commercially or freely available, we often chose the latter. We want you, our readers—better, you, our viewers—to see details as clearly as possible. (Full details on the images are given on pp. 189–194.)

First, gratitude and appreciation. We emphasize our deep appreciation to HarperOne—Publisher Mark Tauber, Executive Editor Mickey Maudlin, Assistant Editor Anna Paustenbach, Production Manager Lisa Zuniga, and copyeditor Ann Moru—for its willingness to accept the proposal and produce a book with color images closely linked to textual comments about them rather than all grouped together as a color insert.

We are also extremely grateful to all those who helped us penetrate locked churches, enter closed archives, and locate difficult items. We also owe special gratitude to the Benedictine authorities at Monte Cassino Abbey (see Chapter 9) and Farfa Abbey in Italy for courtesy and hospitality beyond ordinary academic consideration.

On Friday, August 29, 2014, for example, we were at Farfa Abbey in the Sabine Hills about forty miles north of Rome. Our objective was a small reliquary casket fashioned by Christian artists at Amalfi from African ivory supplied by Muslim traders in the middle of the eleventh century. Waiting in the monastic courtyard as the secretary went for the prior, we expected at best permission to view the ivory casket under glass in the monastery's treasury or museum.

Fifteen minutes later, however, the prior himself crossed the courtyard, and in his hands was the casket covered by tissue paper. He placed it on a desk in his office, apologized for having to leave us, told us to take all the time and photographs we needed, and left us to study the lovely casket in peace and quiet. On the front, its scenes include the Annunciation, the Visitation, and the Nativity above, with the Crucifixion and the Ascension below. In between them, is a universal resurrection image of Christ and his cross liberating from death all of humanity, personified as Adam and Eve (Fig. 0.2, and see the face-page for this Prologue).

That was one of our success stories, but there were disappointments as well. However, as you can see in the number of images presented in our book, discovery far outweighs failure or disappointment. And most of the disappointments were quite minor—a church sealed for repairs or closed on our one day there. There was, however, one case that was but a minor and transient frustration for us, but that later morphed into an ongoing tragedy for many others.

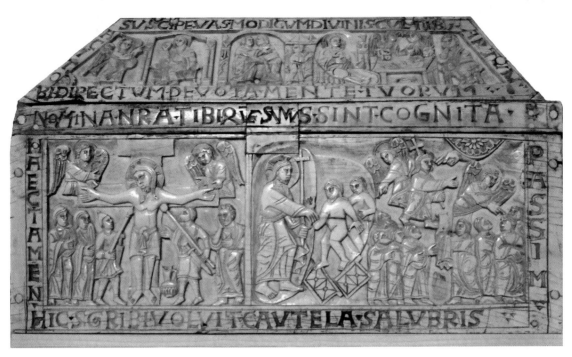

Figure 0.2

Annually from 2000 to 2014, a tetrarchy of four friends composed of Marianne Borg, an Episcopal priest; her husband, the biblical scholar Marcus Borg; and the two of us led a pilgrimage of forty people "In Search of Paul" around Turkey.

The last week of April 2010, we were staying in a lovely Ottoman mansion turned hotel in Damascus's Old City to make special arrangements for our annual Borg-Crossan pilgrimage in May 2011. Our brilliant idea was to include, for the first time, both Syria and Turkey in our forty-person journey called "Paul: From Damascus to Ephesus." At the end of March 2011, however, we realized that we were heading into a civil war and, overnight, the journey became "Paul: From Anatolia to the Aegean."

Still, back in 2010, we headed, on Wednesday, April 28, about fifty miles north of Damascus to Deir Mar Musa al-Habashi, in the eastern foothills of the Anti-Lebanon Mountains. There, the Syriac Catholic Monastery of St. Moses the Abyssinian was founded in the sixth century and then abandoned, founded again in the eleventh century and abandoned, and finally refounded in the twentieth century and . . .

Our visit had two purposes. One was to meet the charismatic Jesuit priest Paolo Dall'Oglio, who, beginning in the 1980s, built Mar Musa—financially and architecturally, spiritually and

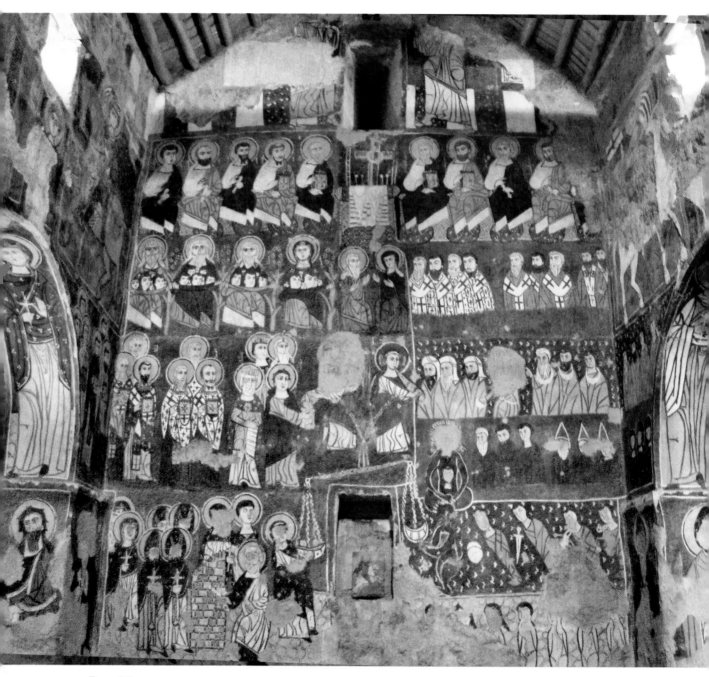

Figure 0.3

ecumenically—into a sacred site for peace and reconciliation between secular and sacred, Catholic and Orthodox, Christian and Muslim. We asked his permission to bring our forty pilgrims to Mar Musa for Mass the following May, and the request was readily granted.

The other purpose was to study the monastery's eleventh- and twelfth-century frescoes and see, for this book, if Christ's Resurrection is depicted among them and, if so, whether it is in the individual or universal tradition. Neither representation, however, is present among the extant imagery. Indeed, instead of any vision of humanity's universal salvation, the restored iconography of the tiny chapel is dominated by the west wall's full-scale rendition of the Final Judgment (Fig. 0.3).

That was, of course, but a small disappointment for our own personal research and totally minimized that day by general awe at Mar Musa, special reverence for Father Paolo, and plans to return with forty pilgrims in May 2011. Then came tragedy. In June 2012 Father Paolo was expelled from Assad's Syria, but slipped back on a peace mission in July 2013. He was abducted by ISIS in its apocalyptic capital at Raqqa and executed, according to reliable but unconfirmed reports.

Resurrecting Easter focuses on the universal resurrection as the image of God's Peace and Reconciliation Commission with humanity, with our species *Homo sapiens*, in Christ. It is fitting, therefore, to include in this Prologue a special mention of Father Paolo Dall'Oglio, SJ, who certainly lived for, and possibly died for, peace and reconciliation in the religious and political spheres. "Blessed are the peacemakers, for they will be called children of God" (Matt. 5.9).

A final thought, but still about peace and reconciliation. In the first Christian millennium, both the individual and the universal tradition were prevalent; either could have become the Easter vision for all of Christianity. Not so in its inimical second millennium; the West chose individual imagery and the East retained universal iconography. What, then, might we hope for in Christianity's just-starting third millennium?

Look at the opening image of Chapter 12 (Fig. 12.1, p. 168). It belongs to a Russian tradition—from as early as the 1500s—that created a combined universal *and* individual vision in a single icon. Even if that never becomes the official Easter iconography for the breadth of the Christian church, should it not be the dominant Easter theology for the depth of the Christian imagination?

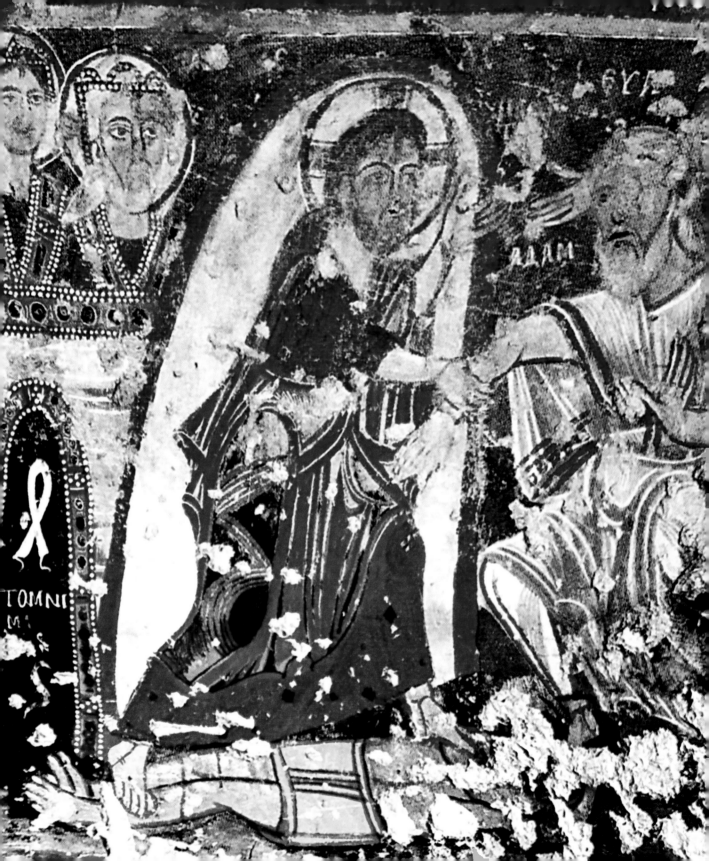

1

Travels in the Realms of Gold

The translation of [the Greek word] Anastasis as Resurrection is correct. But any designation of the subject matter of this iconography as the Descent or Harrowing of Hell misrepresents and distorts the message of the chosen label Anastasis. The title and subject matter of this image refer not to the Descent of Christ into Hell, Hades, Limbo, or Inferno, but to the raising of Christ and his raising of the dead. . . . In the image of the Anastasis, Adam stands for Everyone. . . . "Anastasis" refers simultaneously to the Resurrection of Christ, Adam, and mankind.

ANNA D. KARTSONIS, *Anastasis: The Making of an Image**

WE LEAVE Orlando, Florida, the evening of Sunday, April 22, 2012, and, with plane changes at Frankfurt and Athens, arrive at Larnaca in the Greek portion of the divided island of Cyprus late the next evening. Tired to exhaustion, we are relieved to see our driver standing at the exit with "Crossan" on her upraised sign. Our weeklong home is the Forest Park Hotel in the tiny village of Pano Platres high in the Troodos Mountains. We start the four-thousand-foot climb from the coast in a 1998 white Mercedes beautifully preserved and extremely comfortable despite 150,000 miles on the odometer.

That forty-three-mile trip takes an hour and a half, giving us lots of time to become acquainted with our driver, Sharon Ioannou, an Englishwoman married to John, a Greek Cypriot, who restores and races antique cars. We tell her

* Anna D. Kartsonis, *Anastasis: The Making of an Image* (Princeton, NJ: Princeton Univ. Press, 1986), 4, 6.

11

about our research project in the mountain villages around Platres, where small but fully frescoed churches span four hundred years, from the twelfth to the sixteenth century. Ten of them form, as UNESCO's World Heritage report says, "one of the largest groups of churches and monasteries of the former Byzantine Empire."

Sharon drops us at the hotel around midnight and, standing at the entrance door, we show her the daily itinerary for our visit. She agrees to be our driver for the entire week, and we stagger upstairs to bed. We soon discover that Sharon is not just a driver, but a necessary facilitator. She phones ahead each day to get visiting hours and, in several cases, finds church key holders who open the buildings for us as the only visitors. By the end of the week, Sharon and John are our friends within the ancient protocols of Mediterranean hospitality.

Each day we head out in a different direction from our Platres base with diary for details and camera for pictures. As the week progresses, Sharon notices how we focus in every church on the life-of-Christ frescoes and especially on the ones representing the Resurrection. It is, by the way, only two weeks after Easter, and neon "Kalo Pascha" signs across the main road into several of the mountain villages greet us as we enter.

One day, in the car on the way home, Sharon announces that she has a question for us. "I see your interest in researching Easter traditions," she says, "but here is my problem with Easter. When my Mum comes over for the holidays, we always go to the Easter Vigil service in Platres.

After the new fire is blessed outside, the fully robed priest goes to the closed door of the church and attempts to push it open. But the oldest man in the village stands inside and pushes against him. That seems so unfair. Why choose the oldest man in the village to withstand that much younger and stronger priest?"

Why indeed? Ten years earlier we would have shaken our heads and said that we had no idea how to explain the ceremony. But now, in response, we explain in detail why Easter's symbolism can involve a Stronger One pushing in the door against an Older One. In the Easter Vigil this symbolizes the Risen Christ, a personification of Life, struggling successfully against Hades, personification of Death. In fact, this book is simply that moment's explanation writ large—and with pictures! We are able to explain that Easter Vigil action to Sharon because by April 2012 we are already deeply involved in a project that began a decade earlier in the eastern Anatolian plateau, about 275 miles north of the pine-clad mountains of Cyprus.

☩ ☩ ☩

Our fascinating historical detective story begins around 4:00 P.M. on Wednesday, September 18, 2002. The "tetrarchy" waits in the arrivals hall of Esenboğa International Airport in Turkey's capital city of Ankara as our group clears customs. We leave immediately for the hotel, and on Thursday morning our bus heads south toward Pauline territory in Tarsus and Antioch.

Our first stop, however, is in Cappadocia,

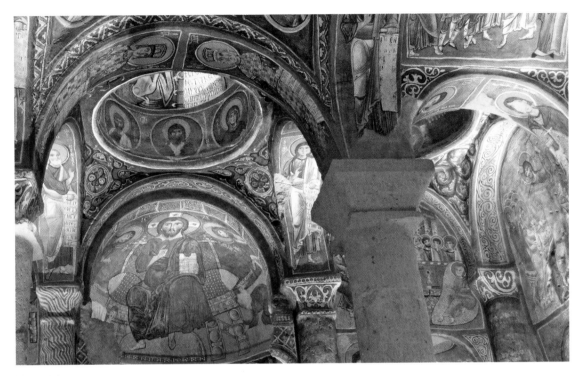

Figure 1.1

where twin volcanoes have created a landscape encrusted with volcanic tuff; where erosion has molded volcanic outcrops into spires of rock and pillars of stone; where valley sides in Göreme, Zelve, and Peristrema hide fully frescoed Byzantine churches inside their rock-cut faces. We have three days in Cappadocia, but our major focus is on Göreme's churches from the tenth and eleventh centuries—before Byzantine Christianity lost Cappadocia and most of Anatolia to Selçuk Islam in 1071.

That afternoon, our group visits six or seven rock churches in Göreme's open-air museum, but in two of them something sparks for us

without our recognizing, at that time, that anything had happened.

The archaeological park's circular space can hold lots of visitors, but narrow stairs, entrances, and interiors cause bottlenecks before each of those rock-cut chapels. We have to wait outside, for example, to enter the Dark Church, or Karanlik Kilise, a magnificent miniature Byzantine cathedral from around 1050.

The church's design is a cross inside a square. Frescoes cover its columns, vaults, and domes. Those images, protected by centuries of darkness—hence the name—are completely restored and are now the best preserved in all

of Cappadocia (Fig. 1.1; note the Anastasis, or Universal Resurrection, at the extreme right).

As we wait our turn to enter the church—more or less patiently—we read the explanatory sign given in Turkish, English, French, and German (Fig. 1.2, red-color emphasis added). The English version records the fifteen scenes of the life-of-Christ frescoes inside: "Annunciation, Journey to Bethlehem, Nativity, Adoration of the Magi, Baptism, Raising of Lazarus, Transfiguration, Entry into Jerusalem, Last Supper, Betrayal of Judas, Crucifixion, Anastasis, Women at the Tomb, Blessing and Mission of the Apostles, Ascension."

We notice that in the English section the Resurrection is called the Anastasis. *Ana-stasis* is a Greek word that literally means "up-rising." "Interesting," we think. "The Resurrection as an uprising . . . but by whom and with whom, for what and against what?"

Still waiting, we look at how the other three languages name the inside fresco called the Anastasis in English. In Turkish it is "Jesus's Descent to Gehenna," in French, "The Descent to Hell," and in German, "Jesus's Travel to the Kingdom of the Dead." We discuss two questions there and then—but vaguely and fleetingly, in idleness, as we await

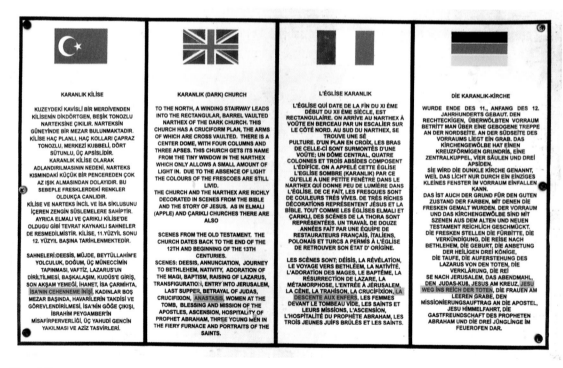

Figure 1.2

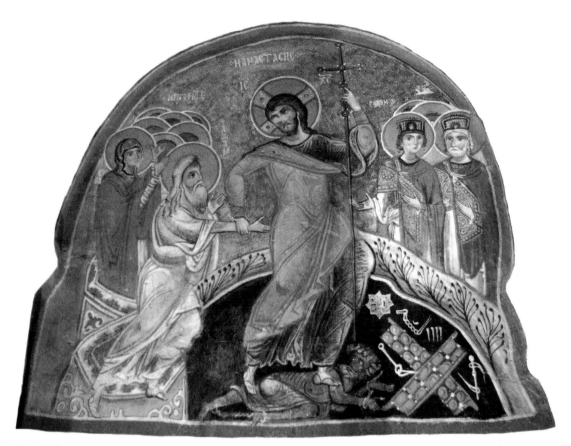

Figure 1.3

entrance into this glorious church in a cave.

First, why use the Greek term "Anastasis" rather than the English word "Resurrection" in an otherwise English-language sign? Second, since Anastasis/Resurrection is about ascending upward, why do the other three languages describe a descending downward? Still, although those questions come up there, they are just idle curiosity at this stage.

Once inside, facing forward under the central minidome, we find the expected series of frescoes showing the Annunciation to the Ascension in a glorious swirl all around us. They are not depicted as a continuous narrative

series, however, but as individual celebrations, as monumental icons of the great annual feast days. Life-of-Christ history appears here as life-of-Christ liturgy—and we are standing inside it.

In the right side aisle is an easily recognizable Crucifixion scene, but immediately to its left is another one recognizable to us not by its content, but only by its name. It says HAN-ACTACIC, in capital Greek letters, and that is where the outside sign got "Anastasis" as its word for "Resurrection" (Fig. 1.3). Yet it does not look like any Resurrection scene we have ever seen.

The central and tallest figure in the painting

is "Jesus Christ," identified by his cruciform halo, his name in the traditional two-letter Greek abbreviations IC XC, and a long ceremonial cross in his left hand. He strides forcefully to viewer right, but looks backward as his right hand firmly grasps the right wrist of a white-haired, white-bearded man identified in Greek as "Adam." Behind Adam is a woman identified as "Eve," and both are being pulled from their sepulchers. Behind them the barest tops of six other heads are visible, identified as "Prophets."

To viewer right are two figures, both crowned, one older and bearded, the other younger and beardless. They are identified as "David" and his son "Solomon." Behind them are two unidentified top-of-heads-only individuals. All of the figures on both sides of Christ have halos. What appears beneath Christ, however, is the most striking element in the entire fresco.

Christ is emerging from a dark semicircular area below the ground (note the trees above the dark area), and he is standing atop, or trampling down, a full-bearded prostrate figure whose feet and hands are chained. This figure looks up with frightened eyes at Christ, whose long cross seems to hold his head down. What is striking is that the image is not of Satan, the opponent of God, but of Hades, the custodian of the dead. He lacks both halo and name, but he is most certainly Hades, the gatekeeper and personification of the "Kingdom of the Dead," as we read in German on the sign outside. Beside Hades are scattered locks, bolts, and bars from a pair

of narrow doors, flattened on the ground, but carefully arranged in a cruciform pattern.

Christ's halo with cross, his long ecclesiastical cross, and those crossed narrow doors form three deliberate connections between the Crucifixion and the Anastasis. The fresco depicts the crucified Christ breaking forcibly into the place Hades, scattering its bolts and locks all around, forming its gates into a cross, chaining the Hades persona, and liberating from the prison of death the whole human race, personified by Adam and Eve. This is the *universal resurrection* of humanity, but called the Greek word Anastasis.

✠ ✠ ✠

We leave the enclosed area of the archaeological park, but there is one more very important cave church to visit—probably the most important and certainly the largest and earliest of them all. In retrospect, we should have stopped here first, before entering rather than after exiting the park's enclosure, because by now we are all hot, dusty, tired, and hungry.

As usual, we wait outside the Buckle Church, or Tokali Kilise, for our turn to enter, but this time we read the usual four-language sign with a deliberate focus. Again, the term "Anastasis" appears in the English-language column with the same (mis)translations in the Turkish, French, and German columns—again, ascent in the first column becomes decent in the other three. Also, since the Buckle Church actually consists of two churches, an "old church"

Figure 1.4

from the early tenth century, which is now the entrance to the "new church" at its east end from the later tenth century, there are two Anastasis images in two separate life-of-Christ series of frescoes, one in each church.

First, the life-of-Christ cycle in the "old church," dated 913 to 920, flows as a continuous narrative in three rows across the top half of the south wall and then across the top half of the north wall. On the north wall (Fig. 1.4), we recognize the Flight into Egypt (*top*), the Multiplication of Loaves and Fishes (*middle*), and the Crucifixion (*bottom*). The final scenes on the bottom row move from the Angel and Two Women at the Empty Tomb, on the left, to the Anastasis, on the right (outlined in white on Fig. 1.4).

The restored frescoes are not as brilliant as those in the Dark Church, but are still very good (Fig. 1.5, and see face-page for this chapter). At the left, the two women (Matt. 28:1) approach the tomb with the ointments (Mark 16:1). The angel sits on the stone/door (Matt. 28:2) beside the black space of the empty sepulcher—the Greek inscription names it "The Tomb"—with a piece of body wrapping left inside (John 20:5–7). This is, of course, the empty-tomb tradition as an indirect portrayal of the Resurrection, which we mentioned in the Prologue.

The empty-tomb scene connects visually with the one directly to its right. It is entitled with a badly abraded "HA[nas]TASIS" to the right of the tomb. The two kings are poised above the tomb and almost seem a part of its imagery. "David," crowned and bearded, is to the right; "Solomon," crowned and beardless, is to the left.

In the center, a cross-haloed Christ strides forcibly to viewer right, trampling down a very large and bound figure of Hades. His right hand grasps that of "Adam," and once again "Eve" is behind Adam with hands raised in greeting and supplication. We recognize immediately that there are striking differences between the Anastasis in the Dark Church and the one in the Old Buckle Church—especially in the depiction of Christ.

Next, we enter the "new church," with frescoes from 950 dominated by a Crucifixion image in its central apse, but we cannot find the second Anastasis anywhere. Luckily we take several photos and later find it on one of them after we get home (Fig. 1.6). Beneath that Crucifixion image is, to the left, the fragmentary top of a Deposition from the Cross scene and, to the right, the fragmentary top of the second Anastasis.

In the left of this Anastasis are the crowned heads and abbreviated names "Da[vi]d" and "Solom[on]." In the center is the head of Christ and above it an inscription of Psalm 82:8a:

Figure 1.5

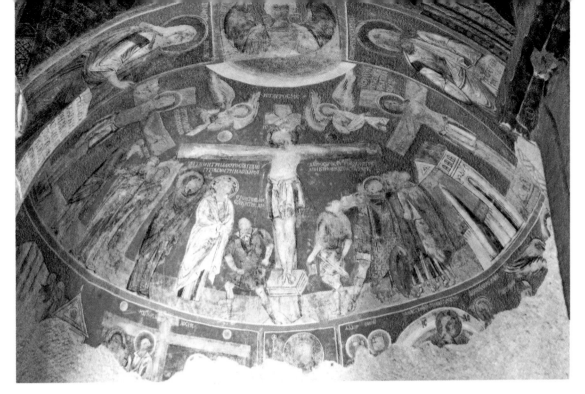

Figure 1.6

"Rise up (*anasta*), O God, judge the earth." To Christ's immediate right is the head—and earliest extant Anastasis inclusion—of "John the Forerunner." Below, but lost forever, are—at least—Adam and Eve and, presumably, a bound and prostrate Hades beneath the feet of Christ. But all of that we learn from our photos after we get home.

✠ ✠ ✠

Our safety procedure for travel photos is to download the Sony camera's pictures daily onto *both* our Macs—and a backup disk as well. In the hotel that evening we download from camera to computers and take a moment to compare those two Anastasis images (Figs. 1.3, 1.5). Even at this stage we can see striking differences.

First, in the Old Buckle Church (Fig. 1.5), Christ is totally enveloped in an aureole of heavenly light, or *mandorla*, that designates him as a divine being. (Because of its oval shape, it is called a *mandorla*, the Italian word for "almond.") Yet in the Dark Church (Fig. 1.3) there is no such heavenly light.

Next, in the Old Buckle Church (Fig. 1.5), Christ does not carry the slim patriarchal cross in his left hand as in the Dark Church (Fig. 1.3). Instead, he gestures in greeting toward Adam and Eve—both are named—and they gesture toward him in response.

Further, in the Old Buckle Church (Fig. 1.5), Christ is facing Adam and Eve in a gesture of "raising up." But in the Dark Church (Fig. 1.3) he is moving away with Adam and Eve in a gesture

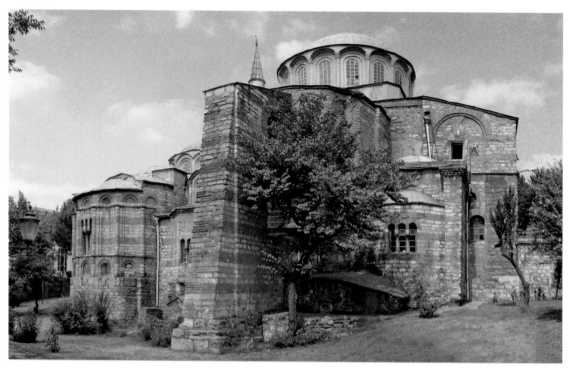

Figure 1.7

of "leading out." In the Old Buckle Church it is an arrival scene; in the Dark Church it is a departure scene. Although we could describe that image of "raising up" (Fig. 1.5) as Christ's Descent into Hell, it is surely incorrect to use that name for the "leading out" scene in the Dark Church (Fig. 1.3). This is Departure from Hades, not just Descent into Hades.

During the next two days in Cappadocia we do not see any more Anastasis images and by Sunday, as we are heading south to Adana, that imagery recedes rather far into the background of our minds. At this point, we have absolutely no idea what those Anastasis images entail. It

is partly that, in a place like Göreme, out-of-this-world theology meets out-of-this-world geography, and you can observe but easily ignore unusual images in such an exotic locale. But that serene ignorance does not last very long and is cured completely before we leave Turkey two weeks later.

✠ ✠ ✠

After Tarsus and Antioch, our tour drives west through Konya and Aphrodisias to Ephesus on the Aegean coast. From there we travel through Pergamon and Bursa, around the lovely lake of Nicea/Iznik, by bus ferry across the eastern

corner of the Sea of Marmara, and finally into Istanbul. Our travel log recalls the next day, Tuesday, October 1, 2002, as "rainy, overcast, fairly heavy rain in the morning, cool," very different weather from Cappadocia's "beautiful blue skies, warm and breezy."

The first visit is to a fifth-century church that became a mosque in the sixteenth (Kariye Camii) and a museum in the twentieth (Kariye Müzesi). It is called the Church of the Holy Savior "in Chora" (Greek, "in the Countryside"), because it was originally built outside the walls of Constantine's new capital city. When the later Theodosian walls enveloped it within the city, the church retained its "in Chora" designation through a rather beautiful pun. A mosaic above the door from the outer to inner vestibule names Christ as "The Chora of the Living."

Between 1315 and 1321, Theodore Metochites of Constantinople, second only to the Byzantine emperor in wealth and power, endowed the Chora Church (Fig. 1.7) with magnificent mosaics and splendid frescoes. He also added a second vestibule (*narthex*) to the west and a burial side chapel (*pareclesion*) to the south (at the left in Fig. 1.7).

In time and place, Metochites's life was remarkably similar to Constantinople's fate. He rose under one emperor, but was exiled under the next and ended his days a monk in the Chora monastery. Thereafter, every time he entered the main chapel (*naos*) from the interior vestibule, he saw above the door his former splendidly robed image offering the restored Chora Church to the enthroned Christ. So also in the early 1300s Constantinople was in glorious renaissance; its Latin Christian conquerors were gone by 1261, and its Ottoman Muslim conquerors would not arrive until 1453.

At Chora Church, we see the full life-of-Mary and life-of-Christ mosaics in the vestibules, visit the main chapel, negotiate the bookstore, and then, when we think we are finished—and our necks cannot look up much more—we finally enter the *pareclesion*, or side chapel for funeral and burial rituals. It is the climax and grand finale of our Chora visit. (Once again, we should have started there.)

On the ceiling of the *pareclesion* is a Last Judgment with the traditional river of red fire for those condemned to Hell. But the Anastasis—maybe the greatest one ever depicted—dominates the entire chapel from its position at the end, high in the half dome of the apse (Fig. 1.8). In the center Christ stands firmly on the shattered narrow gates of Hell with locks and bolts strewn around his feet. He is trampling down a well-trussed Hades, guardian and personification of death, who is lying prone beneath the feet of Christ (Fig. 1.8, note the Greek HANACTACIC title).

Christ is outlined by a star-studded mandorla into which he yanks Adam with his right hand and Eve with his left. To viewer left, from right to left, are John the Baptist (rough-clad), Solomon (crown, no beard), and David (crown, beard). Behind them are several other unidentified figures. To viewer right is Abel, identified

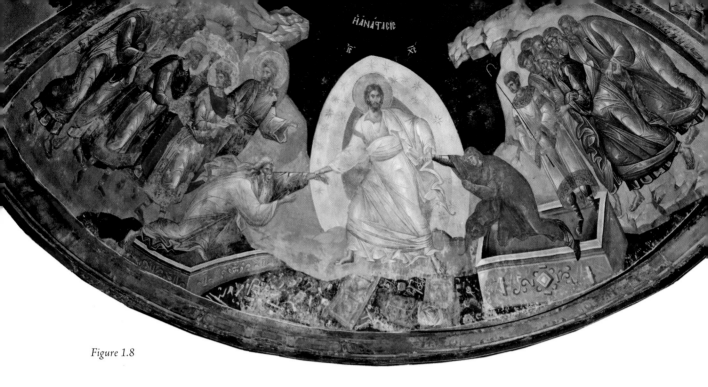

Figure 1.8

by his youth and shepherd's staff. Behind him is another unidentified group.

On Thursday, October 3, we fly home—Istanbul, Munich, Chicago, Orlando. But what is primarily on our minds is not Jesus, but Paul, not Christ's *Anastasis*, but Christ's *Apostolos*. The reason is that we are already in agreement on a Borg-Crossan pilgrimage to Pauline Turkey every year for the future. (We are also pondering the process of extracting Paul from the sixteenth century and its Reformation problems and returning him to the first century and its Roman problems.)

At home, as the dust of travel settles, we start to review and organize about nine gigabytes of travel photos. Projecting them from Mac to TV allows detailed side-by-side comparison of the Anastasis in the Dark, Buckle, and Chora Churches, from Cappadocia to Istanbul, across

a span of four hundred years. Comparing the Resurrection iconography is still only a mild curiosity and a secondary interest—but even that is more than enough at this point.

✠ ✠ ✠

Where are we now, and what comes next? We were beginning to glimpse, even if still but faintly in 2002, an artistic and theological chasm opening up between the standard Western Resurrection and the standard Eastern Anastasis as disparate visions of Christ's Resurrection. We distinguished them as the West's individual resurrection tradition, in which Christ arises alone, and the East's universal resurrection tradition, in which Christ arises and humanity rises along with him, by him, through him. We had—still faintly at this point—two general questions.

First, concerning *place*. In 2002, we had Anastasis images only from western Turkey—from Cappadocia and Istanbul. Were they some localized form of iconography or the official and traditional Easter image for all of Eastern Christianity—from the Byzantine Tiber to the Syriac Tigris and from the Russian Neva to the Coptic Nile?

We didn't know yet that, during the next fourteen years, we would travel across these ancient realms of Byzantine gold once and sometimes twice every year and, in the final rush before writing this book, three times in 2015. We didn't know yet that we would eventually discover that the Anastasis, the universal resurrection tradition, is the official image of Christ's Resurrection for all of Eastern Christianity—and that it would be this book's theological and iconographical challenge to our Western vision of Easter.

Second, concerning *time*—in both narrow and broad sweep. In 2002, we already recognized the changes in Anastasis content across a four-hundred-year span, from the Old Buckle Church in the early 900s (Fig. 1.5), through the Dark Church in the mid-1000s (Fig. 1.3), to the Chora Church in the early 1300s (Fig. 1.8).

One change applies to Christ's hands. He moves from a hand for Adam alone in the Dark and Buckle Church representations (Figs. 1.3, 1.5) to equal-opportunity hands for both Adam and Eve in the Chora depiction (Fig. 1.8). Is a move toward a later Byzantine feminism too modern a notion to consider?

Further, the Old Buckle Church fresco has four liberated characters, Adam, Eve, David, and Solomon (Fig. 1.5), but Chora's has those four plus two more, Abel and John the Baptist (Fig. 1.8). Clearly the Anastasis was not a static image, but a dynamic development across time.

There is, however, an additional question about time across millennia rather than just centuries. In 2002, it was already dawning on us that, at least in the second millennium, Western Christianity accepted the individual and Eastern Christianity the universal resurrection tradition as their official Easter images.

What, however, about the first millennium? How, why, where, and when did each separate iconic tradition originate? Did one come first? Which one? And if one did come first, why did it not succeed as the only one for all of Christianity? Since neither Easter image can derive from a nonexistent Easter description, which—if any—Gospel texts is each associated with, connected to, or accompanied by?

We turn, then, in the next chapter to the first appearance of a direct image of the Resurrection. We were, in fact, so focused on the universal resurrection tradition that we almost missed the fact that the individual resurrection tradition preceded it by three hundred years. That, of course, presses this question: If it was first, why did it not prevail as the single Easter icon for all and everywhere thereafter?

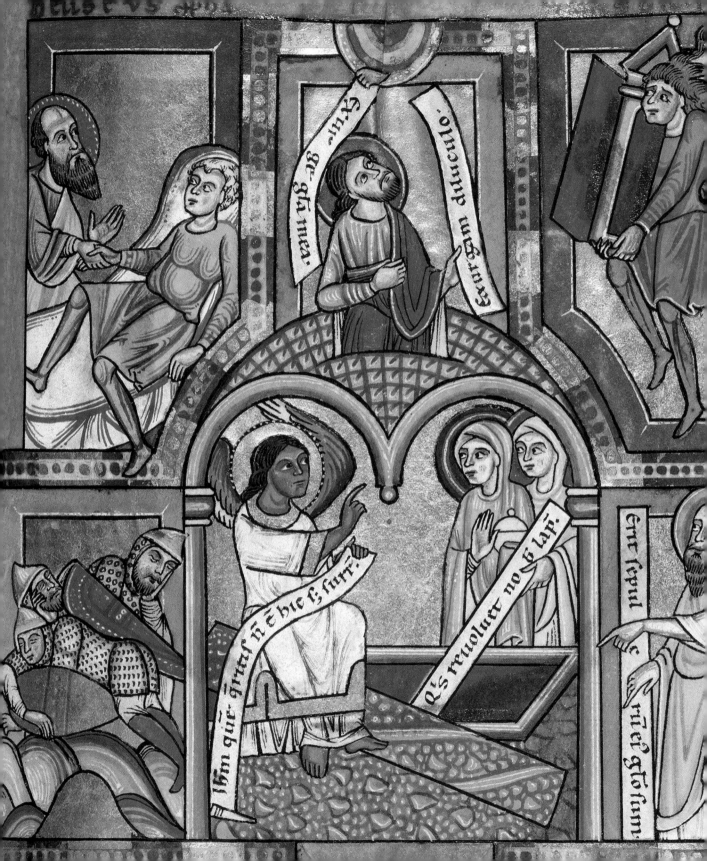

2

"The Guards Told Everything That Had Happened"

[Constantine's battle standard] was made like this. A long spear, overlaid with gold, formed the upright of the cross with a transverse bar across its top. Above this, a wreath of gold and precious stones was set; and within this wreath the Savior's name was abbreviated to its first two characters, with the letter X [that is, Greek chi for our CH] crossing the center of the letter P [that is, Greek rho for our R].

Eusebius, *Life of Constantine the Great*, 1.31 (337–39)

Eusebius, bishop of Caesarea Maritima in Israel and ecclesiastical historian in Constantinople, wrote a formal eulogy for Constantine after the emperor's death in 337, but left it unfinished at his own in 339. Constantine swore to him that, before joining battle with his imperial rival, Maxentius, near Rome's Milvian Bridge on October 28, 312, God granted him both a vision and a dream.

The noontime vision was of "a cross of light in the heavens, above the sun, bearing the inscription, 'Conquer by this'" (Eusebius, *Life*, 1.28). Then, in the nighttime dream "the Christ of God appeared to him with the same sign which he had seen in the heavens, and commanded him to make a likeness of that sign which he had seen in the heavens, and to use it as a safeguard in all engagements with his enemies" (1.29). Finally, as in the above epigraph, Eusebius describes the battle standard—the

vexillum or *labarum*—created by Constantine in obedience to the vision and dream (1.31).

Constantine's battle standard was the first attempt to create an actual image of the Resurrection itself. But it is the individual rather than the universal resurrection and, unfortunately, in this inaugural Easter iconography Constantine's violent imperialism contradicts Christ's nonviolent anti-imperialism (John 18:36).

✠ ✠ ✠

Most of our research project or, better, detective journey, focused on the universal resurrection tradition, and it was 2013 before we got an opportunity to consider fully the alternative

Figure 2.1

iconography of the individual resurrection. We discovered to our surprise that the individual imagery was not just alternative to, but far earlier than the universal option.

It is Friday, May 17, and we are at the Vatican in the Pio Cristiano Museum of Christian Antiquities. Our focus is on the carved frontals of six early Christian sarcophagi dated between 350 and 400 and especially on the very similar central image on each one.

This central image is of the individual resurrection, but it uses a symbolic rather than a physical image of the arising Christ. This gives us the first type in a four-stage typology for Christ's individual resurrection tradition, which we call, accordingly, Individual Type 1, Symbolic Resurrection. Our first example in the Pio Cristiano Museum is fragmentary, the broken-off center of a sarcophagus decorated with elongated S-shaped figures facing inward toward the symbol (Fig. 2.1). Here, Christ's Chi-Rho monogram is almost totally collapsed into the cross itself. The Greek X (our CH) is formed by the upright and transverse bars; the Greek P (our R) is formed by the upright and its circular addition at top right. The cross and the Chi-Rho merge, as it were, to form Christ's Crucifixion monogram.

Furthermore, to indicate the transcendence of that Crucifixion monogram, the image also displays the first letter, *alpha,* and the last letter, *omega,* of the Greek alphabet within the Chi-Rho (our CHR). Why? Because, in the book of Revelation, Christ names himself at the begin-

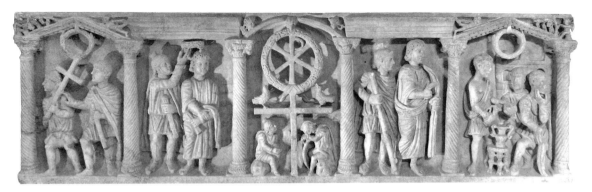

Figure 2.2a

ning and end of both book and time as "the Alpha and the Omega" (1:8; 21:6, 13).

Next, what makes the symbol a direct representation, an image, of the Resurrection itself are the two soldiers on either side of the triumphant and transcendent Cross/Christ. Within the image's horizontal constraints, each of these helmeted guards is shown standing up with one hand on his shield and the other holding his sleeping head. Keep an eye on these tomb guards and notice if they *sleep* and see nothing or *watch* and see everything throughout the rest of this chapter (for example, Fig. 2.2b) and, indeed, throughout Western Christianity's entire tradition of Christ's individual resurrection.

We turn next to a fully preserved sarcophagus with five compartments separated by urban-style columns and lintels (Fig. 2.2a). To the left of the central image of the individual resurrection, in the first panel Simon of Cyrene carries Christ's cross (Matt. 27:32), and in the second Christ is crowned with a wreath of victory—not with a wreath of thorns (Matt. 27:29). To the right, in the fourth panel Christ stands with a

soldier before Pilate as he washes his hands in the fifth panel (Matt. 27:24).

Once again, however, it is those two guards below the crossbar that make this a symbolic image of—precisely—Christ's individual resur-

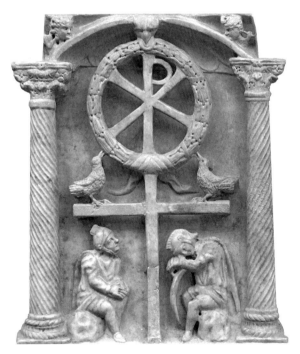

Figure 2.2b

Figure 2.3a

rection. Notice that both are now seated, but the left one looks upward meditatively while the right one looks downward sleepily, resting his head upon his upright shield. Finally, look at the very top section just beneath the arch. There an eagle whose wings are now the arch itself holds the wreath in its beak (Fig. 2.2b). Does Constantine's Roman eagle confer Christ's Resurrection victory?

There are, however, at least as many Resurrection sarcophagi preserved in France as in Italy and, indeed, the model probably derived from the lower Rhone Valley in Provence. We spent the last week in April 2013 based there at Avignon before going on to Rome. But the Provençal examples have long lost their Resurrection imagery—especially Christ's wreathed monogram—to anti-Christian vandalism.

That is why we begin here with the better-preserved Vatican sarcophagi. Without having

seen the sarcophagi at the Vatican in person, we would hardly even have recognized what was once there, but is now long lost in the Provençal ones. In any case, to balance that preceding Vatican example (Fig. 2.2a), here is a splendid Provençal Resurrection sarcophagus with very different content framing its central panel.

We begin at the traditional tomb of Mary Magdalene in the crypt below her basilica at St.-Maximin-la-Sainte-Baume, in southeastern France. Mary is reburied in a late-fourth-century Resurrection sarcophagus, but the central image is almost completely lost. Two other sarcophagi flank Mary's, and today all three are securely protected by bulletproof glass.

We use, however, a preglass stock image, because it allows us to see not only Mary's fourth-century Resurrection sarcophagus, but a better-preserved example to photo right (Fig.

2.3a). This is the traditional tomb of St. Sidoine, or Sidonius, the man born blind but healed by Jesus in John 9 (Fig. 2.3b). The framing panels show, to the left, the healing of a lame man (John 5) and a blind man (St. Sidonius himself? John 9), and to the right, the forgiving of Peter's denials (Matt. 28:75) and the healing of the woman with hemorrhages (Matt. 9:22).

Look now at what is left of that central Resurrection image. The guards have lost their heads, but the left one seems asleep and resting on his shield. The right one is probably awake and may be looking up. Of the cross only the upright remains, but you can see where the crossbar was attached. The wreathed monogram and its elongated streamers (compare the shorter ones in Fig. 2.2b) look more like a papal tiara than a Chi-Rho monogram.

A complete inventory of these Resurrection sarcophagi from Provence to the Vatican, including one reused by a sixteenth-century cardinal for his own tomb in Sicilian Palermo's Cathedral Crypt, provides a very clear conclusion. All of them contain that remarkably similar central image of the Individual Type 1, Symbolic Resurrection. This consistency is emphasized by the fact that the central image is surrounded by images quite divergent from each other in both format and content.

In format, the framing imagery may be two or three separated panels balanced on either side of the central image or continuous streams flowing from the left and the right toward that climactic core. In content, the frames may be of Christ's arrest (as in Fig. 2.2a) or Christ's miracles (as in Fig. 2.3b). Christ may appear alone, with Peter and Paul, or with all twelve apostles.

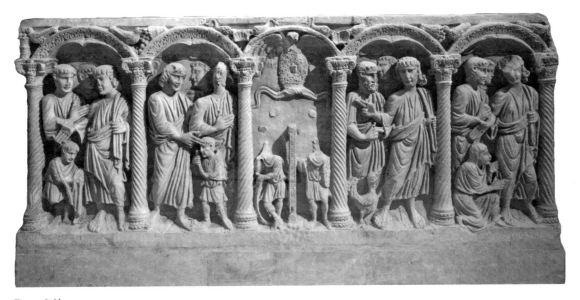

Figure 2.3b

Still, although this is the first ever attempt to portray Christ's Resurrection directly, this depiction creates a rather obvious fourfold discrepancy between physical and symbolic depiction. First, Christ is physically and not symbolically present in the framing panels. Second, so also are all other figures in the panels, for example, Pilate. Third, the sleeping and/or watching guards are there physically and not symbolically. Finally, all other events in the traditional life-of-Christ or great-feasts series show him as physically and not symbolically present.

✠ ✠ ✠

In light of those discrepancies, the necessary next step in the development of the individual resurrection tradition is to have Christ present in the image physically rather than symbolically. We call this Individual Type 2, Physical Resurrection, but it is an image both extraordinary in vision and unique in content.

Among the glories of Ireland's early medieval Christianity are its magnificent high stone crosses, especially those carved with biblical scenes. Among around 250 extant examples of such free-standing crosses, twenty-one have extensive scenes from both Old and New Testaments. Our focus here is on four such examples from the Irish counties of Meath, Louth, and Offaly dated between 850 and 950—but maybe earlier rather than later in that period.

We saw these four crosses multiple times between 2005 and 2015 and photographed them thoroughly, which was very fortunate, because we did not recognize the image on them until we were writing this book. (We went back in September 2017 for better images.) Like the Resurrection images on those Vatican and Provençal sarcophagi we just saw (Individual Type 1, Symbolic Resurrection), these images are also carved on stone, but in them, unlike in the symbolic images, the body of Christ is now physically present; hence they are named Individual Type 2, Physical Resurrection.

Our best image is from St. Ciarán's monastery at Clonmacnoise on the Shannon—but from the replica outside rather than the original inside. It is the bottom image on the west-facing shaft of the Cross of the Scriptures, on the side with the Crucifixion at top center (Fig. 2.4a).

Christ's body, head to the left, lies physically prone, swathed in a winding sheet decorated with three large and equal-armed crosses (can you find the third one?). His face is uncovered, but his head has a dot-studded band around it. Atop his body, but not his face, is a very thick tombstone. Above his uncovered face, a bird has its beak in Christ's mouth to represent the Holy Spirit breathing risen life into his body. This is an extraordinarily unique attempt to depict the actual moment of the Resurrection itself. You could even argue that it is the only one ever attempted, since *once Christ moves, Resurrection has already occurred.*

Be that as it may, the expected tomb guards appear as two helmeted soldiers facing one another. They sit atop the tomb slab with spears on their shoulders and heads bowed down in

Figure 2.4a

interpretation may be more likely. This one is on a biblical high cross now protected inside a small restored church on grounds that once enclosed St. Columba's monastery at Durrow. Its west face, or Crucifixion side, is identical in imagery with that west face from the Cross of the Scriptures at Clonmacnoise. But the weathered image is more clearly identifiable only after seeing the Clonmacnoise version.

The Durrow Cross has the same prostrate body of Christ, heavy tomb slab, inspiriting bird, and facing, helmeted, spear-carrying, sleeping soldiers (Fig. 2.4b). The two Marys appear behind their helmets only as haloed heads. But what about that figure in between the soldiers. Might it be the missing angel or even Adam himself?

sleep. (If something is lost from that space between them, it might be another equal-armed cross.)

To viewer right is a large winged angel also sitting on the stone, and above this angel appear the heads of the two Marys (Matt. 28:1–2). Barely still visible is a tiny figure in front of the angel atop the slab. At best guess, this may represent Adam as a reflection of the universal resurrection tradition in this strikingly unique—but also strikingly localized—version of the individual resurrection tradition.

Because of that possible presence of Adam as representative of all humanity in the Clonmacnoise image, we look at one other example of this image—also in County Offaly—where that

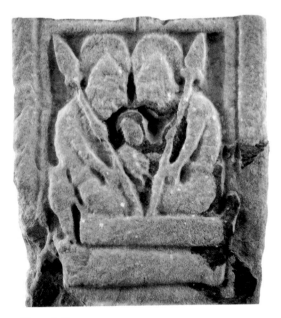

Figure 2.4b

Ireland has two other examples of this unique Type 2 of the individual resurrection tradition. One is on a cross in Kells, County Meath, now moved from its position as a target for lorries in the marketplace to a safer roofed location in front of the Heritage Centre. The image is at the bottom of the side facing the Centre with Daniel in the Lion's Den at the top. The other is on the bottom of the west face, or Crucifixion side, of the Tall Cross—the tallest in Ireland with the most biblical images—at Monasterboice, County Louth.

Both these latter two images are extremely damaged, but recognizably similar to those at Clonmacnoise and Durrow as a specific type of image. Both, however, have one added and interesting feature. Between those two soldier guards and rising from tomb slab to above their bowed heads is a tall, slender ceremonial cross. Remember it, because we meet it repeatedly, as it

emphasizes that Crucifixion and Resurrection—whether individual or universal—are a dialectic, like the twin sides of a coin that can be distinguished but never separated.

☩ ☩ ☩

Although Christ is already physically present in Individual Type 2, a *fuller* physical depiction much closer in appearance to all the rest of the life-of-Christ imagery is surely both necessary and inevitable. And so we get Individual Type 3, Emerging Resurrection. And we get it, but only as a promise of things to come, and even before the special contribution of Ireland that we just saw.

In this new Individual Type 3, Emerging Resurrection, Christ *sits up*, *stands up*, and finally *steps out* of his tomb. But in this type he never gets completely out, never gets free and clear of his tomb. At the very most, he appears half in

Figure 2.5

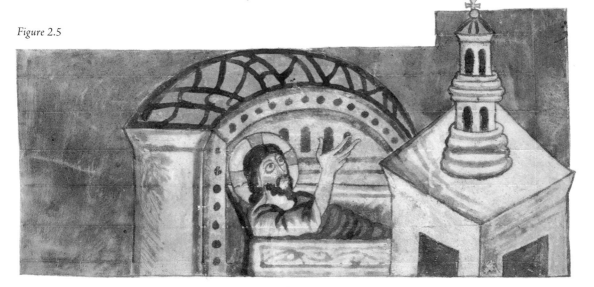

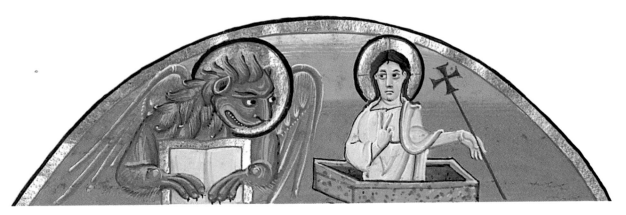

Figure 2.6

and half out, with one leg in and the other out of his sepulcher. Hence our term "emerging."

What strikes us, and what we encourage you to ask in preparation for the next chapter, is: Why does it take four hundred years to get from Type 1 to Type 3 of the individual resurrection tradition? Why does it take so long to do the obvious, to get from a symbolic to a physically living depiction of the Resurrection? The soldier guards are always physically living, so why is not Christ as well? What holds up an earlier advent of his *living* depiction as in all other life-of-Christ images?

The first example of this new type appears between 800 and 820 in the Stuttgart Psalter. Although produced at Charlemagne's personal monastery of Saint-Germain-des-Prés in Paris, this beautifully illustrated Psalter is now preserved in Baden-Württemberg's State Library at Stuttgart in Germany (WLB Bib. Lat. MS 23). On this codex's folio 157r we have the inaugural version of Individual Type 3, Emerging Resurrection. Christ simply sits up in his sarcophagus within a very elegant tomb, but he is already very much physically living rather than symbolically indicated (Fig. 2.5).

The image extends across the full width of the page and comes immediately after these verses: "For the enemy has pursued me, crushing my life to the ground, making me sit in darkness like those long dead. Therefore, my spirit faints within me; my heart within me is appalled" (Ps. 143:3–4). Those verses, and indeed all of Psalm 143, reinforce the image as proclaiming Christ's individual rather than the universal resurrection.

This inaugural ninth-century image is like a swallow arriving far, far ahead of the summer's others. It takes two hundred years before we find the next example of Individual Type 3, Emerging Resurrection. But at least the latter represents progress, as Jesus is standing up rather than just sitting up in his sepulcher.

This scene is on an eleventh-century manuscript from the Benedictine Abbey of St. Peter on Reichenau Island in southern Germany's Lake Constance. It is now preserved in the Bavarian State Library at Munich (Cod. lat. 4454). Each evangelist gets a full-page image in the Reichenau Gospels, and atop Mark's is his symbolic lion to the left and Christ arising to the right (Fig. 2.6).

Next, as we move into the twelfth and thirteenth centuries, Jesus is shown not just sitting up or standing up in his sepulcher, but preparing to step out of it. Slightly later representations of this stage show him half in and half out of his sepulcher; rather awkwardly, one leg is already outside and the other still inside.

A magnificent altarpiece by Nicholas of Verdun—a master artist in copper, enamel, and gold—is in the Leopold Chapel of the Augustinian Klosterneuburg Abbey in Lower Austria. This 1181 masterpiece has fifty-one images in three rows across a left wing, central panel, and right wing; life-of-Christ events occupy the middle row and are framed above and below by mostly Old Testament scenes and a few New Testament ones.

At the end of the middle row of the central panel is an image of Christ preparing to climb out of his sepulcher (Fig. 2.7). He wears a halo with cross, his wounds are emphasized, and a cross-topped staff stands beside him. But now the armed guards are back—one sleeps, one cowers, and one looks up fearfully. The Latin identifies Christ as the "Paschal Lamb" at the bottom and affirms: "The Father gave life after three days in the grave."

Our next example comes courtesy of Jean, Knight of France, Lord of Joinville, and councilor of King Louis IX, who retreated with the disastrous Fourth Crusade to safety at Christian-held Acre, now on the northern promontory of Haifa Bay in Israel. Between 1250 and 1251, for soldiers who were defeated, diseased, dying, and possibly losing faith, Jean prepared a summary of Christian faith by presenting the Apostles' Creed in both text and image.

The creed's phrase "On the third day he rose from the dead" is cited in Old French above its appropriate image (Fig. 2.8). Christ, with emphatic red wounds, sits atop a sepulcher depicted as an altar with two candlesticks. He carries a book (Gospel or Missal?) in his left hand and blesses with his right. The sepulcher/altar shows Christ's individual resurrection as actualized in every Mass. Once again the guards are present—sleeping to the left but watching to the right—and Christ's right foot lands on top of the latter soldier.

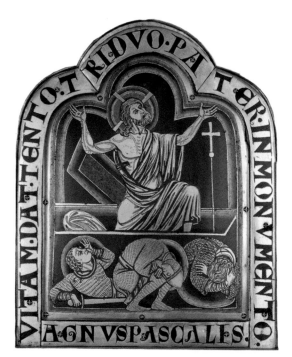

Figure 2.7

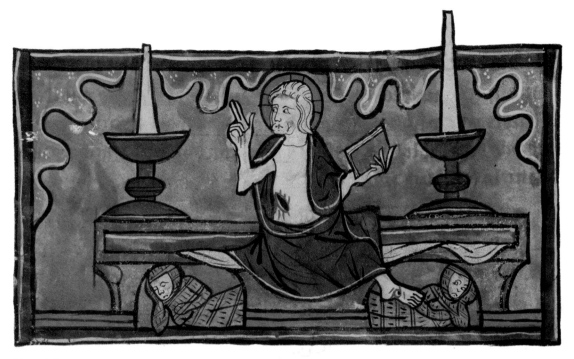

Figure 2.8

In summary, the transition from symbolic to physically living individual resurrection seems to inch across the centuries from sitting up (Fig. 2.5) to standing up (Fig. 2.6) and then from preparing to emerge (Fig. 2.7) to actually emerging—often with the outside foot landing atop a soldier (Fig. 2.8), as if replacing Hades.

At this point, we could easily guess the next development—but we would be wrong. Surely the final stage is to have Jesus fully free of his tomb or sepulcher and standing beside it or in front of it. But, instead, in the next stage, Individual Type 4, Hovering Resurrection, Jesus appears *above* his emptied tomb. He is suspended, soaring, floating, or lingering above and disconnected from the guarded tomb.

Preparatory examples of this new type, Hov-

ering Resurrection, overlap with the preceding type, Emerging Resurrection. Jesus is coming out through the *roof* of the tomb as an obvious transition from emerging below to hovering above. Here are two manuscript examples.

First, near the Pyrenees border with France, the Benedictine Monastery of Santa Maria de Ripoll, in Catalan Spain, produced several beautifully illustrated Bibles between 1015 and 1020. The Ripoll Bible in the Vatican Library (BAV Cod. Lat. 5729) has an image of the individual resurrection that is a perfect example of the transition from Type 3, Emerging, to Type 4, Hovering (folio 370r).

The tomb scene appears at the top left of two levels of Easter images; to the right of the tomb scene is Emmaus; and below it, from right to

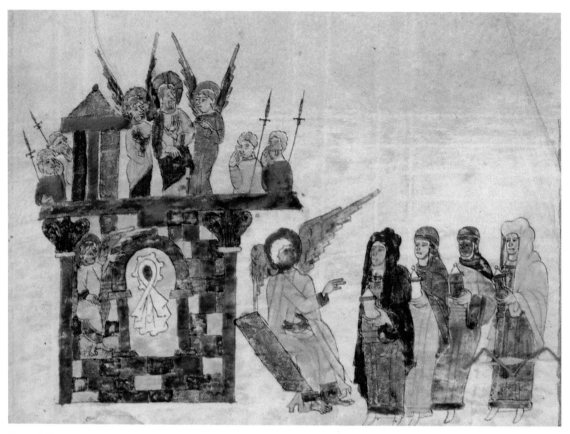

Figure 2.9

left, are three scenes from John 21. Our focus here is just on that tomb scene; notice the tomb's shape for future reference (Fig. 2.9). In the scene with Christ are four guards, four angels, and four female disciples.

The door of the tomb is open, and the abandoned winding sheet is visible within (as in Fig. 1.5). To the immediate right the angel sits on the door and addresses four women with jars of ointment. On the roof of the tomb, beside that towerlike cupola, Jesus stands between two angels with four guards—two on either side—to balance the four women below. The guards are all awake and watching everything—the two at the right have hands to mouths in amazement. Jesus is completely out of the tomb, above it and not beside it, but he has not yet moved to a full separation from it.

Next, we turn from this eleventh-century scene to a very similar twelfth-century image in the Stammheim Missal. This codex was created in the 1170s at the Benedictine abbey of St.

Michael the Archangel in Hildesheim, northern Germany, but it is named for the Stammheim Mansion, north of Cologne, home of the missal's Von Fürstenberg owners until 1997. It is now preserved—with gracious online openness—at the Getty Museum in Los Angeles.

The missal has a full-page miniature for Easter (folio 111r), but for present focus we show only the central core and leave aside the Old Testament images that surround it (Fig. 2.10, but see the fuller version at this chapter's opening page). In the center is an open sarcophagus within a tomb enclosure; in very abbreviated

Latin, the women wonder, "Who will remove the stone for us," and the angel announces, "Jesus, whom you seek, is not here, but risen" (from Mark 16:3, 6). At the left are sleeping soldiers all jumbled up together. At the right is Isaiah pointing to the empty sarcophagus with the prophecy: "His sepulcher shall be glorious" (11:10).

At the top, Jesus is emerging through the roof of the tomb itself. Descending from the hand of God on high, a scroll says, "Arise, my glory," and Christ's responds, "I will arise early" (from Ps. 56:9, Vulgate). As in the Ripoll Bible, this is an equally transitional moment between

Figure 2.10

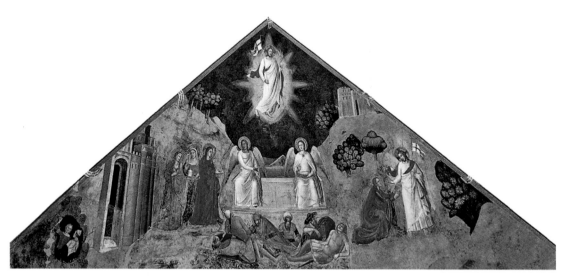

Figure 2.11

Types 3 and 4. Christ is beyond stepping out of his sepulcher, as in Individual Type 3, Emerging Resurrection, but not yet fully out and above it, as in Individual Type 4, Hovering Resurrection. That comes next.

✠ ✠ ✠

The Dominican complex of Santa Maria Novella, in Florence, has a separate chapter house between the basilica and the great cloister. (It becomes the "Chapel of the Spaniards" only in 1556.) Completely frescoed by Andrea di Bonaiuto da Fiorenze in 1366–67, the four-triangle ceiling has an archetypal image of Christ's individual resurrection as Type 4, Hovering (Fig. 2.11).

First of all, notice the image's striking combination of the *causal* moment of the event itself in the verticals and the *consequential* moment of the subsequent events in the horizontals. In the center of this dual aspect are two angels seated on the open sepulcher. Horizontally to the left, three women approach the tomb (Mark 16:1) and horizontally to the right Mary and Jesus converse in the garden (John 20:17). The left is the empty-tomb tradition and the right is the risen-vision tradition as the outcomes of the Resurrection event.

In the vertical dimension, we return to the guarded-tomb tradition, but now with Jesus hovering physically above it and not just emerging from it or connected to it in any way. This, once again, is the instant or moment of the event itself in which five of the six guards are sleeping, but the second from the left is awake and looking upward to see the individual resurrection.

Look very carefully at that central vertical image, because the typology ends here. Christ's Resurrection as Individual Type 4, Hovering Resurrection, is henceforward the traditional Easter icon of Western Christianity. Jesus

floats free and clear above his sepulcher while the guards below are asleep and see nothing or awake and see everything.

Examples of Type 4 multiply exponentially across the following centuries of Western Christianity. As we write this section, we turn to the "Gallery of Art" at the end of Wikipedia's article "Resurrection of Jesus." Ten examples are given there and, in both Type 3 and Type 4, sleeping and/or seeing guards always appear below.

This emphasis on the guarded tomb appears in all four types of Christ's individual resurrection tradition. But why were the guards so important iconographically? They often compete with Christ himself for pictorial space and focal interest. Why not just skip them and focus on Christ emerging from or hovering above his abandoned tomb? Also, why is there that ambiguity across the tradition between sleeping and seeing, between heads down and asleep, and heads up and awake?

✠ ✠ ✠

Within the entire New Testament, only Matthew has the guarded-tomb tradition, and it is carefully interwoven across the entire story of Christ's Resurrection: burial (27:57–61); guards placed (27:62–66); descent of angel (28:1–3); guards prostrated (28:4); empty tomb and risen vision (28:5–10); guards bribed (28:11–15). For Matthew, those guards are clearly important and are presented in counterpoint to the Resurrection itself.

First, the guards were placed to make the tomb "secure until the third day; otherwise his disciples may go and steal him away, and tell the people, 'He has been raised from the dead,' and the last deception would be worse than the first" (27:64).

Next, on Easter Sunday morning, "there was a great earthquake; for an angel of the Lord, descending from heaven, came and rolled back the stone and sat on it. His appearance was like lightning, and his clothing white as snow. For fear of him the guards shook and became like dead men" (28:2–4).

Finally, after the guards "went into the city and told the chief priests everything that had happened" (28:11), the chief priests and the elders decided to bribe the guards: "You must say, 'His disciples came by night and stole him away while we were asleep.' If this comes to the governor's ears, we will satisfy him and keep you out of trouble. So they took the money and did as they were directed. And this story is still told among the Jews to this day" (28:13–15).

If that story is a lie, what is the truth obscured by the falsehood? Since the sleeping is a lie, what did they see when awake? Since the stealing is a lie, what actually happened?

For Matthew, the lie is that the guards were asleep and did not see the bodily abduction. The presumed truth behind that lie is that the guards were awake and did see bodily Resurrection.

Matthew's conclusion is that the guards could have and would have described the Resurrection, had they not been suborned to lie by bribery.

Still, Matthew never describes what the tomb guards actually saw and what they would have admitted, had they not been bribed to lie. Neither does anyone else in the New Testament. But one extrabiblical author does precisely that and thereby explicitly confirms the truth that Matthew claims only implicitly.

☩ ☩ ☩

The guarded-tomb tradition is also found in the so-called *Gospel of Peter*, a second-century work that the majority of scholars think is simply derived from the New Testament Gospels and, in the case of the story of the guards, from Matthew's own version. A small minority think the opposite is true, that Matthew is based on the *Gospel of Peter*, but that is not our present concern. We read the *Gospel of Peter*'s account here as confirming explicitly what Matthew affirms implicitly.

In the *Gospel of Peter*, the guards are placed at the tomb "for three days, lest his disciples come and steal him away and the people suppose that he is risen from the dead" (8:30). But after that, the story changes dramatically:

> When the soldiers were keeping guard, two by two in every watch, there was a loud voice from heaven, and they *saw* the heavens open and two men, shining with a great light, descend and approach the

tomb. But the stone set against the door rolled away to one side by itself, and the tomb was opened and both the young men entered in.

> The soldiers, having *seen* this, woke up the centurion and the elders—for they also were there keeping watch; and even as they were telling them what they had *seen*, they *saw* three men come out of the tomb, two of them supporting the third, and a cross following after them. They *saw* that the heads of two of them reached to heaven, but the head of the one supported by the others surpassed the heavens. (9:35–40)

Our italics indicate this account's fivefold emphasis on the guards "seeing" the actual Resurrection itself. (Notice also those "two men/ angels," because they appear again and again in the subsequent imagery of Christ's individual resurrection tradition.)

In the *Gospel of Peter* both guards and authorities actually and explicitly witness Christ's Resurrection from Earth to Heaven. There is no mention or need for any self-contradictory tale about grave robbery from sleeping witnesses. Instead we have this:

> Having *seen* these things, the centurion and those with him hastened by night to Pilate, leaving the tomb they were guarding, and told all that they had *seen*, in great agony, saying, "Truly, he was the Son of

God." Pilate answered and said: "I am clean from the blood of the Son of God, but this seemed good to you."

Then all, coming forward, besought and exhorted him to charge the centurion and the soldiers to tell nothing of what they had *seen*. "For," they said, "it is better for us to commit the greatest sin against God than to fall into the hands of the people of the Jews and to be stoned." Pilate therefore charged the centurion and the soldiers that they should say nothing. (11:45–49)

We cite this account not as historical, but as explicitly affirming what Matthew records only implicitly. It attempts to describe what Matthew imagines the guards to have seen, what Matthew believes happened.

The whole incident of the tomb guards—from the Gospel of Matthew to the *Gospel of Peter*—is more polemical creation than historical event. But leaving that aside, this guarded-tomb tradition explains their prevalence and importance for Christ's individual resurrection. They alone saw the actual event of Resurrection, told the authorities, and were bribed to lie about it. The individual resurrection tradition, by depicting sleeping and/or seeing guards, tells the lie and reveals its truth at the same time.

✠ ✠ ✠

We return to Irish high crosses one more time as a footnote to the description of the individ-

ual resurrection tradition in the *Gospel of Peter*. Despite all the other life-of-Christ scenes on those biblical crosses and apart from the Individual Type 2, Physical Resurrection, examples we looked at, there is but one single, solitary example of the Type 4 individual resurrection tradition extant anywhere on Ireland's stone crosses. There are so many other incidents, so often the Last Judgment scene, but only one case of an Individual Type 4, Hovering Resurrection! Furthermore, this example of Type 4 is around four hundred years earlier than the fully formed example of Christ completely separated from, hovering above, or moving upward from the guarded tomb below (recall Fig. 2.11).

At the right end of the crossbar on the west face, or Crucifixion side, of Muiredach's Cross at Monasterboice is an image, based on the account in the *Gospel of Peter*, depicting a Type 4 individual resurrection. If Type 2 is unique in content, this Type 4 is unique in timing (Fig. 2.12).

The lower and larger part shows two facing soldiers—as in Type 2 above—but with swords rather than spears on their shoulders. Also, rather than asleep, they are awake, and so crouched that the sharp line between and above their knees forms a deeply cut cross whose upper section derives from the tomb opening itself. As always, Crucifixion and Resurrection are a dialectic, that is, distinguishable but not separable.

Above the cross Christ appears in the center with knees spread, ankles joined together, and outstretched arms supported by an angel on

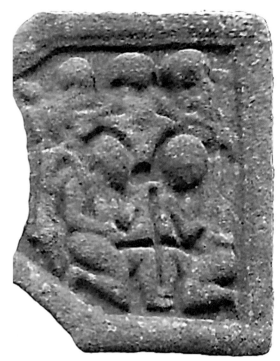

Figure 2.12

either side: "They *saw* three men come out of the tomb, two of them supporting the third" (*Gospel of Peter* 10:39). Finally, squeezed along the side to viewer left are the two female disciples, one above the other (Matt. 28:1–2).

✠ ✠ ✠

Where are we now, and what comes next? From this chapter's tour through the developmental four-stage typology of Christ's individual resurrection tradition, we take two questions into the next chapter.

The first question concerns the tomb. On the one hand, its description is quite clear in the Gospel version. Joseph of Arimathea "laid it [the body] in a tomb that had been hewn out of the rock. He then rolled a stone against the door of the tomb" (Mark 15:46). This is the classic burial mode for the affluent in first-century Israel.

On the other, this rock-hewn tomb is seldom portrayed in this chapter's images as Christ's burial place—especially that rolling stone. Perhaps it just seemed too unusual or too inelegant. But certain images seem to have a rather specific alternative in mind; compare, for example, the details of the inside and outside of the tomb given in Figures 2.5 and 2.9. Are they just generally imagining some more elegant tomb for Jesus, or are they specifically depicting some precise example somewhere? And if so, from where, and why there?

The second question is even more pressing. In this tradition, Jesus's rising is shown as *physically living* only around 800, and thereafter the artistic development takes him out of his tomb very slowly from sitting and standing to emerging and hovering—by 1400. But that, however slow, is at least a steady development. But, before that, why take four hundred years to get from a symbolic to a *physically living* Resurrection?

Granted that Individual Type 1, Symbolic Resurrection, was extant by 400, why did it take until 800 before we get Individual Type 3, Emerging Resurrection? Recall the immediately obvious discrepancies on those Resurrection sarcophagi between physical figures for Jesus and others in the framing panels and for even

the guards in the central panel, but only a symbolic one for Jesus himself in the central panel (for example, Figs. 2.2a, 2.3b). Why take four hundred years to remedy so evident an inconsistent treatment?

In other words, was there some special factor in those four hundred years that made a move from symbolic to living representation less immediately obvious than it seems to us in hindsight? Could that inaugural symbolism have been so changed, specified, intensified, and located that it might have become the traditional Easter image for all of Christianity?

We know, of course, what actually happened in the second Christian millennium, but what could have happened differently in that first one? As early as 400, were there other options beside an inevitable move from symbolic to physical imagery in Christ's individual resurrection tradition?

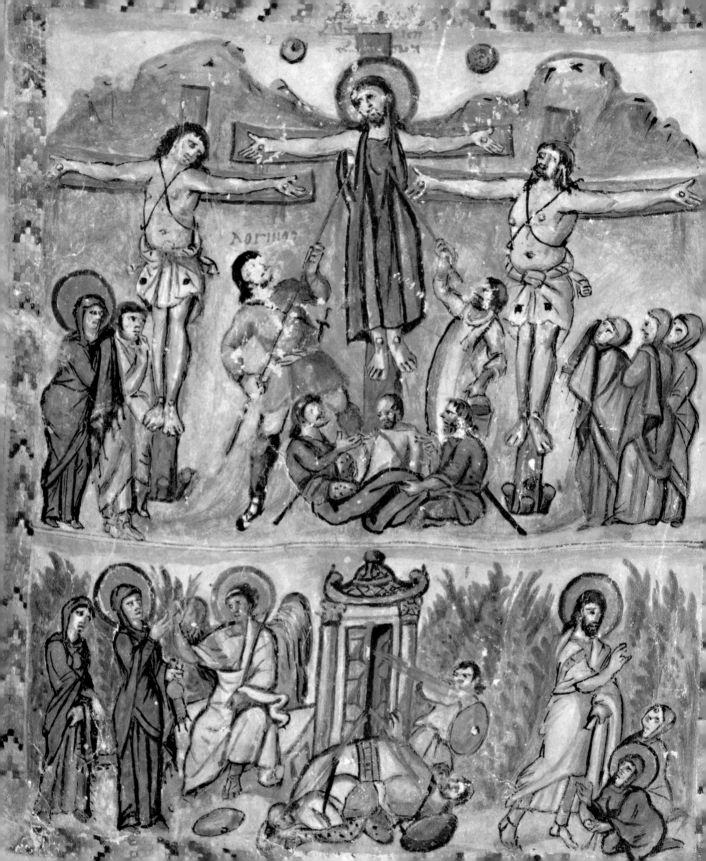

3

"The Cave of the Anastasis"

[During Queen Helena's excavations in Jerusalem] as soon as the original surface of the ground, beneath the covering of earth, appeared, immediately, and contrary to all expectation, the venerable and hollowed monument of our Savior's resurrection was discovered. Then indeed did this most holy cave present a faithful similitude of his return to life, in that, after lying buried in darkness, it again emerged to light, and afforded to all who came to witness the sight, a clear and visible proof of the wonders of which that spot had once been the scene, a testimony to the resurrection of the Savior clearer than any voice could give. . . . This monument, therefore, first of all, as the chief part of the whole, the emperor's zealous magnificence beautified with rare columns, and profusely enriched with the most splendid decorations of every kind.

EUSEBIUS, *Life of Constantine the Great*, 3.28, 34 (337–39)

HELENA, *Augusta Imperatrix* as mother of Emperor Constantine, traveled to the Levant in 325 with both imperial mandates and impressive monies to find, build, and adorn the holy places of her son's new faith. She discovered in Jerusalem both the "True Cross" at the Crucifixion site and the "True Tomb" at the Resurrection site. What better, what more perfect symbol of Christ's individual resurrection could there be than "this most holy cave" in which it happened, the actual empty tomb from which he arose?

The imperial architect Zenobius first cut out the entire cave tomb's burial chamber from its cocoon of surrounding rock and then built

Figure 3.1

around it a small shrine chapel, or tomb edicule (from Latin *ediculum*, "small house.") The cave tomb itself was thus encased in a circular building with columns supporting a conical roof surmounted by a cross. Attached in front was a stepped and gabled porch with low railings, but otherwise it was open on three sides (Fig. 3.1).

The Archaeological Museum of Narbonne, in southwestern France, preserves a model that gives some idea of the original tomb edicule from 325 (Fig. 3.2). It is in local Pyrenees marble from the late 400s or early 500s and, despite much damage, you can still see the pillar bases of the porch, some of the others around the cave shrine, and especially a scalloped shell design

in the apse above the entrance from the porch to the tomb (Is this supposed to represent light radiating from the tomb?).

In 1009, the Fatimid caliph al-Hakim of Cairo temporarily reversed traditional Muslim toleration—since 635—and programmatically obliterated the edicule down to the ground. A millennium later, in 2016–17, the present edicule, structurally buttressed by girders in 1947, is under long overdue scientific restoration by archaeologists, but whether anything at all remains from Constantine's creation remains to be seen. Still, for all those centuries from 325 to 1009, Constantine's original cave shrine, set in a great pillared and domed rotunda at the

west end of the Church of the Holy Sepulchre, became the climactic focus for pilgrims from all over the Christian world.

One such pilgrim spent three years, from 381 through 384, in Jerusalem. Her name was Egeria, but only the middle section of her detailed travel diary survives in an eleventh-century manuscript at Monte Cassino Abbey. She comes from either the Atlantic coast of Spain *or* the Mediterranean coast of France. She records for her "sisters" back home, either as a nun for her convent or as a layperson for her companions.

She writes in a colloquial Latin, travels with great stamina, courage, and enthusiasm, and is away from home for about forty months in all. One striking feature of Egeria's extant account is her very detailed record of the liturgical rites

Figure 3.2

held daily, weekly, and annually in Jerusalem's Church of the Holy Sepulchre:

> On the Lord's Day, the whole multitude assembles in the basilica which is near the Anastasis. The bishop arrives and enters the cave at the Anastasis; all the doors are opened and the whole multitude enters the Anastasis, where countless lights are already burning. Then the bishop, standing within the rails, takes the book of the Gospel, and proceeding to the door, himself reads the [narrative of the] Resurrection of the Lord. And from that hour all the monks return to the Anastasis. Censers are brought into the cave of the Anastasis so that the whole basilica of the Anastasis is filled with odors. (*Egeria's Pilgrimage* 24)

That citation strings together a series of her comments on the Sunday celebrations at the tomb edicule, but what is obvious is that the term "Anastasis" refers here not just to the *event*, but to the *place* of Christ's Resurrection. The Rotunda is *itself* the Anastasis—it contains the "cave" inside and the "rails" outside, and one can enter into this "Anastasis"—physically, liturgically, and mystically.

Think, for example, about the very first time the word "Anastasis" appears on an image. It is around the year 500, on a medallion now lost but known from an 1880 drawing by the Italian Jesuit archaeologist Father Raffaele Garrucci

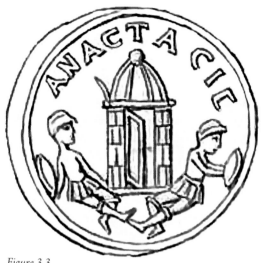

Figure 3.3

(Fig. 3.3). Garrucci's image depicts the expected tomb guards. The one to the left is sleeping with his shield set aside, but the one to the right is more interesting. He seems knocked down or spun away—shield still in hand—from the direction of the opened door. This is an attempt to show the actual moment of the individual resurrection, but as yet with no physical body of Christ in evidence.

What happens when "Anastasis" is not just an event described in a text or depicted in an image, but a *place* that can be experienced physically, indeed as one you can enter and exit as Christ did then in history and does now in liturgy? How does the discovery of what Eusebius calls "this most sacred cave" in our epigraph above change depictions of Christ's Resurrection and indeed emphasize his *individual* resurrection?

What we will see is how as early as 400

iconography begins to expand beyond Individual Type 1, Symbolic Resurrection, first in implicit and then in explicit connection with Christ's tomb edicule in Jerusalem. This helps answer the two questions for this chapter.

First, the discovered cave tomb within the edicule in Jerusalem transcends the described cave with rolling stone in the Gospels. Does it not move, as it were, beyond the *symbolic* to the *concrete* (pun intended)? Granted there is still no physical Christ arising from his tomb, but this actual, factual, historical, *physical* tomb transcends any description in text or depiction in image. Between 400 and 800, could the individual resurrection tradition have settled for the physicality of the actual *tomb* over even the physicality of Christ's *body*? Can this explain why it took until the year 800 before we got Individual Type 3, Emerging Resurrection?

✠ ✠ ✠

First, in the Bavarian National Museum in Munich, there is a 7- by 4½-inch ivory panel dated to around 400. Acquired in 1860 from Martin von Reider, it is commonly known as the Reider Panel (Reidersche Tafel; Inv. 157). This intensely creative icon (Fig. 3.4) depicts both the Resurrection and the Ascension, but our focus here is on the left half, the Resurrection itself.

This is again a *symbolic* depiction of the actual moment of resurrection. Here the solution is the olive tree growing luxuriantly out of the very top of the tomb with birds feeding on its fruit (recall the feeding birds atop the arches in Fig. 2.3b). This is the Resurrection as the Tree of Life for the world; and this olive tree visually links the Resurrection, on the left, to the Ascension on the Mount of Olives, on the right (Acts 1:12).

Two guards are also present—as expected—one asleep and one awake. But they recede very much into the background compared with the

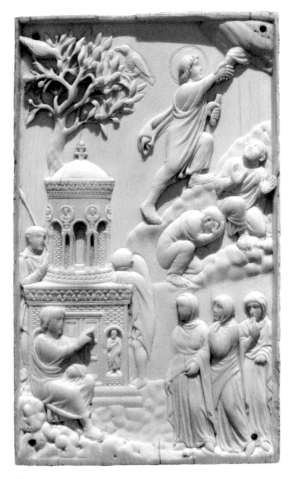

Figure 3.4

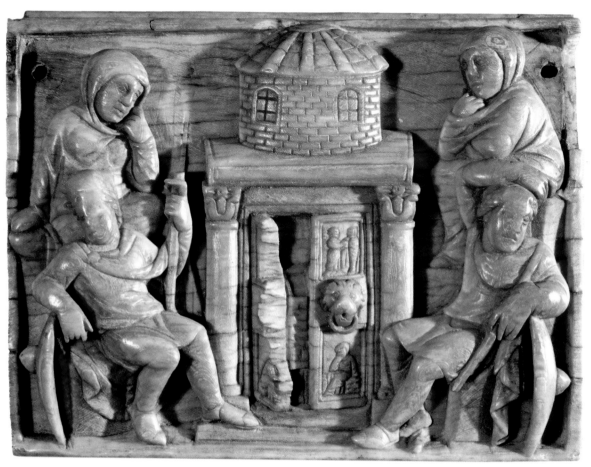

Figure 3.5

image below them, which will live forever in Easter imagery. This is then the empty-tomb tradition, here with three women. (Is this the earliest depiction of the Women at the Tomb? In the Christian baptistery in Rome's border city of Dura-Europos on the Euphrates (233–56), a fresco shows women approaching a star-topped edifice, but this is the Wise Virgins and the Heavenly Feast of Matt. 25:10.)

Furthermore, the tomb is not the biblical rock tomb with rolling stone, but an extremely elegant version that is completely closed. Notice that its square substructure topped by a rounded spire-topped cupola keeps reappearing as Jesus's tomb (Figs. 2.5, 3.5). This is certainly not any exact facsimile of the tomb edicule in Jerusalem, but an imaginative portrayal of its appropriate splendor.

✠ ✠ ✠

Second, the Reider Panel contrasts strikingly with another ivory carving depicting an equally

early image of the symbolic Resurrection. This is one side, 3 by 4 inches in size, from a four-sided reliquary box dated between 420 and 430. Acquired by London's British Museum from William Maskell in 1856, the box is called the Maskell Casket or Maskell Ivories.

The first side shows Pilate washing his hands, Christ carrying his cross, and Christ forgiving Peter's denial. The second side has Judas's suicide and one of the earliest images of the Crucifixion. The third side has the tomb scene. The final side shows Doubting Thomas, from the risen-vision tradition. Our focus is the tomb scene, which, like the preceding Reider Panel, combines direct symbolic Resurrection with indirect empty-tomb tradition (Fig. 3.5).

This scene is often described as the Women at the Tomb, since "Mary Magdalene and the other Mary went to see the tomb" in Matthew 28:1. But, even if that were intended, it is certainly depicted in neither biblical nor traditional fashion. The women here are seated and in mourning posture rather than approaching the tomb to be met by an angel. Furthermore, their posture is identical to that of Mary and Martha in the panels on the bottom of the tomb doors—notice Christ and Lazarus in the top right door image.

Compared to the preceding image, this is, at very best, an inaccurate to inadequate attempt to depict the Women at the Tomb. Yet they are facing toward the tomb, unlike the much more fully depicted guards below them. The guards could be sleeping, but their unsupported heads are turned—defensively?—away from the tomb. Also, the position of the right guard's right hand could designate slumber, but more likely designates protection of the head—from what?

Finally, look at the tomb itself. As with the preceding figure, this is certainly not the biblically described tomb of Christ, and neither is it exactly like Jerusalem's tomb edicule. Still, like that preceding image, it shows a round, windowed top on a square bottom. But the most significant feature of the tomb is its thick, strong door, which is shattered—outward. Inside, you can see the empty sarcophagus.

In other words, this is another *symbolic* attempt to depict the actual event, the moment of Christ's individual resurrection. Its power shatters the doors as it departs through them and forces the faces of the guards away from its splendor. That condition is confirmed over one hundred years later, as we shall see in our next example.

☩ ☩ ☩

Third, in 586, at the monastery of St. John of Zagba on the eastern side of the Orontes River about thirty miles northwest of modern Hama, Syria, a monk named Rabbula signed off—as the calligrapher but not the artist—on an illustrated copy of the Gospels. Known today as the Rabbula Gospels, the codex is preserved in Florence's beautiful Laurentian Library, designed by Michelangelo, endowed by the Medici family, and opened to scholars in 1571.

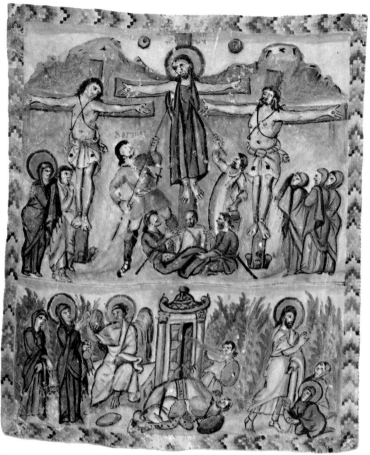

Figure 3.6a

Our focus here is on the full-page Crucifixion and Resurrection scene, but especially on the latter portion and its three images on the bottom section of that page (Fig. 3.6a, and see the face-page for this chapter). It is, like the Reider Panel, another very creative combination of direct and indirect Easter images.

First, the bottom scene to viewer left is from the empty-tomb tradition, with an angel seated on a sarcophagus greeting two women, "Mary Magdalene and the other Mary" (Matt. 28:1). But that other Mary is creatively interpreted here as the haloed Mary, mother of Jesus, from the Crucifixion scene above. Mother Mary carries a jar of ointment, which is biblical (Mark 16:1), but the other woman carries a smoking censer, or thurible, which is liturgical—recall the censers in the tomb edicule that Egeria mentioned above. This empty-tomb tradition image combines the ointment from Gospels and incense from the liturgy. But it indicates creatively the same tomb in Jerusalem then and now (see also Fig. 3.8).

Next, the scene to viewer right, from the risen-vision tradition, shows Jesus with those same two Marys now worshipping at his feet (Matt. 28:9). Once again, the foremost figure is the haloed Mother Mary, who is extremely important in the imagery of the Rabbula Gospels.

Finally, we turn to the central image, which attempts to portray Christ's Resurrection not consequentially, as just seen to the left and to the right, but *causally,* as the actual Easter event itself—but it does so *symbolically* once again. The

tomb is free-standing and so slimly, elegantly upright that it looks more like an ideal cenotaph than a practical sepulcher. You can, however, still see the upper half of the biblical rolling stone, sealed (Matt. 27:66) with a gold-colored band, resting against the opened door of the tomb.

There are three guards in various stages of being struck to the ground by three shafts of light streaming from the tomb. They are clearly wide awake and see this symbolic light of the Resurrection. It bursts open the doors of the tomb in three separate streams, one for each of the three guards. This shows more fully what is imagined as happening in the tomb scene of the Maskell Casket (Fig. 3.5). It is still not the actual or physical body of Christ emerging from the tomb, but it is the rising Christ as an explosion of light (Fig. 3.6b).

Watch those beams. The one to the bottom left strikes down a white-clothed guard who is flat on his face with his shield rolling away from him. The one to the bottom right strikes a red-and-yellow-clothed guard down on his knees and lifting his right arm to defend his face as it looks up at the light source. The one to the top right strikes a third, gray-clothed guard who also looks to the light source, totters toward the ground, and has his right arm up in defense.

This is Christ arising symbolically, or, as the great fourth-century poet-theologian Ephraem the Syrian said in his hymn "On the Crucifixion": "Blessed are you, O Tomb, the only one,

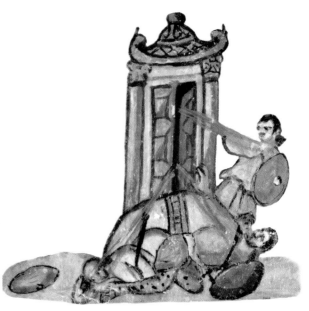

Figure 3.6b

because the only-begotten Light began to shine in you" (8.12). The Rabbula page illustrates the individual resurrection tradition as the three symbolic beams emerge from the tomb to strike three biblical guards. They are not asleep, seeing nothing, but awake and seeing everything.

✠ ✠ ✠

This climax—and conclusion—to the tradition of the causal but symbolic depiction of Christ's individual resurrection is reached by the early 600s, when metaphor becomes metonym and general symbol becomes specific site. By then, Christ's Resurrection is signified above all else by that actual tomb edicule in Jerusalem known widely in experience, memory, and story, but especially from contact relics that could carry its power away to anywhere and everywhere.

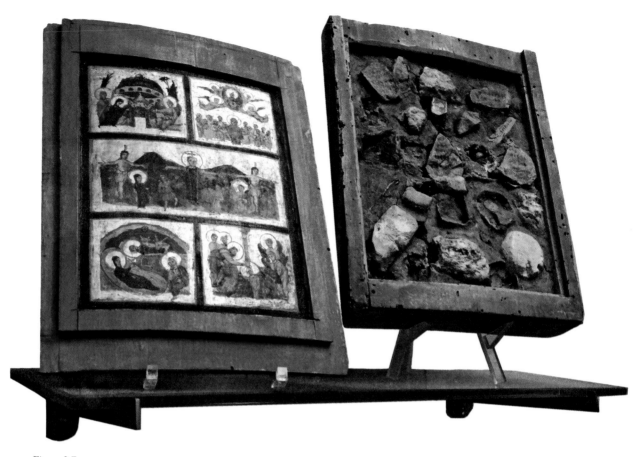

Figure 3.7a

We will look at two examples from the late 500s and early 600s brought back from the Holy Land by pilgrims: a reliquary and an oil flask.

Before it moved to the Vatican Palace in the fifteenth century, the official residence of the pope was in the Lateran Palace, on Rome's Caelian Hill. There, the pope's private chapel was called the Sancta Sanctorum, or Holy of Holies, because of the very precious relics it contained—and still does. These are, of course, sacred and

liturgical, but their containers or reliquaries are now on display in a large glassed cupboard at the south end of the Museo Sacro della Biblioteca of the Vatican Museums.

In the early 600s a pilgrim brought back a collection of wood, cloth, and stone from the Holy Land, embedded the items in a box with titles attached, and painted on its lid the five major sites from which they came (BAV Inv. 1883ab). These are Bethlehem for the Nativity (*bottom left*), Jordan for the Baptism (*bottom*

right), Jerusalem for the Crucifixion (*center*), Jerusalem for Resurrection (*upper left*), and Olivet for the Ascension (*upper right*; Fig. 3.7a).

The still legible titles record, for example, "From the Mount of Olives" or, for our present focus, "From the Life-Giving Anastasis." You will notice that, once again, "Anastasis" refers to the Rotunda and its tomb edicule as the physical place and residual part of Christ's Resurrection. The corresponding top left image is a quite accurate depiction of this structure (Fig. 3.7b).

Above, you can see the windowed and star-studded dome of the Anastasis Rotunda at the west end of the Church of the Holy Sepulchre. Below it is the cone-shaped roof of the encased tomb. But then liturgy, Gospel, and image coalesce as the two women approach from left toward the angel at the right. He points, now as then, to the same actual tomb: "He is not here; for he has been raised, as he said. Come, see the place where he lay" (Matt. 28:6).

The second example repeats and even extends that conflation of liturgy and Gospel as a symbolic visualization of Christ's individual resurrection. Pilgrims in the late 500s and early 600s carried home even more powerful full-contact relics than those in the preceding example. These were tiny flasks containing oil blessed at sacred sites such as the Holy Sepulchre. An anonymous pilgrim from Italian Piacenza described how, during the veneration of the True Cross in the Church of the Holy Sepulchre's Golgotha section: "When the mouth of one of the little flasks touches the

Wood of the Cross, the oil bubbles over, and unless it is closed very quickly it all spills out" ("little" is about 2 inches in diameter).

The major concentration of extant tin-lead pilgrim flasks is east of Piacenza, where sixteen well-preserved double-sided examples are in the treasury of Monza's Cathedral of St. John the Baptist and another twenty fragmentary single-sided ones are in the museum of Bobbio's Abbey of St. Columbanus. They were a gift in 603 from Pope Gregory the Great to Queen Theodelinda and the newly converted Lombards of northern Italy.

Do not think of them as special mementos of a tourist trip, but as participatory conduits of holiness from where it is especially, powerfully, and permanently present to anywhere and everywhere the pilgrims go, as long as they live and at their death. They are *blessings*—as they are explicitly named—for both safety here and security hereafter.

From among them all, we look here at a single tin-lead alloy example, crushed flat and with its neck missing, but beautifully clear on both sides. It is now kept in the Museum of the Dumbarton Oaks Research Library and Collection in Washington, DC.

The two sides of this miniature flask have a collated biblical-liturgical image of the Crucifixion on the front and the Resurrection on the back. This combination is by far the most common one on the extant flasks, and it depicts the two climactic pilgrimage sites, Golgotha for the Crucifixion and Anastasis for the

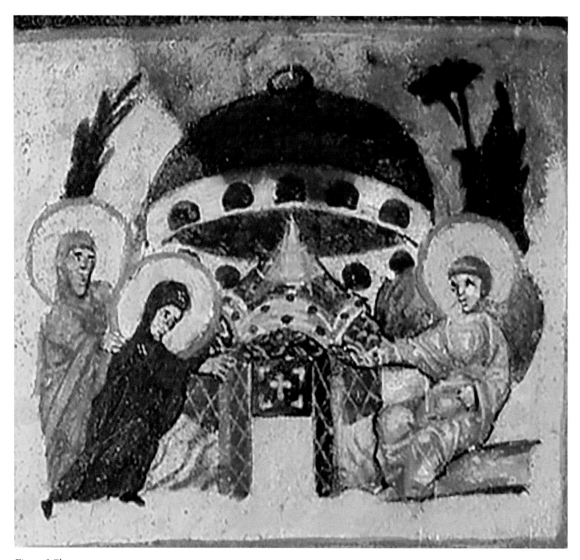

Figure 3.7b

Resurrection—both within Jerusalem's Church of the Holy Sepulchre.

In the Crucifixion image on the front, the biblical aspect comes from the two bandits on either side and the accusatory title on the plac-ard above the head of Christ (Mark 15:26–27). The liturgical aspect comes from two pilgrims venerating the True Cross in the center. But Christ is not shown on his cross. Instead, above the venerated cross is a haloed, bearded Christ

Pantokrator. Around the rim is the Greek caption: "Oil of the Wood of Life from the Holy Places of Christ."

In the Resurrection image (Fig. 3.8) on the back, the biblical aspect comes from the two women approaching the tomb from the left and addressed by the angel to the right (Matt. 28:1). The first woman carries not ointment, but a censer, so they are now part of both Gospel and liturgy or, better, of Gospel as liturgy (recall the second woman in Fig. 3.6a, bottom left).

The liturgical aspect appears most fully in the top depiction of the windowed and columned dome of the Anastasis Rotunda. Beneath it is a very exact portrayal of the tomb edicule. The crescent shape indicates the low entrance from porch to tomb proper with a lampstand before it. At the bottom can be seen the stone about which that anonymous pilgrim from Piacenza wrote: "The stone which closed the tomb door is in front of the tomb door." The caption at the top proclaims ANESTI O KYRIOS, the "Lord is risen" (recall Paul's phrase "rose again"—anestē— for Christ's Resurrection in 1 Thess. 4:14).

Image and place, past and present, here and there, now and then, icon outside and relic inside—all dance breathlessly together. Look, therefore, one last time at that Figure 3.7a, with its icons to the left and correlative relics to the right. If you look long enough, listen carefully enough, and imagine deeply enough, you may eventually hear a sound muffled for us today by our lost sensibility to the incarnation of the spir-

Figure 3.8

itual in the material. That sound is the beating heart of Byzantine Christianity.

✠ ✠ ✠

Where are we now, and what comes next? If you stood in Jerusalem around 600, you might guess—but incorrectly—that the image of Christ's individual resurrection on these pilgrim flasks establishes the Easter image for the future. What could be better than the actual tomb itself, the exact biblical tomb, even if encased in splendor and surrounded by majesty? This is not metaphor but metonym, not symbol but location, not the sign but the thing itself.

Still, you might wonder about these following points—especially if yours is that pilgrim box of icons and relics now in the Vatican Museums (Fig. 3.7a).

All its images—save one—depict the event itself and not just the outcome. You see the Ascension *causally*, that is, actually happening, and not just *consequentially*, with, say, a heavenly Pantokrator image. All its images—save one—are illustrations of events described in the Gospels. All its images—save one—have Christ physically present as the central and climactic figure.

Yet that "save one" is of the Resurrection, surely the most important event of them all—in the life of Christ, in the liturgy of the church, in the history of Christianity. So maybe you guess that no *symbolic* image will ever suffice for Easter when all other life-of-Christ and great-feast images are physical ones? But, of course, by the late 600s, the obvious alternative option is a *physical* image of Christ's individual resurrection.

What arrives, however, in the late 600s is a profoundly divergent concept of Easter, not any variation on Christ's Resurrection as *individual*, but a new image/vision of his Resurrection as *universal*. And in this divergent image Christ is *physically* present from the very first moment—just as in all other images from the Nativity to the Ascension. So this is the answer to our question of why it took four hundred years for the West to move from Individual Type 1, Symbolic Resurrection, to Individual Type 3, Emerging Resurrection.

A completely divergent universal but physical image prompted or forced the creation of an individual but also physical alternative. The

final move from Christ's symbol to Christ's body in the individual resurrection tradition came only after and because it had already happened powerfully in the universal tradition.

To connect with what you already know (Chapter 1) and prepare you for what comes next (Chapter 4), here is a moment of iconographic irony.

It is Monday, May 5, 2008, and we are standing with the Borg-Crossan pilgrimage entitled "Jesus and the Kingdom of God" before the present tomb edicule in the Anastasis Rotunda of Jerusalem's Church of the Holy Sepulchre. It is shaped like a hugely enlarged and grossly inelegant version of that round tower atop a square structure seen earlier (Figs. 2.5, 3.4, 3.5).

We enter the narrow chamber two or three at a time, and to our right is a banner carried around the church during liturgical celebrations (Fig. 3.9). The words on either side proclaim in Greek, CHRISTOS // ANESTĒ, "Christ is risen." But the diamond-shaped center depicts not the individual, but the universal resurrection of Christ.

The caption at the top of this diamond shape has the Greek word ANASTASIS. To the left, Christ, haloed and with a cross in his left hand, stands on the gates of Hades set in cruciform position. Below are locks and bolts scattered in a gaping hole below a split earth. A bearded Christ bends gently forward to grasp the limp wrist of a half-kneeling and half-rising Adam. Behind Adam, Eve stands in striking red garments. Behind her is a haloed John the

Figure 3.9

Baptist, and behind him a youthful Abel holds his shepherd's staff.

This banner celebrates Christ's physical rising, but in universal not individual resurrection. Further, it does so in the very place you might expect only and always his individual resurrection. Finally, that banner's archetypal image appears by the year 700, that is, before the individual tradition ever moves—too late—from Christ's symbolic to Christ's physical Resurrection by the year 800. We turn now to see how this innovative image of Christ's universal resurrection tradition begins (Chapters 4 and 5) and whence it derives (Chapter 6).

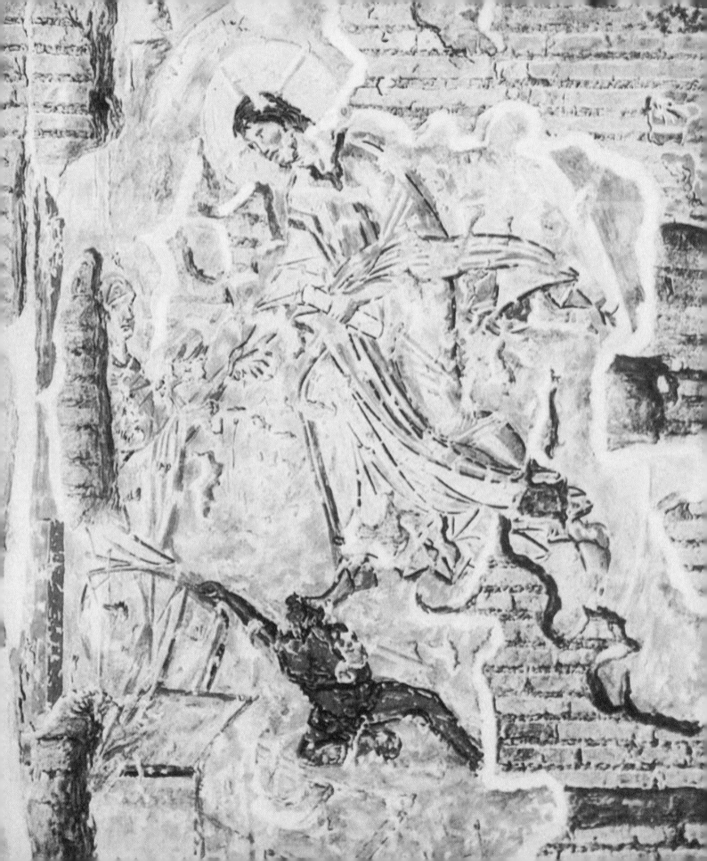

<center>

4

"He Did Not Rise Alone"

</center>

Why then do you marvel at the resurrection of Jesus? What is marvelous is not that he arose but that he did not arise alone, that he raised many other dead ones who appeared to many in Jerusalem.

<center>

Gospel of Nicodemus 17 (LATE 600S)

</center>

WE RETURN to Rome in 2014 and, on Thursday, August 28, arrive, precisely as instructed, at the side-gate of the Roman Forum in Largo della Salara Vecchia around 8:45 A.M. It is still early and quiet for what will soon be a blazing day and a crowded venue.

Our research permission from Superintendent Maurizio Rulli allows us to visit a sixth-century church complex still closed for restoration within the Roman Forum itself. This includes the Oratory of the Forty Martyrs, the Church of Santa Maria Antiqua, and the covered ramp from the Forum church below to the Palatine Hill above. (After a thirty-six-year

closure, the complex was opened to the public in March 2016.) We are here, this lovely summer morning, because those sites contain two of the three earliest extant examples of the Anastasis as Christ's universal resurrection tradition.

After getting entrance tickets, we present our e-mailed permission to the custodians inside the gate and wait for one of them to accompany us to those two splendidly frescoed but securely locked buildings. They were buried in 847 by a landslide of the imperial palaces that once towered above them on the Palatine Hill. Only demolition of a later seventeenth-century church in December 1900

<center>

61

</center>

Figure 4.1

search for depictions of the universal resurrection. These paintings come from a period of conquest when Byzantine Christian rule came to Rome and brought Eastern traditions to the West. In that year, Eastern or Byzantine Romans, having reconquered Italy, dreamed once more of a united East–West Roman Empire. During the "Byzantine Papacy" of the next two hundred years—which Roman Catholicism calls the "Byzantine Captivity of the Pope"—the emperor in Constantinople controlled the power of the pope in Rome.

That imperial domination was political and social, religious and theological, artistic and liturgical. During this Eastern ascendancy in the sixth century, many ancient buildings—especially in Rome's imperial core—were converted into Byzantine Christian churches. They were deliberately intended as countermonuments in context and antimemorials in content to the pagan monuments and memorials all around them. The Santa Maria Antiqua complex is thus a part—and indeed an appropriately climactic part—of the process whereby the Christian Roman Forum replaced the pagan Roman Forum and papal Palatine Hill replaced imperial Palatine Hill.

revealed the original oratory beneath it and the original church behind it.

Good news, of course, that they were rediscovered, but bad news as well, since being reexposed meant they would no longer be preserved from the air. In the 1901 report "Recent Excavations in the Forum," Gordon McNeil Rushforth, Director of the British School in Rome, warned: "It is much to be feared that the paintings, now that they are exposed, will soon lose the freshness of their coloring, as indeed, some have already done." This is especially unfortunate, since Santa Maria Antiqua is "the Sistine Chapel of the eighth century."*

We go back to 537 for some context for these paintings and why we traveled to see them in our

* *The Times* (London), January 9, 1901, p. 13.

At the end of the first century, for example, Emperor Domitian had a vestibule building in the Roman Forum below connected by a covered ramp to his palace on the Palatine Hill above. (A lintel and architrave still survive in place from these pre-Christian buildings of Domitian.) Then, at the start of the eighth century, a Greek-born aristocrat who had grown up on that same hill—from which his father ran the city's Byzantine administration—was elected pope.

This was Pope John VII, and during his thirty-two-month papacy he turned Domitian's imperial complex into a papal enclave. The entrance vestibule became a church and oratory connected by that covered ramp to his papal palace above. This was papal power asserted quite deliberately in a very specific place and time; that is, it established papal presence on the Palatine Hill then as it is on the Vatican Hill now. In that process, the pope also decorated both the church and oratory with new frescoes, and since he reigned only from 705 to 707, we have secure dates for the two Anastasis images created during his redecoration.

✠ ✠ ✠

The custodian unlocks the outside gate of the Santa Maria Antiqua complex, and we walk straight toward the Oratory of the Forty Martyrs to the left of the church (Fig. 4.1). This small chapel commemorates a group of Roman soldiers from the Legio XII Fulminata who converted to Christianity in 316 and were executed

Figure 4.2

by immersion in a frozen lake at Armenian Sebaste, now Sivas in northern Turkey.

Against the tall new brickwork outside, the lower levels of the original walls stand out quite clearly. The plaster still clings to the ancient wall at the right of the doors and, despite the restoration scaffolding, we can easily identify the first of the two Anastasis images that are our morning's purpose (Fig. 4.2).

This outside Anastasis has three characters: Christ, Adam, and Hades (Fig. 4.3, from 1916). Christ absolutely dominates the scene, moving forcefully to viewer left, his cloak streaming out behind him; unfortunately, most of his halo and all of his face have already been lost. His

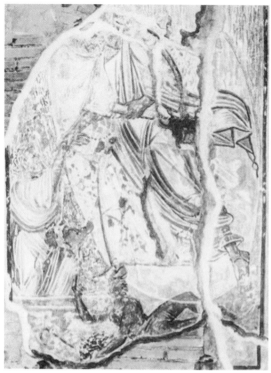

Figure 4.3

Figure 4.4

left hand holds the scroll of a philosopher, and his right hand reaches out to grasp the limp wrist of Adam and raise him from his sarcophagus. Christ's right foot steps on and holds down the prostrate figure of Hades—a name both for death's personification and death's gatekeeper. Hades reaches up awkwardly and attempts to pull Adam back into the grave by his leg.

We note the remnants of a line still discernible around the entire figure of Christ. It is the mandorla, or aureole of heavenly light that designates Jesus as a transcendent figure. Look at

it closely. Christ's right hand pulls Adam inside the mandorla even as his right foot keeps Hades securely outside it. Adam, here representing all of humanity, is already inside Heaven in Anastasis as the universal resurrection, the communal divinization of all humanity.

Leaving the Oratory of the Forty Martyrs, we cross the bottom part of the Palatine ramp, pass through the unroofed atrium, enter the roofed and glass-doored church and, postponing all else for the moment, head immediately to the second Anastasis. It is to our immediate left as we enter the church proper and at the

right side of the door onto the Palatine ramp (Fig. 4.5).

The Anastasis inside the church is almost an exact twin of the Anastasis outside on the oratory wall and certainly comes from the same master model. But there is one very important difference.

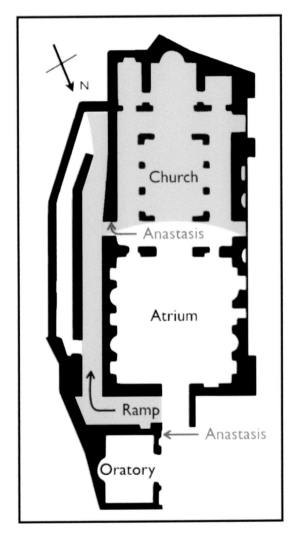

Figure 4.5

This second Anastasis has not three, but four characters: Christ, Hades, Adam, and Eve (Fig. 4.6, from 1916).

Christ is similar to the Christ in the outside Anastasis except that less of his heavenly mandorla is visible. His halo is inscribed with a cross, and he holds a scroll in his left hand. With his right hand he lifts Adam from the sepulcher by his limp right wrist. As Christ stands on Hades's head, Death's prison guard seeks to pull Adam back down in the opposite direction. Eve is visible behind Adam as she lifts her hand in supplication—or admiration. Two other figures are now lost but were discernible in the top left of the 1916 photo—perhaps others arising as well? Regardless, one thing is unmistakable: this iconography represents one of the earliest examples of Christ's universal resurrection tradition.

✠ ✠ ✠

In Chapter 2, we saw the textual basis for Christ's individual resurrection tradition, which eventually becomes Western Christianity's traditional Easter image. It is based biblically on the guarded-tomb tradition from Matthew 27:62–66; 28:4, 11–15. It derives from what the guards must have *seen* but denied with bribes and lies.

Furthermore, whether it is a source or copy of Matthew, the guarded-tomb story is fully expanded extrabiblically in the *Gospel of Peter*, which is much clearer about that entire story. The guards—and authorities—explicitly see the Resurrection, and that entire event is fully described. There is nothing about the guards

sleeping or the disciples stealing. All is seen, and all is then deliberately denied.

We turn next to consider a possible textual basis for Christ's universal resurrection tradition, for what remains permanently as Eastern Christianity's traditional Easter image. Is there biblical and extrabiblical basis for those inaugural images in the Santa Maria Antiqua complex (Figs. 4.3, 4.6)?

First of all, Christ's universal resurrection *is* mentioned, but rather obliquely and enigmatically, in the following verses:

Christ . . . was put to death in the flesh, but made alive in the spirit, in which also he went and made a proclamation to the spirits in prison. (1 Pet. 3:18–19)

For this is the reason the gospel was proclaimed [*literally*, gospelled] even to the dead, so that, though they had been judged in the flesh as everyone is judged, they might live in the spirit as God does. (4:6)

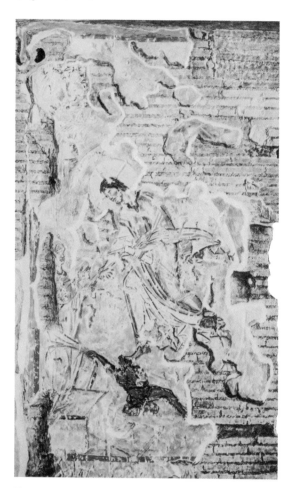

Figure 4.6

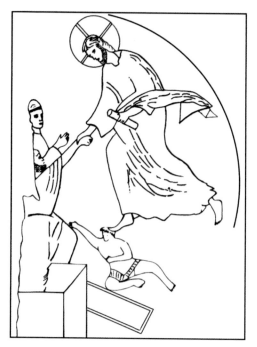

Figure 4.7

Next, the poetic parallelism of "flesh" and "spirit" just seen in 1 Peter 3:18–19 reappears as Paul starts his Letter to the Romans:

The gospel of God . . . concerning his Son, who was descended from David according to the flesh and was declared to be Son of God with power according to the spirit of holiness by resurrection from the dead, Jesus Christ our Lord. (1:1–4)

There are two problems with that NRSV translation of the Greek text. One is that it loses the reversed parallelism of this (pre-Pauline?) poetic fragment:

(a1) from/by the seed of David	*(b1)* according to the flesh
(b2) according to the Holy Spirit	*(a2)* from/by the resurrection of the dead ones

The other is that the Greek phrase used by Paul, *ex anastaseōs nekrōn*, does not mean "by Christ's resurrection *from* the dead ones," but "by Christ's resurrection *of* the dead ones." For Paul, Christ was always "God's Son" (1:3), but becomes "Son of God *with power*" (1:4) not just by his individual, but by the universal resurrection. (Much more about this in Chapter 12.)

Finally, from Paul once again, this time in 1 Corinthians 15:20: "Christ has been raised from the dead, the first fruits of those who have died (*tōn kekoimēmenōn*)." Here also, the Greek is significant as its says not "those who have died," but "those who have slept." Why are those sleepers important? Because that exact same Greek phrase, "those who have slept," reappears one other time in the New Testament, and so we are back once again with Matthew. He gave us the textual basis for Christ's individual resurrection in Chapter 2; does he also give us that for Christ's universal resurrection in this one?

As he describes Jesus dying on the cross, Matthew makes a small insertion into the account he is copying from Mark 15:37–39. It was not even three verses, but it would raise problems that two thousand years of Christian theology would prefer to avoid and forget rather than discuss and explain:

The earth shook, and the rocks were split. The tombs also were opened, and many bodies of the saints who had fallen asleep (*tōn kekoimēmenōn*) were *raised*. After his *resurrection* they came out of the tombs and entered the holy city and appeared to many. (Matt. 27:51b–53)

There may be, once again, a poetic fragment hidden somewhere in that string of six short sentences all beginning with "and" (in Greek).

Be that as it may, Matthew's problem is how to fit that *poetic* insertion into Mark's sequential *story*. His solution is probably the best that could be done, but it is still not very successful.

There is, for example, his double mention of "tombs," as if those saints left them twice, once at Christ's Crucifixion on Good Friday and again at Christ's Resurrection on Easter Sunday. (Where, one might ask, were those sleepers in between?)

More significantly, Matthew connects the "were raised" of the sleepers with the "resurrection" of Christ—it is the same root in Greek. Notice also that Matthew 27:51b–53 and its *rising saints* precede 27:62–28:15 and its *lying guards*.

In summary for Matthew, therefore, the sleepers and Christ rise together, so that Easter is a communal and corporate event *with* Christ rather than individual and solitary event *for* Christ. But, qualified by "some" and "saints," it is certainly not universal—nothing there about Adam and Eve! Still, who exactly are "the saints who had fallen asleep"? Are they Jews or Gentiles? Are they some or all Jews? Are they some or all Gentiles? If some, why? If all, how?

We go once again outside the New Testament to answer that question. As we went to the *Gospel of Peter* for the guards (Chapter 2), we now turn to the *Gospel of Nicodemus* for the sleepers. And here we finally see verbally what we have already seen visually—a textual vision of Easter as Christ's universal resurrection tradition.

✠ ✠ ✠

The *Gospel of Nicodemus* records universal resurrection textually as a story that combines Hades with Hell and shows how a *descent* downward allows for an *ascent* upward. It is only about a descent into Hell in order to create an ascent into Heaven. In this book, therefore, instead of the erroneous title often given for *Gospel of Nicodemus* 17–27, "Descent into Hell," we entitle that section more correctly as "Christ's Universal Resurrection," and you will see how correct that is as we continue into the text itself.

Here is a brief summary of the *Gospel of Nicodemus* 17–27. Joseph of Arimathea (Mark 15:43) tells the chief priests Annas and Caiaphas (John 18:13, 24) that Karinus and Leucius, the two sons of Simeon (Luke 2:25), died, were buried, left behind empty tombs when they rose with Jesus, and are now living in Arimathea. The high priests check their empty tombs, bring Karinus and Leucius to Jerusalem, put them in separate rooms, and have them each write about the events; their two written accounts of Christ's universal resurrection are found to be in perfect agreement on every detail.

This universal resurrection story in the *Gospel of Nicodemus* 17–27 is known in three major versions: Greek, Latin A, and Latin B. What is most striking, as you compare those three versions, is how the universality of the Resurrection diminishes steadily from Greek through Latin A to Latin B.

There are three basic questions lurking here in the background. First, who is raised with Jesus? If only *some*, then who and why? Second, from where are they raised? Is it from Hades and death or from Hell and tor-

ture? What happens when the Greek Hades becomes the Latin Hell? Third, if *all* are raised from Hell, is Hell empty then, now, and hereafter? That specter of an empty Hell explains the tendency of the *Gospel of Nicodemus* to diminish any such universal evacuation across its manuscript tradition.

In 424, Bishop Evodius asked St. Augustine: "Since the descending Christ had preached to them all and set them all free from darkness and suffering by his grace, would Judgment Day find an empty hell?" In reply, St. Augustine insisted that only a very few are liberated by Christ from Hell, but concluded with this exasperated comment: "If Sacred Scripture had said, without naming Hell and its pains, that Christ when he died went to the bosom of Abraham, I wonder if anyone would have dared to say that he 'descended into hell'" (Augustine, *Letters*, 163–64).

✠ ✠ ✠

The *Gospel of Nicodemus* 17–27 opens with this: "Why then do you marvel at the resurrection of Jesus? What is marvelous is not that he arose but that he did not arise alone, that he raised many other dead ones who appeared to many in Jerusalem." That makes an explicit connection with Matthew's claim that "many bodies of the saints . . . were raised . . . and entered the holy city and appeared to many" (27:52–53).

This universal resurrection story names Adam, Seth, Abraham, David, Isaiah, Habak-

kuk, but also groups like the "patriarchs, and prophets, and martyrs, and forefathers" (Greek, 24). All of those are Old Testament saints, but then a New Testament one appears. It is John the Baptist, and he vastly expands the universal resurrection—from Jews to Gentiles.

In Hades, as the eyewitnesses Karinus and Leucius record, John begins by telling about Jesus's baptism and the voice of God at the Jordan. But he ends with this:

> He sent me also to you [Gentiles], to proclaim how the only begotten Son of God is coming here, that whosoever shall believe in Him shall be saved, and whosoever shall not believe in Him shall be condemned. On this account I say to you all, in order that when you see Him you all may adore Him, that now only is for you the time of repentance for having *adored idols in the vain upper world*, and for the sins you have committed, and that this is impossible at any other time. (Greek, 18)

John speaks not to Jewish saints, but explicitly to Gentile sinners, and that expands exponentially the number of those to be raised. You can, by the way, see doctrinal damage control in that final sentence that insists this is a one-time-only chance: "this is impossible at any other time."

We are not told if any or all of those sinful Gentiles rejected or accepted Christ in Hades. But the story seems to presume that all those

Gentiles, when confronted with Christ's transcendental glory and asked to choose between imminent liberation or permanent detention, chose Heaven over Hades.

That presumption of a universal liberation from Hades in the Greek version is confirmed, first of all, by how differently the two Latin versions handle this doctrinally sensitive question. They omit completely any mention of Gentiles in John's speech:

> And now I have gone before His face, and have descended to announce to *you* that the rising Son of God is close at hand to visit us, coming from on high to us sitting in darkness and the shadow of death. (Latin A, 18)

———————

> I received from Him the answer that He would descend to the lower world. Then father Adam, hearing this, cried with a loud voice, exclaiming: Alleluia! which is, interpreted, The Lord is certainly coming. (Latin B, 21)

In Latin A, the "you" to whom John speaks is only "the multitude of the saints," and no Gentiles are mentioned in any way. Latin B is even more textually ruthless: John's descent is replaced by that of Christ, and Adam's acclamation keeps the full focus on Christ.

In general, a more universal liberation is characteristic of the Greek over the Latin versions.

The two risen witnesses start their story like this across the three versions:

> We then were in Hades, with all who had fallen asleep since the beginning of the world. (Greek, 18)

———————

> And when we were, along with all our fathers, lying in the deep, in the blackness of darkness. (Latin A, 18)

———————

> When, therefore, we were kept in darkness and the shadow of death in the lower world. (Latin B, 18)

The opening text changes from an emphatic universality of "we, with all who had fallen asleep since the beginning of the world," to "we along with our fathers," to a simple "we" with no others mentioned.

What is at stake here for Christianity's doctrinal dogma is this. If Christ took "all" out of Hades once, why not again? Especially if Hades is read as Hell, and Hell was once emptied of "all" its inhabitants, why not again at the Last Judgment? Is Hell a permanent prison or a transient hotel? Those text changes show an intent to exorcize completely the specter of universal salvation.

An even more striking development appears in the fascinating interchange between Satan, "heir of darkness, son of destruction, devil,"

and Hades, "all-devouring and insatiable one." Satan boasts that he has conquered Christ and is sending him down to Hades, but Hades responds:

> All those that I have swallowed from eternity I perceive to be in commotion, and I am pained in my belly . . . for I think that he is coming here to raise all the dead. . . . Not one of the dead will be left behind in Hades to me. . . . Turn and see that not one of the dead has been left in me, but all that you have gained through the tree of knowledge, all have you lost through the tree of the cross. (Greek, 20, 23)

Neither Latin A nor Latin B has any equivalent to those claims that Hades was emptied of *all* its former inhabitants in the universal resurrection of Christ. They are responding to an obvious doctrinal question: If Hades/Hell was emptied once, why not again? That doctrinal problem motivates the changes across the three versions from Greek through Latin A to Latin B. But Greek explicitly describes Christ's Resurrection as universal.

☩ ☩ ☩

So the *Gospel of Nicodemus* offers compelling textual evidence for a universal resurrection tradition, and this depiction of its universality is not an anomaly. In Jacques Paul Migne's classic 1864 collection *Patrologia Graeca*, with parallel-column Latin translations, several homilies

attributed to the fourth-century St. Epiphanius of Salamis on Cyprus are labeled "doubtful or spurious." They are actually from a seventh-century Pseudo-Epiphanius.

The second homily, *On the Great and Holy Saturday*, contains this somewhat startling interaction between Christ and Adam in Hades:

> The Lord enters among them bearing his conquering cross. . . . Taking Adam by the hand, he says: "Rise up, you who sleep, and Christ will enlighten you. I am your God but, because of you, I became your son; because of you, *and all those descended from you*, I now speak with authoritative command: To the prisoners, Depart; To those in darkness, Be Enlightened; To those who are asleep, Awaken.
>
> I command you [Adam]: Awake sleeper! I did not create for this, that you remain chained in Hades. Arise from the dead. I am the life of the dead. Arise, my creation, arise *my likeness, made in my own image.* Arise, let us leave here. For you are in me and I in you, we are but one undivided person. (Migne, *Patrologia Graeca*, 43.481)

The universal resurrection (note our italics above) is the restoration of a creation with all humanity made in God's own "image and likeness" from Genesis 1:26–27.

Next, Pseudo-Epiphanius's seventh homily, *On the Holy Resurrection of Christ*, like the Gos-

pel of Nicodemus, makes an explicit connection to Matthew 27:51b–53 by saying: "When the Lord hung on a tree, the graves split, and Hades opened, and the dead rose, and souls escaped, and many of the resurrected appeared in Israel when the mystery of Christ was fulfilled." (Very often the Anastasis images of the universal resurrection show a split and opened-up earth as the general background—see, for example, Figure 1.8. That links all such images to a biblical basis in Matt. 27:51b–53).

Also, like the second homily, the seventh homily applies Resurrection to all of humanity:

> The Lord rose, then, after three days . . . and all the descendants of the nations were saved in Christ. For one was judged and multitudes were saved. For the Lord died on behalf of all. . . . He, entering in this way, raised up all humanity to the height of heaven, bearing a gift to the Father not of gold, nor silver, nor precious stone, but rather that humanity which he made "according his image and likeness."

Humanity's universal resurrection is no more and no less than a restoration of humanity's universal creation in God's own "image and likeness" from Genesis 1:26–27.

Finally, the seventh homily extends the universal resurrection beyond humanity to the earth itself—again as a restoration of Genesis 1. In that creation story deliberately shed blood was never to stain the earth:

> God said, "See, I have given you every plant yielding seed that is upon the face of all the earth, and every tree with seed in its fruit; you shall have them for food. And to every beast of the earth, and to every bird of the air, and to everything that creeps on the earth, everything that has the breath of life, I have given every green plant for food." And it was so. (Gen. 1:29–30)

If animals and humans are all originally vegan, no blood is spilled even for food. Then, in Genesis 4, Cain kills Abel, and God announces, "You are cursed from the ground, which has opened its mouth to receive your brother's blood from your hand" (4:11). Here, in this seventh homily, the earth itself is restored to inaugural purity: "The earth cried out, saying, 'Master, spare me from evil, relieve me of anger, free me from the curse, because of which I received blood and human bodies, and, yet more, your body. Master, receive back your Adam.'"

In summary, by the end of the 600s, the *Gospel of Nicodemus* 17–27 and Pseudo-Epiphanius's second and seventh homilies agree with the image of Adam and Eve as representing all of humanity in exit from an emptied Hades. The Resurrection of Christ is the triumph of all humanity over death, and of the Earth itself over desecration.

✠ ✠ ✠

Where are we now, and what comes next? It is very simple for us today to recognize those twin

images in the Santa Maria Antiqua complex as the universal resurrection, because we know how this core develops ever afterward. But how did the people who first saw them recognize what they depict?

The images are already basically formed in this their inaugural appearance with the core four of Christ, Hades, Adam, and Eve. But how is the meaning self-evident to, say, a pilgrim visiting Rome in the early 700s? What prevents a misinterpretation? Maybe, thinks a pilgrim, this is Christ raising Lazarus from the grasp of Hades with Mary or Martha interceding for his powerful assistance (John 11:1–44).

You already have a hint at an answer from the start of this present chapter when we described those twin frescoes as "two of the three earliest extant examples of the Anastasis." To answer our question, we turn next to the third of those three earliest extant images of the Anastasis as universal resurrection.

This takes us across the Tiber from Roman Forum to Vatican Hill, from the Anastasis as isolated image to Anastasis as iconographic climax in a life-of-Christ series, and from this to the next chapter.

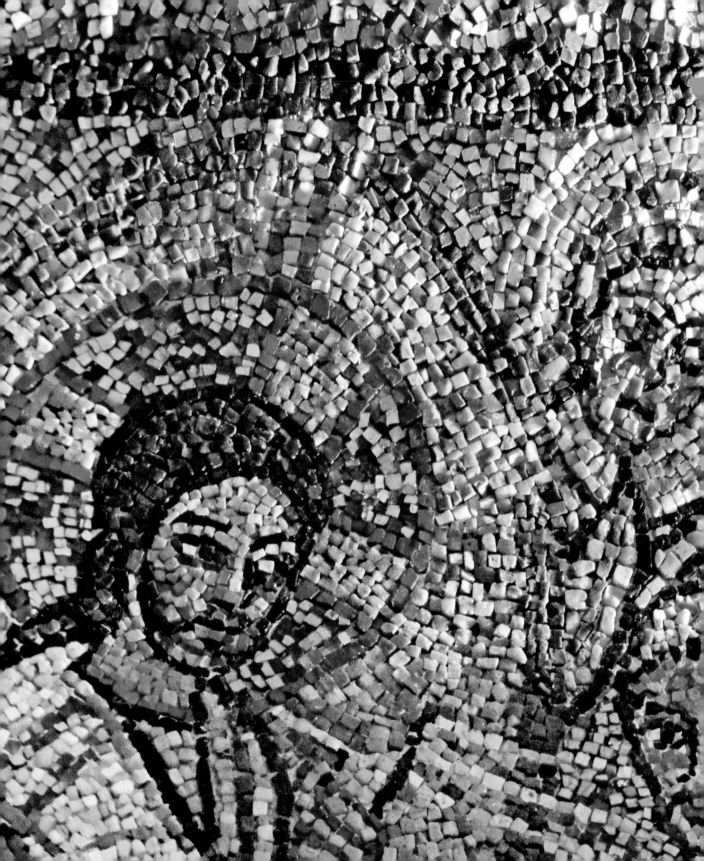

<center>5</center>

"So That Posterity Might Be Amazed by the Lavishness"

<center>*He built an oratory of the holy mother of God inside the church of the*
Blessed Apostle Peter. He colored its walls with mosaic and expended
there a large amount of gold and silver. He was buried in front of
the altar of the holy mother of God which he had constructed.</center>

<center>*Liber Pontificalis*, ON POPE JOHN VII (705–7)</center>

LESS THAN A YEAR after that trip to see the Santa Maria Antiqua complex we are back in Rome. On the late afternoon of Thursday, May 28, 2015, we enter St. Peter's Basilica, make a sharp right, and head immediately to a side chapel in the northeast corner. We stop here for two reasons. One is for a ritual observed every time we enter this great basilica: we stand before Michelangelo's magnificent Pietà, a masterpiece that mourns with all those mothers who have ever held a murdered child in their arms. The other reason is because the third of those first three Anastasis images comes from an earlier side chapel in that same northeast corner.

Come back with us well over a full millennium to October 707 and the burial that month of the "Byzantine" Pope John VII. You will recall him from his frescoes in Santa Maria Antiqua and especially from those twin Anastasis images seen in our preceding chapter. As soon as he was elected in March 705, he began

<center>75</center>

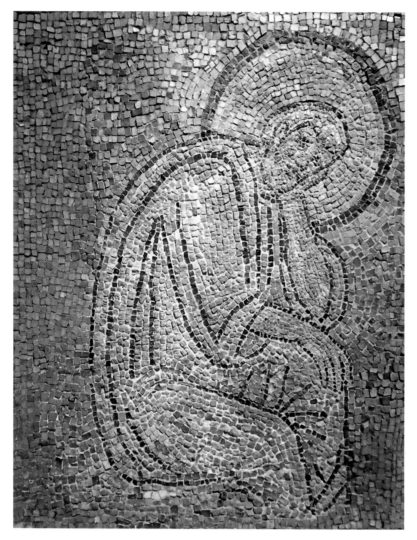

Figure 5.1a

built in the mid-400s to honor St. Peter or of Pope John VII's chapel built in the early 700s to honor Mary. Old St. Peter's was completely demolished by 1609 and replaced by what we know today as (New) St. Peter's. How then is it possible to envisage that oratory of John, "Servant of Holy Mary," described in this chapter's epigraph?

More is probably known about this papal burial oratory than about anything else from Old St. Peter's Basilica—for two reasons. One is that some fragments are still extant from its mosaic images, presumably preserved out of belated respect. Here are three of them from the life-of-Christ series: Joseph, from a Nativity scene, now in the Pushkin State Museum of Fine Arts, Moscow (Fig. 5.1a); Maria Regina, from the large central scene, now above an altar in the Church of San Marco, Florence (Fig. 5.1b); Mary, Joseph, the Christ Child, and an Angel, from the Magi scene, now in the gift shop at the

to prepare his burial chapel in that northeast corner of St. Peter's Basilica. It was dedicated to Mary, consecrated on March 21, 706, and ready in good time for his death on October 8, 707.

As we stand here this May evening in 2015, nothing is extant of either Constantine's basilica

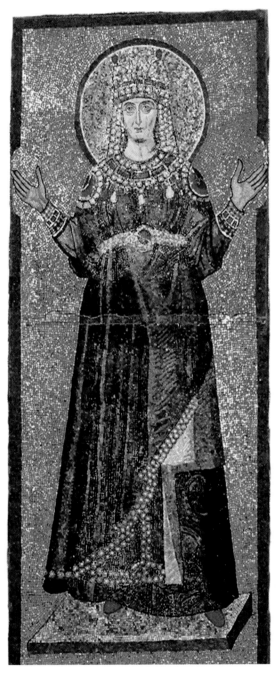

right of the Basilica of Santa Maria in Cosmedin, Rome (Fig. 5.1c).

The other reason is that this chapel was the very last section of the original Constantinian basilica to be destroyed in September 1609. But, as early as October 1605, the new Borghese pope, Paul V, had ordered the papal archivist Giacomo Grimaldi to document—in descriptions, drawings, and histories—the relocation of papal tombs and sacred relics necessitated by that destruction. Between 1609 and 1621, therefore, Grimaldi produced drawings and descriptions in several handwritten copies, manuscripts now preserved by libraries in Rome, Florence, and Milan.

From all this data, as we stand in the northeast corner of New St. Peter's in 2015, we can imagine, both adequately and accurately, Pope John VII's burial chapel in Old St. Peter's from

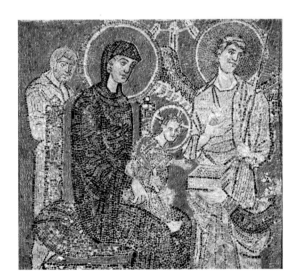

Figure 5.1b

Figure 5.1c

Figure 5.2

the early 700s to the early 1600s. It is a walled-off rectangular enclosure in the corner (Fig. 5.2), about 40 feet long along the north wall (F, E, B) and 28 feet wide along the east wall (A) of Old St. Peter's. The oratory is magnificently decorated with marble and mosaic. Indeed, the pope's epitaph proclaims: "Having removed the previous squalor, he brought together splendor from all regions, so that posterity might be amazed by the lavishness."

On the north wall is a narrative cycle from the lives of Peter and Paul (Fig. 5.3) that rather pointedly notes what Peter did in the "City of Jerusalem," in the "City of Antioch," and in "Rome," but never in Constantinople! John VII is a Byzantine pope—but a pope first and a Byzantine second.

On the east wall is another mosaic with a narrative cycle from the life of Christ (Fig. 5.4). Below it is the chapel's altar (red I), and in the floor before altar and mosaic is the porphyry oval above the pope's tomb (red C). You can see

CIVITAS HIEROSOLYMA · CIVITAS ANTIOCHI·

ROMA

NERO MAGVS PETRVS S·PAV·LVS

NERO MAGVS

Figure 5.3

how Grimaldi's drawings (Figs. 5.2, 5.4) display the northeast corner in flat perspective, but imagine it as a 90-degree angle (at B/A in Fig. 5.2 and at red L in Fig. 5.4).*

* On May 29, 1620, Giacomo Grimaldi climbed up to the pope's Quirinal Palace on the highest of Rome's seven hills. He carried with him fifteen years of work in two volumes of over five hundred pages each that are now preserved as Barberini Latin Codex 2733 in the Vatican Library. That May day was Grimaldi's formal presentation of the *Records* (Latin *Instrumenta*) detailing the past history and present fate of all those papal remains and sacred relics relocated from Old to New St. Peter's Basilica. (A print-format facsimile of Codex 2733, edited by Retto Niggl and published by the Vatican in 1972, weighs 13 pounds.)

Grimaldi's luxurious drawing of the pope's oratory in 1618 (Fig. 5.2) contrasts rather obviously with the architectural austerity in his official presentation volume of 1619–20 (Fig. 5.4). The former drawing, however, is more illustrative of the pope's claim of "lavishness" in the chapel's decoration.

In any case, those twin drawings indicate how that northeast corner appeared when the oratory was dedicated in 706. Our interest centers on the mosaic above the altar on the east wall (A in Fig. 5.2, G in Fig. 5.4). Why? Because among its multiple scenes from the life-of-Christ sequence is another extant image of the Anastasis from 705–7. It may be the earliest of all three, as the pope's burial chapel was probably completed even before his full decoration of the Santa Maria Antiqua complex.

✠ ✠ ✠

The life-of-Christ mosaic in Old St. Peter's is around 17 feet wide by 13 feet high. Grimaldi calls it "Historiae Jesus Christi," that is, scenes depicting a biblical narrative in a single iconic image. There are sixteen scenes distributed over seven panels with one, two, or three scenes per panel. The two central panels depict the small-scale pope offering his oratory as a gift to a very large-scale Mary (Fig. 5.1b).

In his 1612 diagram (Fig. 5.5), Grimaldi identifies each of those sixteen scenes by red letters on the drawing and then identifies them with corresponding red letters below: Annunciation (H), Visitation (I), Nativity (K), Shepherds (L),

Magi (M), Presentation (N), Baptism (O), Three Miracles (P, Q, R), Lazarus (S), Entry (T), Supper (V), Crucifixion (X), Resurrection (Y), and Empty Tomb (Z).

Our focus here is on that entire bottom right panel of the mosaic. After the Crucifixion, it depicts, as it were, the very moment when the direct universal resurrection tradition (Y) arrives and displaces the indirect empty-tomb tradition (Z) as the future Easter icon of Eastern Christianity.

It is hard, by the way, to decide whether Grimaldi's multiple hand drawings of the same mosaic are help or hindrance in reconstructing its original content—especially with regard to the universal resurrection tradition (the Anastasis). They are not like copies of the same printed image, but more like variations of an oral tradition or a

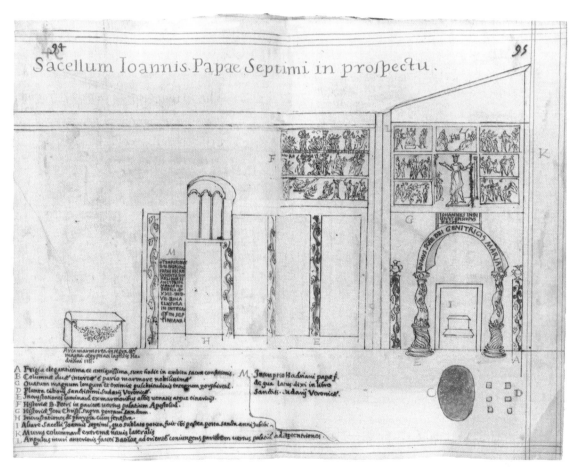

Figure 5.4

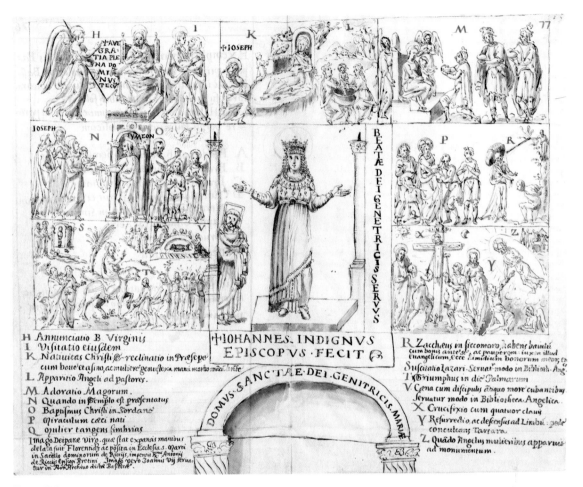

Figure 5.5

musical composition. We look, therefore, at four different versions of these images in order to reconstruct what it looked like when the mosaic first glittered above the burial site of Pope John VII.

First, the 1609 drawing (Fig. 5.6) has no empty tomb scene, and the Anastasis has only three figures. Christ reaches out from his mandorla toward the reaching hand of Adam, who is either kneeling in supplication or emerging

from his sarcophagus. Those hands, however, do not touch, even though Adam's is already inside the mandorla. Below Christ is a prostrate figure, presumably Hades.

The 1612 version (Fig. 5.7) has the empty tomb scene with seated angel and three women in the top right corner. The Anastasis has three figures—but different ones than in the 1609 image. Christ grasps a beardless Adam by his

Figure 5.6

Figure 5.7

arm and pulls him inside the divine mandorla. At bottom right is the only other figure in the drawing. She is clearly female and must represent Eve.

The 1620 drawing (Fig. 5.8) has the empty tomb with a standing angel and two women in the top right corner. Christ reaches out from his mandorla to grasp the wrist of Adam, and once again Eve is probably one of the two others reaching upward beside Adam. The figure prostrate on his face in the center is presumably Hades (as in Fig. 5.6). Christ now stands atop a rather diminutive Cerberus as the traditional hellhound who guards Hades.

Finally, the 1621 copy (Fig. 5.9) has a seated angel and three women at the empty tomb. Christ pulls Adam's arm inside the mandorla, while two others wait their turn. Eve is, once again, presumably one of them. Christ tramples on a larger Cerberus.

Grimaldi always identifies that Anastasis as: "Resurrection and Descent into Limbo, trampling Tartara underfoot" (red Y text). Tartaros is an ancient Greek term for the deepest part of Hades as a special place of eternal suffering for the worst offenders. Limbo is almost the opposite. It is a Roman Catholic term for the outermost part of Hades where there is no suffering

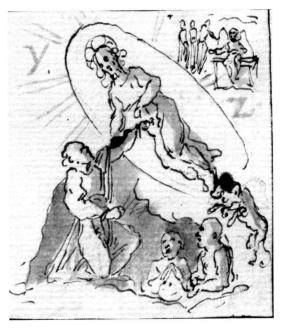

Figure 5.9

Figure 5.8

and whence exit does not raise the problems involved in exit from Hell. Still, he describes it as both "Resurrection and Descent," not just as "Descent" alone.

In summary, considering all Grimaldi's variants, our best judgment is that the original east-wall mosaic had at least four main protagonists: Christ within his heavenly mandorla; Adam grasped by wrist or arm and pulled toward or into that divine aura; two other figures beside him, one of which is most likely Eve; and Hades prostrate on the ground. The hellhound Cerberus is not a Byzantine Easter tradition. Its presence may have come from Pope John, but

it is probably much more likely that Grimaldi invented it.

The three earliest images of the universal resurrection tradition all derive from the brief but brilliant pontificate of Pope John VII between 705 and 707. Two decorate a papal enclave for his life (Chapter 4), and one—probably the earliest one—decorates a burial oratory for his death (Chapter 5).

Furthermore, in those first three extant examples of the universal resurrection tradition, it appears as already basically complete with Christ, Hades, Adam, and Eve. It is fundamentally fully formed when it first survives. And, of course, in all three cases Christ is moving to viewer left.

We now have an answer to that question from the end of the preceding chapter. It is the universal resurrection tradition that concludes the papal life-of-Christ series from Old St. Peter's and would therefore be recognized as such in the papal frescoes from Santa Maria Antiqua and the Oratory of the Forty Martyrs (Chapter 4).

✠ ✠ ✠

It takes one hundred years before another clearly dated example of this universal resurrection tradition appears in the extant record, and it is another striking example—again in mosaic, again from a burial chapel, again from Byzantine iconography, and again in papal Rome.

We place it here in its proper sequence within the universal tradition. But we know it from an earlier Roman visit on Saturday, August 27, 2011. You will notice, by the way, that the chronology of our site visits seldom coincides with the historical sequence of the individual or universal tradition's development. We get the pieces of our puzzle when we can and, especially, when we know enough to get them where we happen to be. Only later do all the pieces fit together.

The Basilica of Santa Prassede hides in a Roman side street, takes siesta very seriously, and contains a small, completely mosaiced, and absolutely gem-perfect funerary chapel. Pope Paschal I (817–24) built it to house the remains of his mother, Theodora Episcopa, and those of some saints taken from the catacombs. Among

them is Zeno of Verona; hence its name, San Zeno Chapel.

The chapel, located halfway along the basilica's right or east aisle, is in cruciform shape with four arches supporting a central dome. Barrel-vaulted niches extend to the left, right, and before us as we enter. The pope placed his mother's sarcophagus in that left niche immediately under a mosaic that includes Mary, Prassede, and Theodora herself.

As we face that mosaic, there is another one below the springing of the arch to our right (Fig. 5.10, white outline added). It is placed there so that Theodora will see it immediately as she rises from her tomb on the Last Day. This Anastasis is, of course, the main reason for our visit this afternoon. Unfortunately, only the top is extant, as marble sheathing has replaced it below that upper section.

Still, in what is left, the heads are enough to indicate six individuals (Fig. 5.11). Christ is in the center with a cross-inscribed halo and a radiant mandorla, but is here moving to viewer right. He has a scroll in his left hand and his right arm is moving downward presumably toward the wrist of Adam. Eve is beside Adam to viewer right.

Two other figures balance Adam and Eve on the other side of Christ to viewer left. This is the earliest securely dated presence of David and his son Solomon in the development of the universal resurrection tradition imagery (recall later examples in Figs. 1.3, 1.5, 1.6, 1.8). Although they are rather compressed because of space con-

Figure 5.10

straints, both are crowned; David is bearded and Solomon beardless. Behind Christ is the haloed archangel Michael.

Think, then, as we conclude this chapter, about those first three Anastasis images at the start of the 700s and that next single one at the start of the 800s. The pattern is similar for those earliest universal resurrection images: they all appear in papal Rome but under powerful Byzantine influence and probably using Byzantine artists.

✠ ✠ ✠

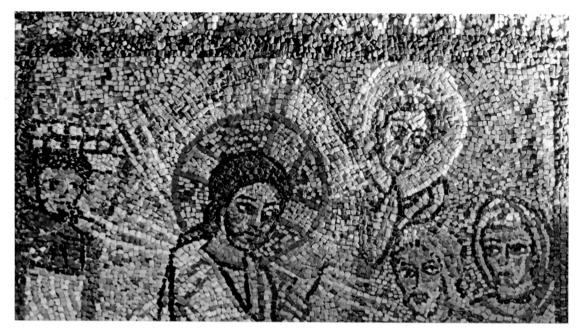

Figure 5.11

Where are we now, and what comes next? By the year 700, we have two divergent and competing *direct* images for the actual moment of Christ's Resurrection and the content of Easter's icon.

The first image, by 400, is of Christ's individual resurrection tradition, but he himself is not depicted centrally, bodily, or physically. The actual moment is portrayed symbolically, and in fact Jerusalem's actual tomb rather than the Christ's actual body seems the preferred major symbol of this individual resurrection (Chapters 2 and 3).

The second image only arrives by 700. It is of Christ's universal resurrection tradition, but he himself is centrally, bodily, and physically present from the very beginning (Chapters 4 and 5).

Furthermore, the earliest extant versions of this new universal image are not just random outliers (Chapter 4), but represent an alternative *direct* vision of the Easter moment and are already displacing the *indirect* image of the empty-tomb tradition (Chapter 5).

Each resurrection tradition—the individual and the universal—has both verbal descriptions and visual depictions. Here then is the next question. Does the visual derive from the verbal, does the image derive from the text, in either, neither, or both resurrection traditions?

On the one hand, the individual tradition's visual depiction derives from the verbal description in Matthew (27:62–66; 28:4, 11–15) and the *Gospel of Peter*—hence the presence of those

sleeping and/or watching guards. But, on the other, does the same hold true for the universal tradition? Does it derive from the textual tradition seen in Matthew (27:51b–53) and especially in the *Gospel of Nicodemus*? If not, are both text and image at least originally independent registers, independent vectors of the visual and the verbal? If so, and especially for this book, whence did the specific imagery of the universal vision evolve? These are the questions for the next chapter, and here is one hint toward an answer.

Christ's individual resurrection tradition needed both the guarded-tomb tradition in the Gospels of Matthew and Peter and the model of Christianized imperial iconography to create its inaugural image (Chapter 2). What about this new universal resurrection tradition's inaugural image? Where did its precise depiction come from? It certainly connects to the biblical Gospel of Matthew and the extrabiblical *Gospel of Nicodemus* (Chapter 4). But, once again, does connection mean derivation? Furthermore, if Christian imperial iconography is so vital for the *first* individual resurrection imagery (Chapter 2), is it equally vital for the *first* universal resurrection imagery? For answers, we turn to the next chapter.

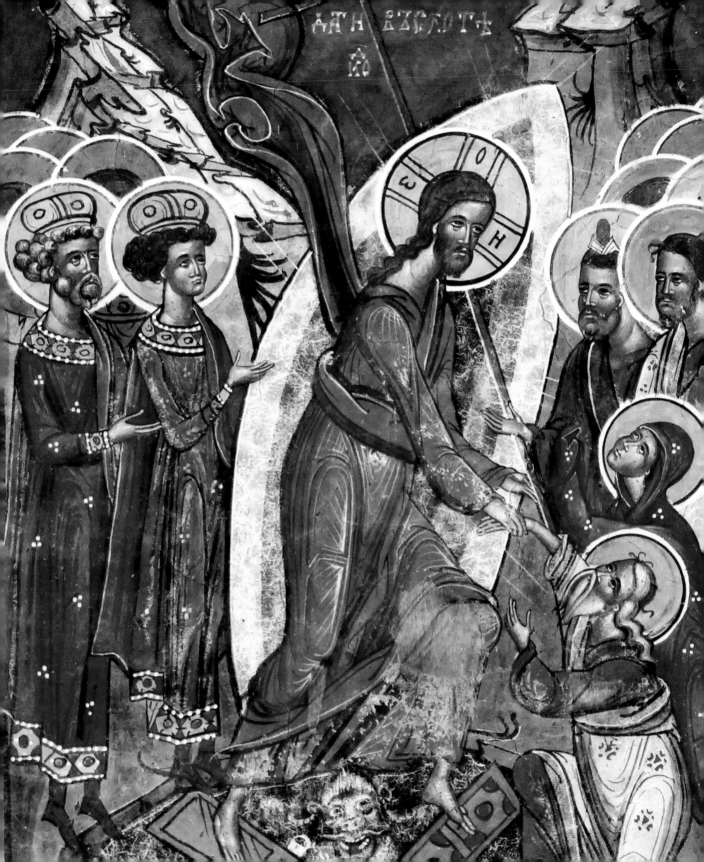

6

"The Anastasis, the Joy of the World"

Christ is risen, and life reigns!
Christ is risen, and not one dead remains in a tomb!
For Christ, being raised from the dead,
has become the first-fruits of them that have slept.

PASCHAL HOMILY ATTRIBUTED TO ST. JOHN CHRYSOSTOM (CA. 400)

THE ANSWER to the last chapter's terminal question about derivation seems immediately obvious: image illustrates text, depiction follows description, and the universal resurrection icon is a condensed visualization of the *Gospel of Nicodemus* (recall it from Chapter 4). And, at first glimpse, that interpretation seems obviously correct.

On the one hand and in general, those Old and New Testament images that fill early Christian basilicas derive originally from illustrations in biblical texts. For example, the British Library preserves the charred remains of a 440-page illustrated manuscript of the book of Genesis from the 300s or 400s (Cotton Otho B VI). It originally contained around 350 illustrations, and you can still see the influence of such textual miniatures on glistening mosaics from the Cappella Palatina in Palermo to San Marco in Venice. It is easy, therefore, to imagine the Anastasis image as simply illustrating the text of that *Gospel of Nicodemus*.

Furthermore, in particular, the absolute core of the Anastasis is the (wounded) hand of Christ grasping the limp wrist of Adam to raise him from death. That image certainly agrees with

the text in which Christ "stretched out his right hand, and took hold of our forefather Adam and raised him up" and "went into paradise holding our forefather Adam by the hand" (*Gospel of Nicodemus*, Greek, 24–25).

On the other hand, Anna Kartsonis, in her monumental study *Anastasis: The Making of an Image*, denies emphatically that the Anastasis derives from the *Gospel of Nicodemus*: "The assumption that the text of Nicodemus is the breeding ground for the Anastasis has to be rejected. The core of the image alone and the text itself differ in at least two important respects: the text distinguishes Hades from Satan, while the image does not. Instead, the image emphasizes the trampling of the defeated Hades, which is not even mentioned in the Greek text."* That conclusion is definitely correct, for three main reasons.

First, Eve is never mentioned in the "Christ's Universal Resurrection" section of the *Gospel of Nicodemus*, but across the development of the Anastasis image from 700 to 1200 she is very rarely absent and usually clearly emphasized. (But recall her omission in Fig. 4.3.) Indeed, you can see that entire five-hundred-year development as the steady ascendancy of Eve to proper status equal with Adam as an ancestral personification of the entire human race.

Second, the text has seven named characters all present, of course, at the same time: Adam, Seth, Abraham, David, Isaiah, Habakkuk, and

John the Baptist. The image has six characters, but they are different ones and they only accumulate slowly across several centuries: first Adam and Eve by 705–7, then David and Solomon by 800–825, next John the Baptist by 950, and Abel by around 1000.

Finally, and above all else, the text is primarily about Satan rather than Hades, while the image is about Hades alone. The text, in fact, has a long discourse between Satan and Hades—in which the former is by far the more evil and malevolent character. Think of the following interchanges in the *Gospel of Nicodemus* and note our italicized emphasis on universality (recall this from Chapter 4):

First, Satan, "the heir of darkness," boasts to "all-devouring and insatiable" Hades that the wonder-working Christ is now dead and coming soon to the realm of Hades. But Hades wonders if Christ might be too powerful for them. Satan tells him to "make ready, in order that you may lay fast hold of him when he comes."

Next, Hades continues to protest. What, he asks Satan, "heir of darkness, son of destruction, devil," about Lazarus, whom Christ has already raised from the dead? "Wherefore also I adjure even you, for your benefit and for mine, not to bring him here; for I think that he is coming here *to raise all the dead*. And this I tell you: by the darkness in which we live, if you bring him here, *not one of the dead will be left behind in it to me*" (Greek, 20).

* Anna Kartsonis, *Anastasis: The Making of an Image* (Princeton, NJ: Princeton Univ. Press, 1986), 16.

Then Christ comes, of course, and not only empties the ancient prison of all its dead, but chains Satan and hands him over to Hades: "Then the King of glory seized the chief ruler Satan by the head, and delivered him to His angels, and said: With iron chains bind his hands and his feet, and his neck, and his mouth. Then He delivered him to Hades, and said: Take him, and keep him secure till my second appearing" (Greek, 22).

Finally, Hades ends by mocking his prisoner Satan as "Beelzebul, heir of fire and punishment, enemy of the saints." He tells him to "turn and see *that not one of the dead has been left in me*" and, in reprisal, "since I have received you to keep you safe, you shall learn by experience how many evils I shall do unto you, O arch-devil, the beginning of death, root of sin, end of all evil" (Greek, 23).

In the *Gospel of Nicodemus*, therefore, the conflict is much less Christ versus Hades as a personification of death and much more Christ versus Satan as a personification of evil. Hades just wants to hold on to his dead, but Satan wants to destroy Christ. Indeed, with regard to Christ's universal resurrection tradition, this first detailed text is already more developed than the first detailed image (Figs. 4.3, 4.6).

We conclude, therefore, that the *Gospel of Nicodemus*'s section on the universal resurrection is not the original source for the Anastasis image. It is an important verbal parallel for understanding the visual content, but here the text is not the direct source of the image. Instead, both seem separate developments of the late Byzantine 600s. But, of course, the text may *later* influence the image across the five-hundred-year span of its iconographic development. That is especially evident where Satan-as-evil takes precedence over Hades-as-death and/or Hell-as-punishment takes primacy over Hades-as-prison.

If that is correct, we are still left with this chapter's main question. Whence comes the format of the Anastasis as the new image of Christ's universal resurrection tradition? How does someone in Constantinople formulate that basic scene of Christ trampling on Hades to liberate humanity from death? What does it come from, if not from a text? Hint: What, in antiquity, is the only universal communication, the only true mass medium, the only message source available to everyone?

✠ ✠ ✠

In May 2014, we are in northeastern Romania to visit a complex of Orthodox churches within a radius of forty miles around Suceava as our base for the week. The "painted churches" of Bucovina are frescoed inside, as is usual, but also outside, which is emphatically not so usual. Eight of them form a World Heritage Site from the Kingdom of Moldavia in the 1400s and 1500s.

It is Saturday, May 10, and at 9:00 A.M. our host and driver stands by his Passat wearing a deep-blue T-shirt that proclaims, on the front,

"The Sistine Chapel of Eastern Europe is Voronet Monastery," and on the back, "The Best Accommodation in Romania is Villa Alice." Both "Sistines," Vatican and Romanian, were completed in the 1500s, but although Michelangelo painted only inside the Sistine Chapel, Toma painted on both the inside and outside of the Voronet Monastery and several other churches.

The Church of St. George of the Voronet Monastery is the most stunning of those extraordinary "painted churches." Standing before its outside south wall, with five frescoed rows to the left and eight to the right, we focus on its Anastasis to probe the origins of Eastern Christianity's Easter image (Fig. 6.1, yellow outline added). Apart from its location, the image is standard, and we choose it here precisely because it is so representative of the tradition.

Christ, with cross halo, mandorla, and long symbolic cross, strides to viewer right, his cloak billowing high from his forceful descent. The gates of Hades are in cruciform format, and Christ stands atop them with a rather bloated and hideous gatekeeper peering out below them; David, Solomon, and others are to the left; Adam, Eve, John the Baptist, and others are to the right (Fig. 6.2). All of that is quite traditional, as is indeed the feature to which we now draw your special attention.

Figure 6.1

Christ's hand raises Adam from his sarcophagus, but notice that Adam is half kneeling or, better, he is half rising from a kneeling position. His right knee is already up, but his left knee is still down. That precise position is quite standard across the Anastasis tradition. That is not the problem. The problem is why it is so standard despite being so awkward. When all the other figures are usually standing, *why is Adam so often half rising from a kneeling position?*

That is our first clue to the source of the Anastasis scenario. It comes not from traditional stories in texts or scriptures, but from traditional images on coins or medallions minted specially for important historical events.

Take, for example, a Roman imperial medallion of Constantius Chlorus, husband of Helena, and father of the future Constantine the Great. It is in perfect condition, from a golden hoard discovered in 1922 near Arras in northern France.

The front of the medallion (Fig. 6.3a) shows Constantius with an authoritative eagle-topped staff in his right hand. He is depicted as victor by a laurel wreath and a laurel-decorated robe. He is named: FL[avius] VAL[erius] CONSTANTIUS NOB[ilis] CAES[ar], that is, *Caesar*, or subemperor, of the western half of the Roman Empire. In 296 CE, he reconquered Britain, which was held by two rebel Roman commanders—first Carausius and then Allectus—who had ruled for a decade without imperial consent. Constantius minted the medallion to celebrate his victory.

The back of the medallion (Fig. 6.3b) shows Constantius in military dress, holding the spear of authority in his left hand. To viewer left the goddess Victory crowns him with a laurel wreath. To viewer right he reaches out his right hand to grasp the right hand of an armed woman who is allowed to retain shield and spear in her left hand.

Constantius raises a symbolically female Britain from a kneeling position. She is already half rising in a scene that depicts victory not as conquest and subjection, but as freedom and

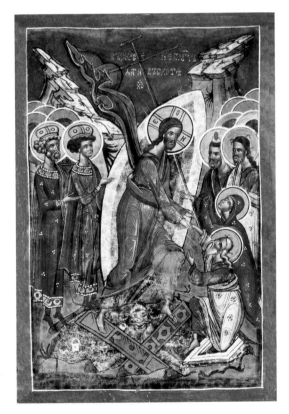

Figure 6.2

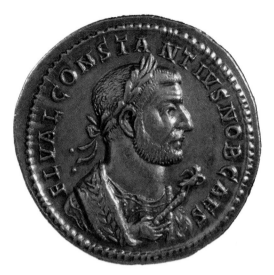

Figure 6.3a

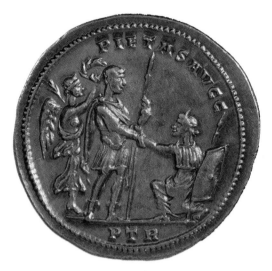

Figure 6.3b

liberation. The motto reads PIETAS AUGG[us-torum], that is, the "Piety of the Augustuses" (the plural is used in the Latin because both East and West have an Augustus, or emperor). "Piety" denotes clemency or mercy. That PTR at the bottom is short for Prima Treverensis and identifies the mint as Trier in Germany.

The back of the medallion is where we begin to answer this chapter's constitutive question about the origins of the Anastasis scene. Compare Christ, with heavenly mandorla, halo crown, and cross of authority, to Constantius, with heavenly victory, laurel crown, and spear of authority. Compare Adam as a male symbol of liberated humanity with Britannia as a female symbol of liberated Britain (Figs. 6.2, 6.3b).

On Constantius's victory coin, the liberated one is being raised up from a kneeling position on the ground, so that one knee is up and one knee is down. That works well when the figure

is arising from kneeling on the ground. But Adam rises not from the ground, but from lying in the sepulcher. His posture is therefore rather awkward. Still, it is precisely that half-risen awkwardness that is a telltale sign of the origins of the Anastasis iconography in the imagery on imperial coinage.

What about that area beneath the feet of Christ with its scattered locks and bolts, its cruciform doors, and especially its rather grotesque and animal-like figure of Hades (Fig. 6.2)? There is no such content on the Constantius Chlorus medallion (Fig. 6.3b). There, the conquered and thereby liberated people are explicitly allowed to keep their weapons.

If the Roman image is victory *as* liberation (Fig. 6.3b), the Christian image is victory as both conquest and liberation (Fig. 6.2). It is the victory of Christ as both *trampling down* Hades/death in conquest and *raising up* Adam/human-

Figure 6.4a

Figure 6.4b

ity in liberation. Those two facets are simultaneous moments of the same incident. They are the interactive negative and positive aspects of the single universal resurrection event.

But where did that dualism of victory as both conquest and liberation come from? Are we still dealing with Roman imperial coinage? To answer affirmatively, we next look closely at the later coinage of the now Christianized Roman Empire.

<p style="text-align:center">✠ ✠ ✠</p>

One hundred years after Constantius Chlorus, the Roman Empire was ruled by Theodosius I the Great (379–95). He was the last emperor to hold together—just barely—both its Eastern and Western sectors. He was also the first to impose Christian doctrinal orthodoxy on both "pagans" outside and "heretics" inside his domains.

We begin with two coins of Theodosius I,

chosen precisely because their images are extremely traditional both before and after his time. Both proclaim victory, but the first is the brutal reality of victory as conquest (Figs. 6.4a, 6.4b), and the second is that just-seen public-relations style victory as liberation (Figs. 6.5a, 6.5b).

The front of the first coin (Fig. 6.4a) shows the emperor's head, with pearl diadem, and the top of his military uniform. The motto reads D[ominus] N[oster] THEODOSIUS P[ius] F[elix] AUG[ustus], that is to say, "Our Lord Theodosius, Pius, Happy, Augustus" (the title *Felix*, "Happy," by the way, can mean either "Lucky" or "Blessed").

The back of the coin (Fig. 6.4b) shows Theodosius in full military dress trampling down a conquered and bound captive with his left foot. The emperor holds the globe in his left hand and the *labarum*, the official Christianized

Figure 6.5a

Figure 6.5b

on the captive's prostrate body, this is victory as absolute subjection—this is a traditional image of victory as conquest.

Hold that in mind as we turn to the second example. The front of the second coin (Fig. 6.5a) is very similar to the front of the previous one (Fig. 6.4a). The emperor is again "Our Lord Theodosius, Pius, Happy, Augustus."

The back of the coin (Fig. 6.5b) tells us that it was minted at Siscia (ASIS) between 378 and 383. Once again it depicts the emperor pearl-diademed, in full military dress, but cloaked as well. His left hand holds the globe; the goddess Victory is atop it, and she offers a victory wreath to him. But now the image changes radically from that preceding coin (Fig. 6.4b) and follows the tradition seen on the medallion (Fig. 6.3b).

The emperor's right hand reaches out to raise a crowned female figure symbolic of the *oikoumene*, or inhabited world. He raises her from a kneeling position and thereby displays victory as traditional freedom. This is victory as liberation. You will notice that, whether the victorious ruler reaches to the left or the right, the liberated personification is half risen from a kneeling position, in the very process of being raised from subject status.

We now have a first major conclusion on the origins of the Anastasis. Two separate but traditional images for victory were taken from imperial coinage and combined into a single depiction. The dominant theme is still victory, but the universal resurrection tradition inte-

military standard, in his right (recall Chapter 2). The motto reads, appropriately, VIRTUS EXERCITI, meaning "Strength of the Army." The coin was minted at Nicomedia (SMNA) between 383 and 388. This is the victor's foot

grates victory as conquest in the *trampling down* of Hades/death with victory as liberation in the *raising up* of Adam/humanity.

✠ ✠ ✠

Models of victory from Byzantine imperial coinage, therefore, furnish the first of two types of the universal resurrection, Universal Type 1, Trampling Down and Raising Up. As you recall, the first examples of this type are from a Byzantine pope in the early 700s (Figs. 4.3, 4.6).

The second type of the universal resurrection is Universal Type 2, Trampling Down and Leading Out. In fact, this was what we first saw in that 1050 Cappadocian cave church, which became the genesis of this book in 2002 (Fig. 1.3). Notice, however, that Type 2 is a *leading out* rather than a *raising up*. Does Type 2 also derive from Byzantine imperial coinage?

Surprisingly, the first extant example of Universal Type 2, Trampling Down and Leading Out, also occurs—like Type 1—under Byzantine artistic influence in papal Rome. This time it is under Pope Paschal I, who reigned from 817 to 824 and who accepted the soft power of Byzantine artistic influence, but not the hard power of Byzantine political force.

You may recall one Anastasis image from Pope Paschal I in the San Zeno Chapel (Figs. 5.10, 5.11), but that is in mosaic. This present one is in metal and is part of his emphasis on relics in an attempt to assert the far greater antiquity and sanctity of papal Rome over imperial Constantinople.

Rome's Lateran Palace was the pre-Vatican home of the papacy, and its relic-filled chapel was called the Sancta Sanctorum, or Holy of Holies—you may recall this from Chapter 3

Figure 6.6

(Fig. 3.7a). Among these relics was a now lost gem-studded cross containing a relic of the True Cross. Pope Paschal I placed it on a cross-shaped cushion inside a cross-shaped silver casket, which was embossed, chased, and gilded (Fig. 6.6).

The heavy-plated casket has twelve scenes along the sides and five more on the front; around the ones on the front is an inscription: "Bishop Paschal ordered [this] to be made for the People of God." Apart from the standard post-Resurrection images of Christ from the empty-tomb and risen-vision traditions, there is also an Anastasis on the top left side. You can only see some of it on Figure 6.6, but a 1916 photo shows it in full (Fig. 6.7).

The haloed Christ moves to viewer right holding a cross over his shoulder with his left hand. His right hand clasps the wrist of Adam, whom he leads toward a single door at the extreme right. Christ is half glancing back toward Adam. Eve is not shown despite quite adequate room for her presence. It is clearly a Leading Out, with no trace of any Trampling Down.

This is the first extant and securely dated example of a type that appears thereafter in full depiction as Universal Type 2, Trampling Down and Leading Out. The obvious question is: Does this Type 2 derive, like Type 1, from Christian imperial coinage?

The brutal reality of imperial victory as *trampling down* could be replaced euphemistically not only by *raising up* the conquered from bondage into liberation, but also by *leading out* the vanquished from barbarism into civilization. All of that, of course, is simply victory's propaganda using images of a kinder, gentler imperialism.

Take, for example, a bronze coin of the Byzantine emperor Constans I from the Heraclea mint (ALEA) in 348–51. The front shows the emperor facing left, pearl-diademed, in military garb, and holding the globe in his hand (Fig. 6.8a). The motto reads D[ominus] N[oster] CONSTANS P[ius] F[elix] AUG[ustus]—the same titles as on the Theodosian coins (Figs. 6.4a, 6.5a).

The back has a helmeted soldier in military uniform, but the spear in his left hand is held at rest and pointed downward (Fig. 6.8b). He moves to the right but looks back at a smaller figure whom he leads after him, right hand to right hand. The motto reads: FEL[icis] TEMP[oris] REPARATIO, "Happy Days Are

Figure 6.7

Figure 6.8a

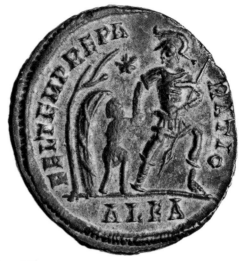

Figure 6.8b

Here Again"—recall FDR's slogan in 1932.

The image is not one of *dragging off* a conquered enemy to captivity, slavery, or execution as on other coins. It is a vision of *leading out* from a hut in the forest, as you can see in that section to viewer left on the back. It is, in other words, about liberation, about the assisted transition and "happy/lucky" (*felix*) evolution from forest hut to urban base and from ancient barbarism to modern civilization.

✠ ✠ ✠

We now have the best available answer to this chapter's question about the origins of the universal resurrection, or Anastasis, image. Somebody, somewhere, sometime during the late 600s CE took *three* traditional scenes of imperial victory from Byzantine Christian coinage and composed them into these *two* types of Anastasis scenarios:

Universal Type 1, Trampling Down and Raising Up (by 705–7)

Universal Type 2, Trampling Down and Leading Out (by 817–24)

Obviously, therefore, raising up or leading out is about ascent into Heaven and not just about descent into Hades/Hell/Limbo. It is about the Anastasis as the universal resurrection tradition and not the individual resurrection tradition of Easter.

That is all we can say with some certainty. But if we were to guess—and we can do no more here than guess—the following must suffice. Some imperial artist in Constantinople was illustrating, say, the Gospel of Matthew. All went well from the Nativity and Flight through the Crucifixion and Burial. The major events were clearly described, and each needed only to be encapsulated in an appropriate

depiction. But then came Matthew 27:51–53. *Problem:* How was that to be depicted as a scenario? *Solution:* Use imagery from imperial victory coins as models.

We began this chapter with an example of the universal resurrection tradition's Type 1, Trampling Down and Raising Up, from around 1547, in the Church of St. George of the Voronet Monastery in Romanian Bucovina (Fig. 6.2). We end it with an example of the universal resurrection tradition's Type 2, Trampling Down and Leading Out, from around 1050, in the Cathedral of Mary's Assumption on the island of Torcello in the Venetian lagoon (Fig. 6.9).

In both cases, as you can see, the Trampling Down is quite similar. Christ, with cross, stands atop the narrow gates of Hades (the location), with Hades (the personification) crouching below them with locks, bars, and bolts strewn all around. Adam and Eve, David and Solomon, John the Baptist, and several others are evident in both cases.

But the essential difference is between Raising Up in Type 1 and Leading Out in Type 2. That development makes it explicitly clear that Anastasis is not just about Christ's individual descent into Hell, but about Christ's universal ascent into Heaven.

Apart from that papal casket's image (Fig. 6.7), the Anastasis traditionally combines into a single image both Trampling Down and either Raising Up or Leading Out. This chapter proposes that those two archetypal options derive from divergent combinations of three Byzantine coins.

☩ ☩ ☩

Where are we now, and what comes next? Focus, for a moment, on the period between the 820s and 840s. In the Stuttgart Psalter from Paris, the individual resurrection tradition's imagery has finally moved from symbolic to physical depictions of that Easter moment. After four hundred years, the actual, corporeal, embodied and living Christ finally sits up in his tomb (Fig. 2.5). By that same year, the universal resurrection tradition is a hundred years old and has already developed the Anastasis with both Raising Up and Leading Out.

We now have two evenly competing Easter icons, since both have Christ arising in full somatic form just as in all of the other life-of-Christ or great-feasts iconography. Next, bracket what we know about the results of this competition in the second Christian millennium. By 820, we are not even at the end of the first millennium. What do you imagine will happen to Easter's imagery if you are thinking about it around 820?

Easter, as the climax of Christ's life and the church's liturgy, could receive a double image, with Christ *both* communally ascending to Heaven *and* emerging individually on Earth— for all of Christianity. Or either image could become the official and traditional image of Easter—for all of Christianity. Indeed, Easter's individual resurrection tradition seems poised to

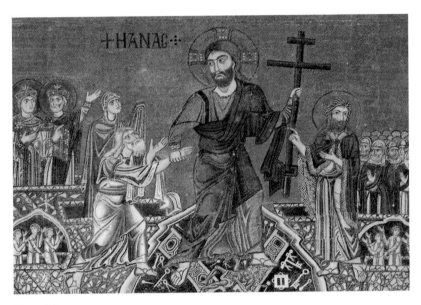

Figure 6.9

become that normative vision—for all of Christianity. How is that even imaginable?

First, in general, the moment seems propitious. Between 750 and 850, Eastern Christianity went through two iconoclastic spasms involving the destruction of images and the persecution of artists. These were based on a misunderstanding of biblical law, which does not forbid making but does forbid worshipping images or, if you prefer, making images for worship. Idols—not images—are forbidden: "Do not turn to idols or make cast images for yourselves" (Lev. 19:4; see also Exod. 20:4–5a; Deut. 5:8–9a).

Be that as it may, the theological division between anti-image Eastern Christianity and pro-image Western Christianity was over by 850, so maybe, just maybe, the West's individual Easter could now have prevailed over the East's universal tradition?

Second, in particular, we are not simply pondering counterfactuals, thinking about options never realized, wandering along roads never taken. How does the Byzantine iconography of Easter appear in the immediate posticonoclastic 840s? Does the evidence indicate a shift from the universal to the individual resurrection of Christ?

Answers to these questions—surprising and even somewhat astounding ones—take us now from fresco and mosaic to manuscript and codex, from illustrated churches to illuminated Psalters, from Byzantine-influenced Rome in the eighth century to Byzantine-controlled Constantinople in the ninth century, and from this to the next chapter.

"Rise Up, O Lord;
Do Not Forget the Oppressed"

*Christ's Resurrection is the most frequently applied Christological
interpretation . . . in the ninth-century marginal Psalters. It
appears in several versions: [1] Christ rising from the Tomb,
[2] the Anastasis (Jesus defeating Hades and raising Adam
and Eve), [3] the Myrophores (the Holy Women at the Tomb),
and [4] David standing next to Christ's Sepulcher.*

MARIA EVANGELATOU, *Liturgy and the Illustration of the Ninth-Century Marginal Psalters**

IN THE LATE 840s at Constantinople, three small but beautiful Septuagint (Greek) Psalters were produced in which specific verses were illustrated with miniature images painted in the top, outer, and lower margins of the leaves[†] (hence the somewhat unfortunate term "marginal Psalters"). Today they are known as the Khludov Psalter, the Pantokrator Psalter, and the Paris Psalter. The sheer visual exuberance of their numerous miniatures is an immedi-

* Maria Evangelatou, "Liturgy and the Illustration of the Ninth-Century Marginal Psalters," *Dumbarton Oaks Papers* 63 (2009): 59–116. Downloaded from JSTOR on September 19, 2015.
† Machine-printed books have *pages*, but handwritten or manuscript books (*codices*) have leaves or *folios* (*folium* is Latin for "leaf"; hence English "foliage"). Each folio in a manuscript book has a front, or *recto*, and a back, or *verso*, usually designated *r* and *v* in codex discussions.

ate and very polemical celebration of the final failure in iconoclasm's hundred-year attempt to ban images from Christianity.

In May 2015 we visit Moscow to study the original Khludov Psalter (conserved as Cod. Gr. D. 129) in the State Historical Museum at 1 Red Square. The codex is named for the financier and manuscript collector Aleksey Ivanovich Khludov (1818–82), but was acquired by the government in 1917.

The first reason for our Moscow visit is, of course, to answer those questions posed at the end of the last chapter. But a second reason is of equal or maybe even greater importance. Since specific verses are linked to specific Anastasis images, they show *here and now* for us what Anastasis meant *there and then* for them. Those text–image linkages furnish precious insight into the meaning of Christ's Resurrection at official Constantinople in the middle of the ninth century.

✠ ✠ ✠

Before leaving for Russia, we submitted to the museum the required documentation for a research pass to study the Khludov Psalter. We had to supply complete details on past scholarly contributions, present research projects, and future publications involving that specific manuscript book. The museum did not reply—not yes, not no, not anything. We turned for help to our friend Svetlana Goryacheva, chief librarian of the Russian State Library in Moscow. She became our project's facilitator—and savior.

We arrive in Moscow the late afternoon of Thursday, May 21, 2015, and have dinner with Sveta at our hotel, the Ararat Park Hyatt, on Saturday evening. She presents us with an extraordinary welcome-to-Moscow gift: the out-of-print Russian-language full-color facsimile of the Khludov Psalter.*

Sveta is to call Dr. Elena V. Ouhanova of the State Historical Museum's Department of Manuscripts at 10:00 A.M. on Monday and then call our hotel with a "go" or a "no." In the meantime, we have Sunday to study Shchepkina's beautiful facsimile and prepare for Monday in case we get to see the original Khludov Psalter.

Although it is a long waiting-to-exhale weekend, all goes well, and at exactly 10:05 on Monday morning, we get the go-ahead: "Your research passes are approved. Go to the staff entrance of the museum. Not the main entrance inside Red Square, the one outside. The staff's door is behind the statue of Marshal Zhukov."

The manuscript reading room on the sixth floor has two levels and a central well containing three long tables and four smaller desks—all topped with book stands. One of those smaller desks has been reserved for us, and once we are seated, the director brings us two boxes. The first one is dark blue and velvet-lined with ribbons to extract the heavy, double-clasped original Khludov Psalter. The second one holds

* Marfa Vjacheslavovna Shchepkina, *Miniatures of the Khludov Psalter: Illustrated Greek Codex of the Ninth Century* (Moscow: Iskussivo, 1977). OCLC gives only twenty-six libraries worldwide copies of this book—none are in North America.

a facsimile volume—not that Russian one from Moscow in 1977, but a Spanish one from Madrid in 2006 (Salterio Chludov, *Archivo Histórico de la Ciudad de Moscú*).

Original and facsimile are both placed on our desk's book stand, and we are left to study them side by side. We take our time and examine every single folio, recto (front) and verso (back), one at a time. Some folios are missing, but the greater shock is how some images have been removed—not torn out, not scissored out, but cut out cleanly with, say, a razor blade.

We first look through the entire codex, folio by folio, and notice how each miniature illustration is linked to its appropriate verse by matched markers. There are eight single miniatures and one double miniature explicitly labeled "Anastasis" in red. For our purpose, that gives us a definitive list of ten images. Late that afternoon, we purchase high-resolution digital photos of those ten specific folios accompanied by the right to use them in this book

Back home that summer of 2015, we connect computer to television and study the Khludov Psalter's "Anastasis" images in mega-screen detail. This confirms clearly and immediately what we had already glimpsed dimly and fleetingly in Moscow. Except for one Anastasis image, which we hold for the next chapter (folio 100v), the other nine fall into two very separate categories.

To our astonishment, those categories are the individual resurrection tradition (six examples) and the universal resurrection tradition (three examples). Normally, of course, the Greek title "Anastasis" means the Byzantine vision of Christ's universal resurrection—as throughout this book. But in the Khludov Psalter the term is used for *both* individual and universal images of Christ's Resurrection. That ambiguous usage of "Anastasis" intensifies the questions proposed at the end of the last chapter.

What does it mean that both individual and universal resurrection traditions are here called by the same name? And especially, what does the numerical preponderance of individual over universal images indicate? Is the individual version becoming the preferred Eastern vision of Easter? Is the struggle for a common Christian icon of Christ's Resurrection and a unified Christian iconography of Easter to conclude in a triumph of the individual over the universal vision?

✠ ✠ ✠

The six "Anastasis"-entitled images of the individual resurrection are on folios 6r, 9v, 26v, 44r twice, and 78v of the Khludov Psalter. At first glance, they seem like extensions or expansions of that Stuttgart Psalter's folio 157r (Chapter 2), and it does look like the East is starting to accept the West's vision of Easter. Notice, for example, the importance of the tomb itself in both the West's Stuttgart Psalter and the East's Khludov Psalter.

First, there are three images of the *closed* tomb without Jesus present: folio 44r has only the two women beside it (Fig. 7.1, lower section); folio 6r has David and the guards beside it (Fig. 7.2); and folio 44r has David, women,

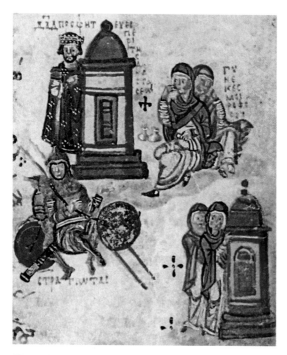

Figure 7.1

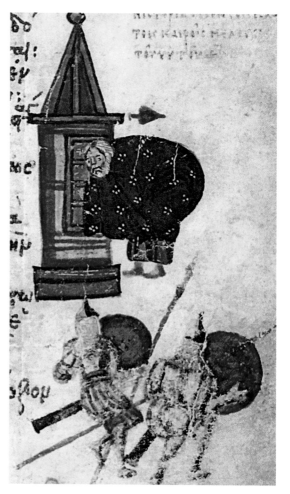

Figure 7.2

and guards beside it (Fig. 7.1, upper section).

Next, folio 9v depicts both David and Christ. But it is difficult to decide whether Christ is inside, outside, or simply superimposed on the tomb (Fig. 7.3). Notice that this folio's version of the tomb is domed and windowed as distinct from the peak-topped versions on the other folios (compare Fig. 3.7b).

Finally, there are two images where Christ is clearly standing outside the tomb: one with David on folio 78v (Fig. 7.4) and one with David and the guards on folio 26v (Fig. 7.5).

What is most striking about all six of those images is their emphasis on the tomb itself—it is the only constant in every one. Women, guards,

David, and even Christ himself may be present or absent, but the tomb is always there and always the same shape—with that one exception noted already (folio 9v, Fig. 7.3).

Furthermore, those images "depict" the tomb edicule, and in one case even the Anastasis Rotunda in Jerusalem's Church of the Holy Sepulchre (Fig. 7.3). Something else, something

Figure 7.3

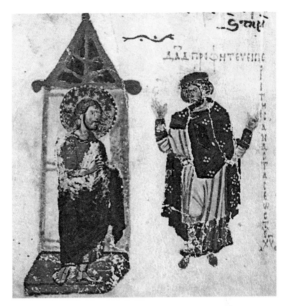

Figure 7.4

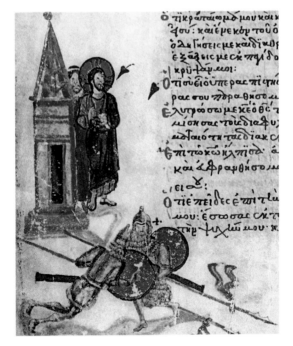

yet to be seen, is at work here, and until it is fully understood (in Chapter 8), we hesitate to see any deliberate transition from universal to individual resurrection tradition in the Khludov Psalter. This is only a very preliminary and tentative conclusion to be finally confirmed or rejected only after the next chapter. It is, however, supported so far by two major reasons.

Figure 7.5

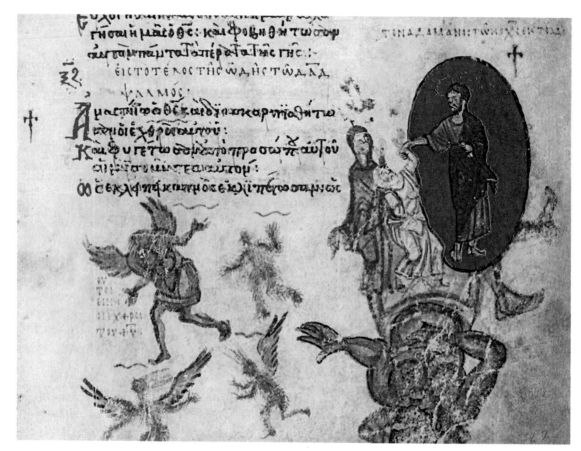

Figure 7.6

✠ ✠ ✠

A first reason to suspect any deliberate transition from universal to individual in the Khludov Psalter is that, along with six images of the individual, it also has three of the universal version—and all are entitled "Anastasis." These are on folios 63r, 63v, and 82v.

All three fit within the established Universal Type 1, Trampling Down and Raising Up. But they also have some striking adaptations

reminding us that this universal Easter scenario is dynamic, not static, liturgically conservative but also creatively developmental. We return to these adaptations later (Chapter 11).

Folio 63r (Fig. 7.6) has one very unique aspect. The appended red-letter caption reads (above mandorla): "Christ raising (*anestōn*) Adam from Hades." The corresponding caption for folio 63v (Fig. 7.7) is even more startling (left of mandorla): "Another *anastasis* of Adam." That

links back to the description for 63r, and the twin images are back to back on either side of the same folio.

There is a very explicit, doubled, and unique reminder that, since it is universal, this resurrection tradition is not only that of Christ, but also that of Adam. It is the resurrection of all humanity in, by, with, and through that of Christ himself. This hardly indicates any abandonment of the universal vision (recall epigraph to Chapter 1).

Furthermore, in all three images, Hades is monstrously engorged from swallowing so many dead people over the millennia. That is still clear in folios 63r and 63v, and although in folio 82v (Fig. 7.8) Hades is almost totally abraded, you can still see the remnant of his head facing out under Christ's feet, his right hand under Eve, and his left leg at the bottom of the folio.

Recall what we cited earlier from Hades's words to Satan in the *Gospel of Nicodemus* (Chapters 4 and 6): "All those that I have swallowed from eternity I perceive to be in commotion, and I am pained in my belly" because "not one of the dead has been left to me" (Greek, 20). Hades personifies death as the people-eater whose engorged belly holds the whole human race. Once again Adam and Eve are all of liberated humanity.

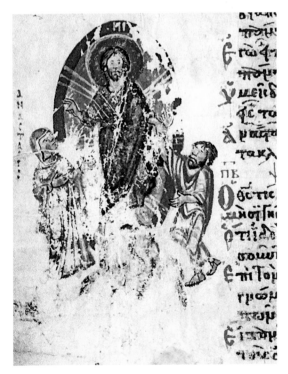

Figure 7.7

Figure 7.8

✠ ✠ ✠

A second reason to question any deliberate transition from universal to individual is that, whether the Khludov's images are of the individual tradition with Christ and David or the universal one with Christ and Adam, the verses chosen as "Anastasis" prophecies indicate a corporate, communal, and universal vision. Look at the texts chosen for illustration—in the order and translation of the English NRSV rather than the Greek Septuagint.

First, the six images of the individual resurrection tradition illustrate these specific verses (note, by the way, that "rise up," "rouse up," and "wake up" have Greek roots—*anastēmi* or *egeirō*—associated with Christ's Resurrection in the New Testament):

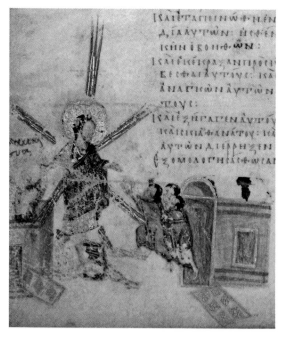

Figure 7.9

1. "Rise up, O Lord, in your anger; lift yourself up against the fury of my enemies; awake, O my God; you have appointed a judgment." (Ps. 7:6; folio 6r; Fig. 7.2)

2. "Rise up, O Lord; O God, lift up your hand; do not forget the oppressed." (Ps. 10:12; folio 9v; Fig. 7.3)

3. "Take me out of the net that is hidden for me, for you are my refuge. Into your hand I commit my spirit; you have redeemed me, O Lord, faithful God." (Ps. 31:4–5; folio 26v; Fig. 7.5)

4. "Rouse yourself! Why do you sleep, O Lord? Awake [*literally*, Rise up], do not cast us off forever!" (Ps. 44:23; folio 44r; Fig. 7.1, upper section)

5. "Rise up, come to our help. Redeem us for the sake of your steadfast love." (Ps. 44:26; folio 44r; Fig. 7.1, lower section)

6. "Then the Lord awoke as from sleep, like a warrior shouting because of wine." (Ps. 78:65; folio 78v; Fig. 7.4)

First, and above all else, it is David who "speaks" in all those verses, and he speaks especially for the abandoned and the oppressed. Second, even though the image is always of Christ's individual resurrection, the verses presume that Christ is never alone, but that his Resurrec-

Figure 8.2

the other an iron bedstead. The latter is covered with a single white sheet, starched as stiff as a nun's wimple."*

For me, it is Wednesday, May 25, 2016, in the fourteenth-century Pantokrator Monastery, north from the Iviron on Athos's east coast. I am here to see the Pantokrator Psalter manuscript from the late 840s. Still, all else is the same as for Dalrymple: white walls, flagstone floor, small chair, small table, iron bed, and gracious monastic hospitality. Austerity and beauty or, better, austerity as beauty. Outside my window at dusk swallows trace arabesques against the darkening

sky, and at dawn the sun flames magnificently across the Thracian Sea (Fig. 8.2, my cell is circled in red).

Mine is a fast and very focused trip.† For access and hospitality, I am very grateful to the abbot, Archimandrite Gabriel, to the council of elders, and to Father Vissarion, the scholar-monk who is the monastery's secretary. Visiting this sacred peninsula is an incredibly complicated process. Not only does it require a flight

* William Dalrymple, *From the Holy Mountain: A Journey Among the Christians of the Middle East* (New York: Holt, 1997), 3.

† This is my second visit to Athos. The first, in 1972, was a day-long trip by car from Thessaloniki to Ierissos (on the monastic peninsula's northeastern border) and thence by boat from Ierissos to Vatopedi Monastery (Figure 8.1). By day dolphins crisscrossed derisively before the 20-foot fishing caïque, and by night stars glimmered uninterrupted from horizon to horizon.

from Orlando through Dulles, Zurich, and Athens, to Thessaloniki, but it also requires very delicate paperwork for Mount Athos itself.

Only ten non-Orthodox and one hundred Orthodox males are admitted to Athos each day. So you reserve a year ahead and confirm a week ahead, but only get your official four-day visa—called a Diamonitirion—an hour before you are to depart for entrance to Athos. By 7:30 A.M. on Wednesday, I am in line at Ouranoupoli's Pilgrims' Office (*more fully*, Holy Executive of the Holy Mount Athos). The small office is already

Figure 8.3

crowded but also fully computerized, and I soon have my long-reserved visa in hand. It is more like a diploma than a visa and gives my name, religion, nationality, passport number, and date of admission to Athos (Fig. 8.3).

By 8:30 A.M. I am in another line for the daily passenger-and-vehicle ferry that takes two hours—with stops if needed—along the peninsula's western coast from Ouranoupoli to Dafni, the only official "port" for Athos. The boat's name is *Azion Estin* ("It Is Right"), the opening phrase in a hymn to Mary from Eastern Christianity's liturgical chant.

By 9:30 A.M. I am in the final line to board the boat. Every passenger's passport and visa are carefully checked by a Coast Guard officer before you even get to present your ticket to a steward. Fifteen minutes later the ferry draws its heavy iron bow up off the pier, backs out, turns around, and heads very slowly south, close in along the Athos shoreline.

Heavily backpacked pilgrims crowd the open deck high on the back of the ferry, and we are escorted by insistent seagulls who have learned two delicate acrobatic tricks. At the rails, they can catch tossed pieces of bread in full flight and even take them from extended fingers by flipping their wings parallel to the boat at the last minute.

The ferry stops at various monasteries on the way to Dafni, for example, at the Russikon, the Russian Orthodox Monastery of St. Panteleimon. Primate Kyrill, for the Russian church, and President Putin, for the Russian state, are to

Figure 8.9

five of the universal vision. With regard to images, you could read that as a movement away from Easter as the East's universal resurrection (five cases) toward accepting the West's individual resurrection (twelve cases). But in both Khludov and Pantokrator the verses illustrated by this novel imagery are often corporate, communal, and universal—at least for the dispossessed and oppressed.

Look back, for example, at the verses just illustrated by Pantokrator 24v and 26v. The

ied in any of them. That latter image of David standing to the left as Christ emerges from his tomb to the right is copied on Bristol 21v (Fig. 8.9). The appended title is "Christ rises from the dead ones," and the illustration connects to Psalm 12:5 once again.

Finally, there is that single image of the universal resurrection tradition on Pantokrator 83r (Fig. 8.10) illustrating the verse: "God gives the desolate a home to live in; he leads out the prisoners to prosperity, but the rebellious live in a parched land" (Ps. 68:6). We already saw that same verse used in Khludov Psalter, folio 63v (Fig. 7.7). Both images have the monstrously enlarged Hades, but compare who gets to stand on his stomach in each case!

✠ ✠ ✠

Think now, in summary, about the resurrection tradition in all three of these mid-ninth-century illustrated Byzantine Psalters: all together, there are twelve examples of the individual and only

Figure 8.10

images are quite individual for Christ, but the texts are universal for the oppressed, the despoiled poor, and the groaning needy. Put together, images and texts do not point to Christ's Resurrection as just about Christ alone.

You can now see clearly the core problem for Chapters 6 and 7 and, indeed, for the general thrust of this book. If we are not watching a declining preference for the Byzantine tradition of Christ's universal resurrection and an increasing preference for the innovation of Christ's individual resurrection; if we are not watching the Eastern invention of the Western Easter; then these questions press even more forcibly upon us.

What is the purpose and intention of having both the individual and universal images of Easter—and indeed with the former more prevalent than the latter—within this trio of official Psalters created for the patriarchal monastic liturgy of the Byzantine capital, Constantinople, in the later 840s? If the East is not changing its Easter image, what is it doing?

✠ ✠ ✠

The first indication of an answer has been hinted at already. It is the fact that only the tomb edifice itself is consistently present in each and every individual resurrection scene in both the Khludov and Pantokrator Psalters. All else—even Christ himself—may be omitted, but not that specifically shaped tomb. Why?

It represents, first of all, a very deliberate choice. These Byzantine artists know, of course,

the Gospel stories about the actual tomb of Christ. An image on Khludov 87r and Pantokrator 122r shows two men carrying Christ's dead body into a hillside cave tomb. The caption reads "Joseph and Nicodemus." They hold the dead Christ in a sheet with only his face showing (Father Vissarion notes, "like a sack of potatoes")—it is a brutally unsentimental vision of John 19:40. The connected verse is, "You have put me in the depths of the Pit, in the regions dark and deep" (Ps. 88:6). Still, despite what they know quite well from the Gospel, they choose to consistently retain that elegant cenotaph-style tomb for Christ's Resurrection. Once again, why?

You already know the answer. That tomb depicted in the marginal Psalters is not historical from the New Testament story, but liturgical from the Holy Sepulchre church. It is the imagined tomb edicule from Jerusalem's Church of the Holy Sepulchre as seen earlier (Figs. 2.5, 2.9, 3.2–7b).

In other words, the tomb in those twelve Psalter images of Christ's Resurrection deliberately *represents* the actual tomb in Jerusalem's Church of the Holy Sepulchre. It is, of course, quite appropriate to actualize the biblio-historical Resurrection into its liturgical reenactment. Easter is an "always" event. Still, why this sudden emphasis on the obvious in the later 840s in Constantinople? The answer requires one final point.

✠ ✠ ✠

Figure 8.11

Recall that the Khludov Psalter had ten images red-titled as "Anastasis," but that we only discussed nine of them—six for the individual and three for the universal resurrection (Chapter 7). We now return to focus on the tenth Anastasis image as the best solution to our questions about purpose and intention.

We have, in Khludov 100v, a radically different Anastasis image from anything seen so far (Fig. 8.11). Christ stands atop Hades prostrate on a large sarcophagus and turns toward a churchlike building from whose top a woman's head, right shoulder, and hand reach out toward

him. The connected verse reads: "You will rise up (*anastas*) and have compassion on Zion, for it is time to favor it; the appointed time has come" (Ps. 102:13). There are also two added red-letter captions: to the left of Christ is the vertical caption "Anastasis" and above the building is "Hē Hagia Siōn" ("Holy Zion").

Much of Khludov 100v is badly abraded, but is better preserved in a later eleventh-century illustrated Psalter that derives from that ninth-century prototype. The Barberini Psalter, for example, preserved in the Vatican Library, has a very clear image of that scene on its folio 171r (Fig. 8.12). The caption again reads "Holy Zion," but with no mention of "Anastasis."

"Holy Zion" is the Byzantine basilica on Mt. Zion destroyed in 614 during a Persian siege of Jerusalem. But why is Christ's Anastasis and its Trampling Down of Hades associated with a destroyed holy site in Jerusalem? We come now to the final point in understanding this heavy intrusion of individual resurrection into the much more traditional universal resurrection vision of Byzantine Easter imagery.

First, and in general, early Christianity claimed to have replaced Judaism and pointed to the crowded Church of the Holy Sepulchre as triumphant over the abandoned ruins on the Temple Mount. But when Islam captured Jerusalem in 637 and in 691 built the Dome of the Rock in direct competition with the Church of the Holy Sepulchre (Islamic dome versus

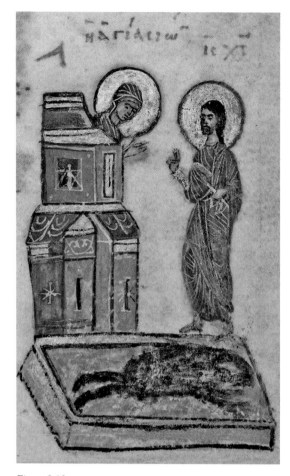

Figure 8.12

sites, monks, and pilgrims in Abbasid Palestine were especially vulnerable.

Contemporary texts record "the venerable places of the holy Anastasis, of Golgotha, and the others that are in the holy city of Christ our God were profaned" and heavy taxes were levied on "the holy church of the Anastasis of Christ our God and on the other churches which were in holy Jerusalem." Furthermore, nearby desert monasteries were "made desolate."* Monks fled to Constantinople and were received there generously by both emperor and patriarch.

Islam's triumphant—and often antagonistic—control of Christianity's holy sites in Bethlehem and Jerusalem best explains this innovative individual resurrection imagery from the Byzantine 840s. The purpose of the innovation is not the singularity or individuality of Christ's Resurrection, *but the particularity and locality of Christ's tomb.* The innovation claims rights to Christianity's pilgrimage sites—Bethlehem and Jerusalem, Holy Zion and Holy Sepulchre—as based on the prophecies of David in the psalms.

The Qur'an notes that Allah "exalted some of the prophets over the others, and to David . . . gave the Book of Psalms" (Sura 17.55). For Islam, David is preeminent among the prophets as the only one who was also a ruler (like Muhammad himself). In other words, this individual resurrection imagery

Christian dome!), did that prove Islam had now triumphed over Christianity?

Second, and in particular, the Abbasid caliph Harun ar-Rashid (Harun the Just) ruled the Islamic Empire from 786 to 809. But at his death civil war erupted between his two sons, Al-Amin and Al-Ma'mun, and lasted until the latter's victory in 828. Within the empire-wide turmoil between 809 and 828, Christianity's

* Kathleen Corrigan, *Visual Polemics in the Ninth-Century Byzantine Psalters* (Cambridge, UK: Cambridge Univ. Press, 1991), pp. 95–96.

with the actual tomb edicule in Jerusalem as its dominant core, as well as its certification by David, makes a powerful apologetic from Christianity to Islam.

We now have our answer about the purpose and intention of the individual resurrection imagery illustrating David's prophetic psalm verses in Constantinople's later 840s. It is a pointed polemic against anti-Christian intolerance in Muslim Palestine during the early 800s. It says to Islam: "David, prophet, king, and psalmist, foretold that the churches and monasteries, holy places and pilgrimage sites in and around Jerusalem would be Christian, and you must always respect that vision."

There might also be an underlying polemic from a Constantinople successfully but only newly noniconoclastic to an Islam still more or less traditionally iconoclastic. Be that as it may, this intrusion of the individual resurrection is both new and fleeting in Byzantine Easter tradition. It is of a certain time and place—patriarchal creativity from Constantinople in the later 840s. It arrives without ancestry and leaves without progeny—except, of course, in later illustrated Psalters that copy its prototypes. But it never replaces the traditional Eastern Anastasis of the universal resurrection tradition.

☩ ☩ ☩

Where are we now, and what comes next? Images of Christ emerging from his tomb (half inside and half outside) are already present in Western Christianity's Stuttgart Psalter by the 820s and in Eastern Christianity's Pantokrator Psalter by the 840s. Granted that the former has Christ emerging by sitting up (Fig. 2.5) while the other has him emerging by stepping out (Fig. 8.8), and granted the very divergent meanings and motivations behind that transient similarity, here are the next two questions.

When, where, and how does Western Christianity finally decide irrevocably that its Easter icon is officially, formally, traditionally to be Christ's individual and not Christ's universal resurrection tradition? We know that this is eventually established in the second Christian millennium (Chapter 2), but when, where, how does it happen? Also, granted that decision, what does Western Christianity do with that universal imagery? (Chapters 9 and 10).

To answer those questions, we must look at the tenth through twelfth centuries; we must turn from illustrated parchment codices to illustrated parchment scrolls, from the Byzantines in the East to the Lombards in the West, and from Chapters 7 and 8 to Chapters 9 and 10.

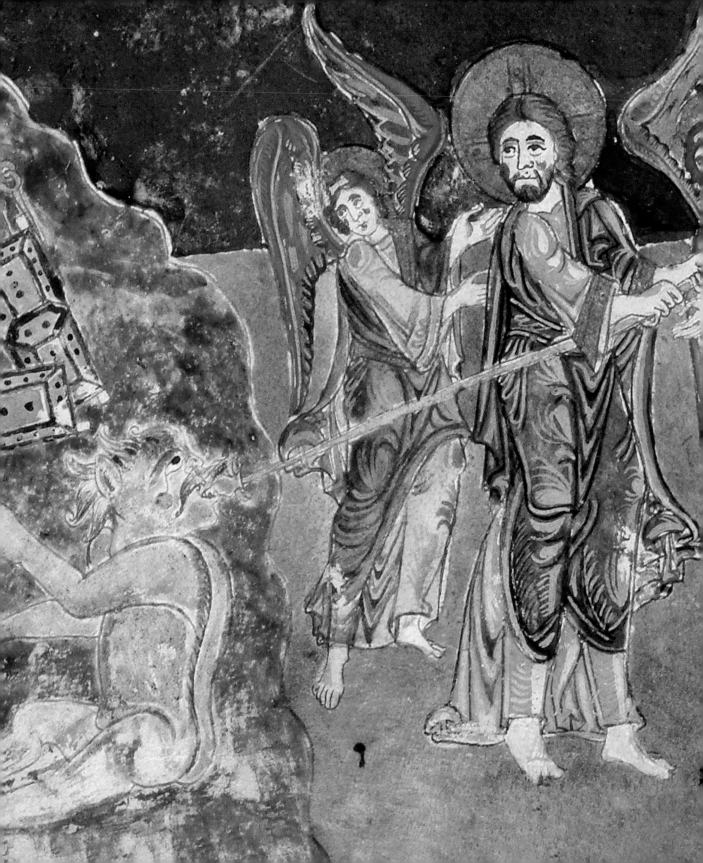

9

"Let Now the Angelic Choir of Heaven Exult"

*Around 960–70, Archbishop Landulf of Benevento commissioned
a new type of illuminated manuscript, a liturgical scroll
containing the text of the Exultet hymn, the chant celebrating the
Resurrection of Christ. This initiative was soon after imitated
throughout the entire Lombard territory of southern Italy.*

Nino Zchomelidse, *Art, Ritual, and Civic Identity in Medieval Southern Italy**

WHEN Archbishop Landulf commissioned a new liturgical scroll in the 900s, he created something unique in the celebration of the Easter Vigil. He did not, of course, invent the Easter Vigil as the liturgical celebration of Christ's Resurrection on the eve of Easter Sunday. Neither did he invent the Vigil's ceremony of taking new fire from outside the church to light the Easter candle inside as symbol of

Lumen Christi, the Risen Christ, the Light of the World. Nor did he invent the beautiful Latin hymn called the Exultet—from the opening line, *Exultet iam angelica turba caelorum*, "Let now the angelic choir of heaven exult."

What he did invent—and it is a brilliant invention—is a combination of text, music, and imagery that forms the basis for a radically new vision of the Exultet ceremony. Then he placed that new combination not in a parchment book, but on a parchment scroll, an archaic medium with much symbolic authority. Finally, that

* Nino Zchomelidse, *Art, Ritual, and Civic Identity in Medieval Southern Italy* (University Park: Pennsylvania State Univ. Press, 2014), 34.

scroll was not inscribed and illustrated horizontally from left to right, but vertically, to be seen and sung from top to bottom.

This created a liturgical ritual of sacred theater powerful enough to last through four hundred years of political and ecclesiastical change. It lasted even as the Lombards and their capital at Campanian Benevento succumbed to the invading Normans with their capital at Sicilian Palermo. It lasted even as the local Beneventan rite yielded to the domination of the new Roman liturgy of the reforming Pope Gregory VII. It lasted even as the archbishop of Benevento ceded ecclesiastical precedence to the abbot of Monte Cassino.

That famous abbey, founded originally by St. Benedict in 596, restored magnificently by Abbot Desiderius in 1071, and destroyed unnecessarily by Allied bombing in 1944, now stands fully rebuilt about seventy miles northwest of Benevento in southern Italy. Our plan, on Monday, September 1, 2014, is to visit the abbey's archives and study the second of its two eleventh-century Exultet scrolls. (Its first Exultet is fragmentary.)

This research trip to Italy involves a week in Rome, another in Naples, and, as we drive from one to the other, a visit to Monte Cassino to study its Exultet 2. To answer this chapter's questions, we need to study the Easter imagery in the Exultet tradition. We want to see if within its imagery the West finally and irrevocably chooses individual over universal resurrection, and this is simply where we begin the process. It is our first chance to study an Exultet scroll in situ.

Although the archives are usually closed on Mondays, we have requested permission, and Father Mariano dell'Omo, OSB, accepts this day as our only opportunity and agrees—with true Benedictine hospitality—to admit us to the abbey archives this morning.

Slowed on the road by thunderstorms, we arrive at 11:30 and are welcomed into a large conference room. The rolled-up scroll, dated between 1105 and 1110, is already placed on the table for our visit. Archivist dell'Omo unfurls it,

Figure 9.1

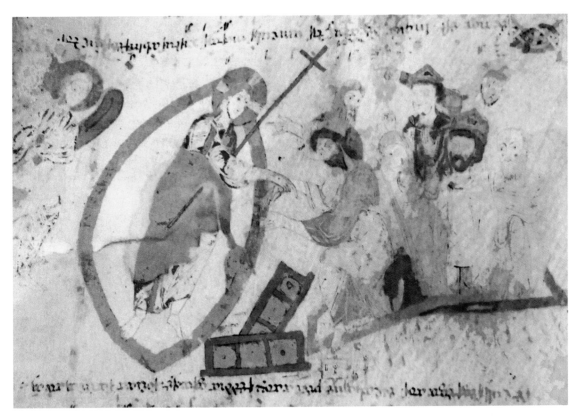

Figure 9.2

and at 16 feet it takes up the entire length of the table (Fig. 9.1).

The scroll contains the musically annotated text of the Exultet hymn interspersed with twenty images at appropriate places within its sequence. After the Crucifixion image, the *direct* Anastasis image of the universal resurrection tradition appears, and then comes *indirect* resurrection tradition with the three anointing women (Mark 16:1) from the empty-tomb tradition and the two worshipping women (Matt. 28:9) from the risen-vision tradition.

By now you recognize this resurrection image as a standard Universal Type 1, Trampling Down and Raising Up (Fig. 9.2). The scene is badly abraded, but reads like this from viewer left to right: two angels; a cross-haloed, wounded Christ within a mandorla, cross in left hand, right hand grasping Adam's right hand; Adam; Eve dimly visible to the right of Adam; above Adam's head, John the Baptist pointing to Christ; to the right of Eve, the two kings (the lower one is the bearded David, the upper, the beardless Solomon); and at least two others.

Below are gates, locks, and bolts, but no Hades figure. (Notice, for future reference, those two angels at viewer left.)

One striking feature of that image is difficult to see in its present worn condition: the text and the images are upside down relative to one another. Obviously, the texts have to be right-side up so the deacon can chant them, but, as the long scroll is unwound downward from the high ambo/pulpit, the images have to be reversed for two reasons. One is simply so viewers can see the images right-side up—in so far as they could see in a darkened church. The other and maybe more important reason is so that the scroll's sacred and secular personages are not shown descending headfirst to the floor.

✠ ✠ ✠

We continue from Monte Cassino to our hotel high on the spine of the Sorrento Peninsula in the tiny village of Sant'Agata sui Due Golfi, whence you can see—as its name suggests—both the Gulf of Naples to north and the Gulf of Salerno to south.

Then, on Friday, September 5, we drive the full length of the peninsula's magnificent coast from Positano through Amalfi to Salerno. We walk up that city's narrow streets to the eleventh-century Cathedral of St. Matthew and, behind it, to the Diocesan Museum, on the first floor of a classically elegant courtyard building.

There, in a dimly lit display room with two large banners hanging in the inside corners, we unexpectedly find our second Exultet scroll of the week. (We are actually in the museum to study the Salerno Ivories.) But unlike the rolled-up Monte Cassino Exultet 2, this Salerno Exultet scroll is separated into its constitutive parchment skins (membranes) and enclosed in eleven glassed and lighted display consoles sticking out from the room's three inside walls. But there is an even more startling difference between the two Exultets.

Up to this point in our travels, the universal resurrection always combines Trampling Down and either Raising Up (Type 1) or Leading Out (Type 2) in a single composite image. But here, for the first time in our experience, this Exultet scroll from around 1250 divides the Anastasis into two images with Trampling Down separated from Leading Out—a division emphasized by their display on different membranes, in different consoles, and on different walls. We have never seen this mode of separation before, and we think of it as a Split Anastasis.

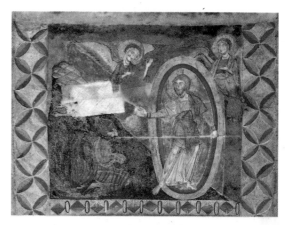

Figure 9.3a

On the one hand, this separated Trampling Down scene is a new creation utterly divergent from the traditional Byzantine image of Christ's victory over Hades (the person) and Christ's evacuation of Hades (the place). It contains three very basic changes in our standard expectations for the Anastasis tradition (Fig. 9.3a).

First, Hades, the place of inevitable and permanent death for *all* humans, is now Hell, the place of inevitable and permanent torture for *some* humans. Notice those delicately flickering flames of hellfire at bottom left.

Next, Hades himself has now doubled to become both Hades and Satan. And Satan is now bound as in the *Gospel of Nicodemus* (Latin B, 24). The narrow gates of Hades/Hell are at the left above Hades and Satan.

Also, the Trampling Down of Hades has now become a Spearing Down of Satan. Christ's left hand does not carry a cross, but a long spear: the cross as a symbol of violence *done to* the nonviolent Christ is replaced here by a spear as a symbol of violence *done by* the violent Christ.

Finally, when Trampling Down becomes Spearing Down, Christ no longer has direct bodily contact with Hades/Satan, but stands a full spear's length away. Christ, accompanied by two angels and cross-haloed within a mandorla, rebukes Satan with his right hand. Recall those two angels in the Anastasis on the Monte Cassino Exulet 2 (Fig. 9.2); although that image is otherwise a traditional Universal Type 1, the two angels connect it to the Trampling Down portion of Salerno's Split Anastasis (Fig. 9.3a).

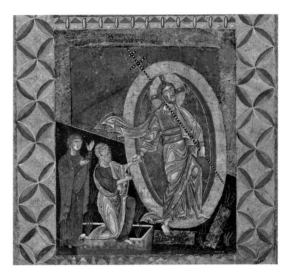

Figure 9.3b

On the other hand, compared to that separated Spearing Down, the separated Leading Out image (Fig. 9.3b) is quite traditional. Christ, cross-haloed within a mandorla, holds a tall slim patriarchal cross in his left hand. He reaches back for Adam's limp wrist and raises him from the usual half-kneeling, half-rising position. Eve stands fully beside him, and Christ leads them both toward viewer right. Still, there are flickering flames as Hades becomes Hell not just in the Spearing Down, but in the accompanying Leading Out.

By 2014 we already know a very wide variety of Anastasis images across Eastern Christianity, but this Split Anastasis imagery is a complete surprise. For background, we have with us a book on the Exulet tradition. Of the images on the Salerno Exultet, it says: "These pictures are the same cycle as that which appears in Vat. lat.

9820 and the Casanatense Exultet."* Salerno's Exultet and its Split Anastasis are not then unique.

The Split Anastasis is a radical innovation in the Exultet tradition, and it raises a very obvious question. Is this the process wherein Christ's individual resurrection finally becomes normative as the West's Easter over the universal resurrection as normative in the East? Is this Split Anastasis a first major step in that direction for Western Christianity?

In any case, we cannot follow up on that question as a more precise version of the ones at the end of the last chapter. Clearly we will need to examine these two Exultet examples before we can continue our investigation. The two Roman libraries just mentioned that hold those additional Split Anastasis examples are closed for summer vacation and, besides, we fly home—Naples to Frankfurt to Orlando—in three days. We plan a return trip to Italy in 2015 to continue work on the doubled images of the Split Anastasis and on the Exultet liturgy as the matrix for West's individual and the East's universal vision of Easter.

✠ ✠ ✠

It is a glorious Thursday morning, May 28, 2015, as we walk close to the wall of Vatican City along the Via di Porta Angelica from St. Peter's Basilica toward the Vatican Museums among crowds already heading in that same

direction. We are headed for the Vatican Library to examine the earliest Exultet scroll still in existence. But, almost immediately, we stop at the Porta Sant'Anna, and this book's authorial "we" of Sarah and Dominic must once again become a temporary "I" of Dominic alone, because only one person is allowed to examine a rare scroll at a time.

The Vatican Library—the Biblioteca Apostolica Vaticana—was completely closed from 2007 to 2010 for extensive renovations that included guaranteeing the integrity, protecting the security, and digitizing the content of eighty-two thousand manuscripts, which are now coming online free of charge. Enhanced electronic security is certainly necessary for the world's greatest collection of manuscripts. (In 1987 a trusted art historian stole pages from a fourteenth-century manuscript to finance his retirement, but instead of $500,000 he got fourteen months in an American jail.)

A Swiss guard in a blue regular-duty uniform protecting St. Anne's Gate into Vatican City waves me over to the small Italian police station inside. An official takes my passport, gives me a name badge for the "Library," and directs me along the road to the north end of the Belvedere Courtyard. There, inside the world's most ordinary door to the world's most extraordinary library, the secretariat oversees the stringent electronic security controls.

Months earlier I had sent my general academic résumé, current research project, and specific Exultet request to Dr. Paolo Vian, direc-

* Thomas Forrest Kelly, *The Exultet in Southern Italy* (New York: Oxford Univ. Press, 1996), 239.

tor of the Manuscript Department, and he had responded affirmatively—and very graciously. This morning it takes the secretary about a half hour to get my photograph on the front and my academic details in the magnetic strip on the back of a personal key card. From then on, everything I do this May morning—entrances and exits, starts and finishes—is controlled by this key card, which is valid for one year.

The manuscript reading room is narrow and vaulted, with windows to the left and niched sculptures to the right. There are about a dozen tables on either side with three front-facing chairs apiece. At that far end, facing those tables and their book rests, is a large dais for the librarians. At front left is a computer where you enter specific requests by swiping that key card and typing in the details—or you can order by a given code from your own computer.

My electronic request is for what is described as "perhaps the most important of all surviving Exultets."* Shelf-marked as Vat. lat. 9820, it is the earliest Exultet still extant, securely dated between 981 and 987. It is a copy—made for a Beneventan convent—of that inaugural Exultet mentioned in this chapter's epigraph. Its early date is emphasized by the fact that texts and images were *originally* not reversed to one another—that only happened to it during membrane separation and textual revision in the twelfth century.

The computer screen informs me that only

the director can permit study of this particular manuscript. He is at his desk beside the entrance, takes me to a small room behind the librarians' dais, and opens a color facsimile scroll of the Exultet across the table. I indicate the two images of the Split Anastasis that I need to see, and he asks me—solemnly and officially—if I *need* to see the original. After a "yes," I am seated at the large front table for "precious manuscripts."

As I wait, one librarian covers my table with a felt cloth while another descends by elevator to the bomb-, fire-, and dust-proof vault 12 feet below the ground in the nearby courtyard corner. He returns and lays carefully on that felt cover two separate sections of the Exultet, each encased vertically between two 3- by 1-foot sheets of heavy clear plastic screwed tightly together at top and bottom.

In the separated Spearing Down image of this Split Anastasis (Fig. 9.4a), Christ, cross-haloed within a mandorla, is accompanied by two angels (recall Fig. 9.2). There are two beastlike figures—a manacled Satan in front and Hades behind him—encased in the flames of Hell. With his left hand, Christ holds a long lance at the throat of Satan, and with his right he rebukes him with a teaching gesture. The gates of Hades become Hell are above the heads of the two demons/monsters.

Next, in the separated Leading Out of this Split Anastasis (Fig. 9.4b), Christ is again cross-haloed within a mandorla—but now his wounds are clearly visible. His cross is also quite

* Kelly, *The Exultet in Southern Italy*, 251.

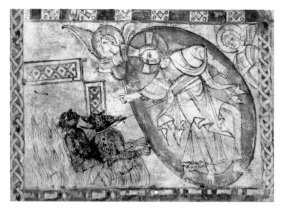

Figure 9.4a

(allowed along with paper and pencil) to compare them with the photos we took of the Salerno Exultet in 2014. The close similarities are immediately obvious: for the Trampling/Spearing Down images, compare Figures 9.3a and 9.4a; and for the Leading Out images, compare Figures 9.3b and 9.4b. As Kelly's *The Exultet in Southern Italy* suggests, the Vatican and Salerno examples share a common subtradition.

<p style="text-align:center">✠ ✠ ✠</p>

different as he leads Adam and Eve out to viewer right. There are no narrow gates, but other paired figures peer from their sepulchers at top left. Note especially that here again Hades has become Hell with strong fiery flames.

With both parts of the Vatican Exultet's Split Anastasis in front of me, I open my computer

The existence of this Split Anastasis subtradition is confirmed for us the next day when both of us are allowed to study together another example of it in the Casanatense Library.

Halfway between the Pantheon and the Corso, beside the Church of St. Ignatius Loyola, down the narrow Via di Sant'Ignazio, is an elegant gem of a library. Founded around 1700 by Cardinal Girolamo Casanata—hence its name—it passed first to the Dominican order and then to the Italian government. It holds about six thousand manuscripts, and our 10:00 appointment this morning is to see one of them, a twelfth-century example in this same subtradition of the Split Anastasis (Casanatense Ms 724.3).

We stop at the secretariat to have our data recorded on individual key cards—but without photos. The vice-director, Dr. Isabella Ceccopieri, brings us into the manuscript reading room—two stories high around a central well containing a single very large table with heavy book rests on top and six chairs on either side. The full Exultet is brought to us in a 3- by 1-foot

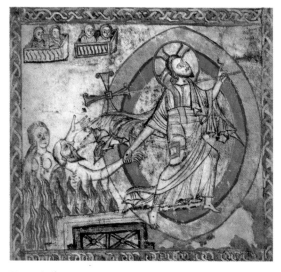

Figure 9.4b

horizontal binder with separated sections of the manuscript attached to its pages and tissue paper between each.

The Spearing Down image (Fig. 9.5a) shows Christ at viewer right, cross-haloed, without mandorla, and accompanied by two angels. With two hands, he plunges a long lance into the mouth of a bestial, engorged, and manacled figure. This is more a Hades than a Satan persona, and although he is manacled, there are no visible flames of Hell. Gates, locks, and bolts are strewn inside Hades (place).

In the other half of the Split Anastasis (Fig. 9.5b), we expect either Raising Up or Leading Out. It was the latter option in both the Vatican and Salerno Exultets, but it is mostly the former in Casanatense 3. Christ is cross-haloed and without mandorla; his left hand holds a heavy cross while his right grasps Adam's wrist. Eve is behind Adam, and below them are gates, locks, and bolts. But heavy flames depict their exit not from Hades, but from Hell (Fig. 9.5b: compare Figs. 9.3b, 9.4b).

✠ ✠ ✠

At this point we have within the Exultet tradition this Split Anastasis as a connected subset that extends from that Vatican Exultet in the tenth century, through the Casanatense Exultet in the twelfth century, to the Salerno Exultet in the thirteenth century. This subtradition creates major innovations within—and even against—the standard iconography of the traditional universal resurrection tradition.

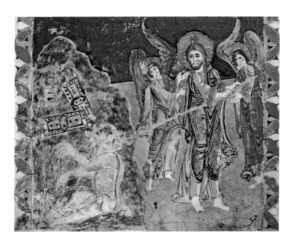

Figure 9.5a

The first and most basic innovation is the Split Anastasis itself. In the previous Anastasis tradition the Trampling Down of the persona Hades and the Raising Up or Leading Out from the place Hades form a single composite image.

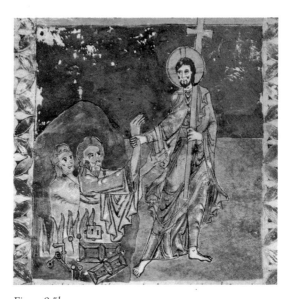

Figure 9.5b

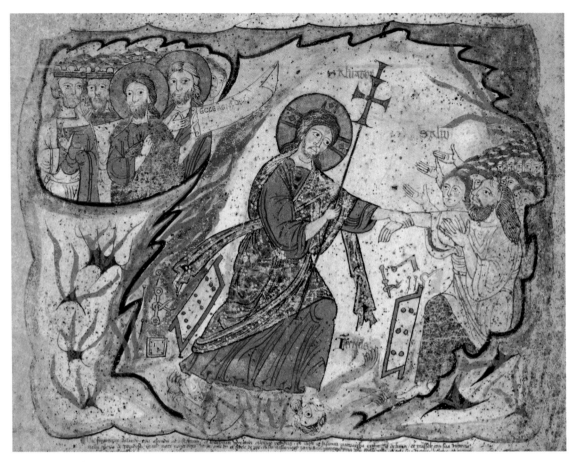

Figure 9.6

In this new subset, that single image is split into two—but their original unity is still indicated by having both in the same scroll each time. We never find that Trampling/Spearing Down there without either a Raising Up or Leading Out.

The second innovation is that Hades is now Hell, with all other changes consequent on this development, including the fact that Satan accompanies or replaces the Hades persona. Furthermore, Hades as Hell appears not only on the separated image of Spearing Down (Figs. 9.3a, 9.4a), but also on its accompanying image of Leading Out (Figs. 9.3b, 9.4b) or Raising Up (Fig. 9.5b).

The third innovation is that the figures of two angels replace the figures of Adam and Eve in the Spearing Down scenes (Figs. 9.3a, 9.4a, 9.5a).

The fourth innovation concerns Christ's weapon in this new Spearing Down image. Already in the fourth century, hymns sang of

Christ's cross piercing the Hades persona in the throat or stomach to release the dead from this great and ancient people-eater. But, in these new images, there is neither cross nor cross-topped spear, but only a long spear. Violence done *to* Jesus through the cross becomes violence done *by* Jesus through the spear.

Finally, in the general Exultet tradition, even outside these Split Anastasis examples, the standard traditional Anastasis with both Trampling Down and either Raising Up or Leading Out often depicts Hades as Hell.

Here is one representative example (Fig. 9.6) of Hades as Hell, from another Exultet in the Vatican Library (Barb. lat. 592, folio 2r). The image is quite traditional except for two aspects. A minor one is those Latin words: *Salvator* ("Savior") over Christ; *Salus* ("Salvation") over Adam, Eve, and the others; *Infernus* ("Hell") over Hades as Satan; and *Ecce Agnus Dei* ("Behold the Lamb of God") on the banner of John the Baptist (left top). The major aspect, of course, is that the whole scene is filled and even framed by the fiery flames of Hell.

✠ ✠ ✠

Where are we now, and what comes next? We have seen only five Easter Vigil Exultet scrolls so far (Chapter 9), and this limited database needs far fuller expansion before any final conclusions are possible on our basic question about it as the matrix for Easter's divided destiny between Western *and* Eastern Christianity (Chapter 10). Still, even at this point we recognize two par-

adigm shifts within the universal resurrection tradition in those five Exultet scrolls.

First, we see a general tendency to replace the place Hades with Hell and the Hades persona with Satan—watch those flickering flames! Second, we see a specific Split Anastasis subtradition that separates the Trampling/Spearing Down (Christ with Hades and Satan) from either Raising Up or Leading Out (Christ with Adam and Eve). Also, of course, Christ's spear, but never his foot, touches Hades as Satan.

Here, then, is a provisional conclusion for confirmation in the next chapter. In this Exultet tradition we are watching the crucial moment when Western Christianity begins to establish Christ's individual resurrection rather than Christ's universal resurrection as its official future Easter image.

As we shall see in this next chapter, earlier but isolated Western examples may prepare for this moment, but it is only across the full Exultet tradition that we can actually watch it happen—over three quite deliberate and definitive stages.

We know by the end of May 2015 that we need a far larger database of the Exultet tradition within the Easter Vigil liturgy in order to test that proposal. The question is how exactly to do that, because those Exultet scrolls, apart from two in England and one in France, are preserved all over Italy from Pisa to Bari. How to do that survey takes us to the next chapter—and its confirmation of the above proposal.

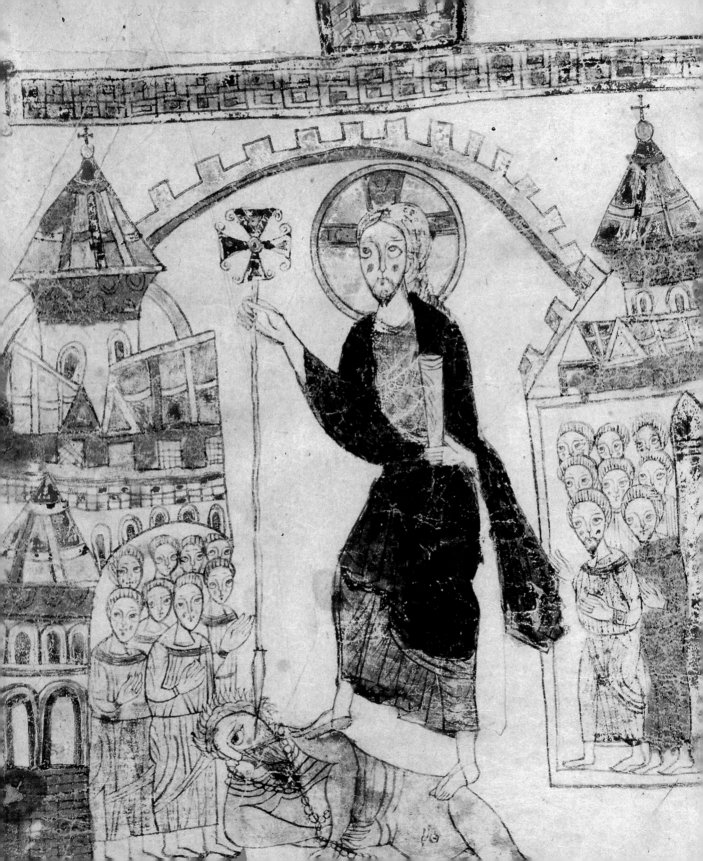

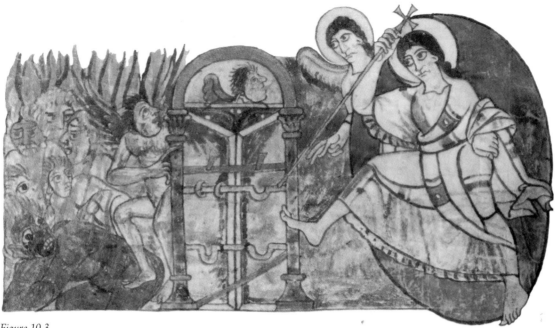

Figure 10.3

Maybe during Christianity's first millennium either the individual or universal vision, or even both in some combination, might have become normative as Easter's icon. But during the second millennium, as in Troia Exultet 3, the West opts definitively for an individual Easter, just as the East continues definitively with a universal Easter. And that answers this chapter's first question, but leaves us still with its second one.

✠ ✠ ✠

Once the individual resurrection displaces the universal resurrection as the West's official Easter image, what does it do with that universal vision itself? Traditional across Christianity since 700, it cannot now be easily erased or simply ignored within Western consciousness. The West's solution for this imagery went through first a tentative solution and then a final and definitive one.

The first solution arrived as soon as the individual resurrection tradition had a physical image of Christ emerging from his tomb (Chapter 2). Recall the Stuttgart Psalter's folio 157r from the early 800s and its inaugural image of Christ *physically* sitting up in his sarcophagus (Fig. 2.5). There is, however, another image, on folio 29v, that must be taken in tandem with it, and it is officially and accurately described by scholars as Christ's "Descent into Hell" (Fig. 10.3).

To the left of the image are the well-locked and well-barred gates of Hell. Inside all is aflame, including some winged fire-spitting demons. A monstrous Hades/Satan cowers in the bottom left corner surrounded by similar beings. Christ, within a mandorla and accompanied by an angel, strides in forcibly from the right. In his raised right hand is a long slender

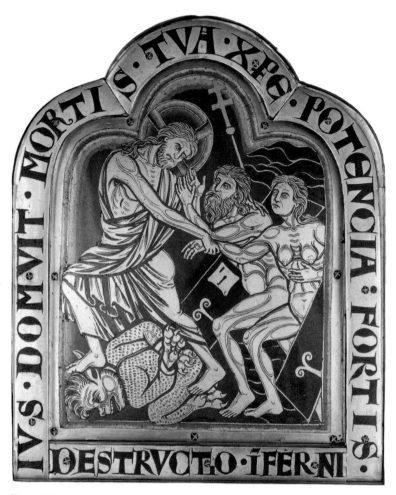

Figure 10.4

universal resurrection once its individual version moves from Christ's symbolic to his physical presence. This is but an earlier attempt at the Split Anastasis solution in the just-seen subtradition of the Exultet liturgy. It reduces the universal tradition to its Trampling Down element, omits completely any Raising Up or Leading Out of Adam and Eve, and restricts the content to a "Descent into Hell."

This does not work too well or too long, of course, because it simply cuts the traditional image of the universal resurrection in two, retaining Hades and Satan but discarding Adam and Eve. But the full traditional universal resurrection is still all over the Western world, so what to do with it?

cross—not yet a lance or spear—but he uses its butt to strike the gates.

The verse illustrated by this image is: "Lift up your heads, O gates! and be lifted up, O ancient doors! that the King of glory may come in. Who is the King of glory? The Lord, strong and mighty, the Lord, mighty in battle. Lift up your heads, O gates! and be lifted up, O ancient doors! that the King of glory may come in" (Ps. 24:7–9).

This is a first part of the answer to our question, the West's first solution for handling the

The second and better solution is much simpler, and we saw it in 2002 at the very start of our travels in the Cappadocian sunshine (Chapter 1). This accepts the full traditional universal resurrection image and simply *renames* it as the "Descent into Hell," the "Harrowing of Hell," or the "Descent into Hades/Hell/Limbo." You can call it anything, in fact, as long as you do not call it "Resurrection."

Figure 10.5

Here are two examples of this renaming process, as Individual Type 3, Emerging Resurrection, continues from the 1100s into the 1200s. For the 1100s, we return to that supremely beautiful and theologically profound 1181 altarpiece by Nicholas of Verdun in Klosterneuburg Monastery near Vienna. Recall the individual resurrection as Type 3, Emerging, which ends the middle row of the middle section (Fig. 2.7). Immediately before it—just after the burial scene—is a traditional image of the universal resurrection, but here it is entitled underneath in Latin as the "Destruction of Hell" (Fig. 10.4).

Christ stands atop a monstrous Hades/Satan figure while Adam and Eve emerge from Hades/Hell (note the flames at the upper right). Christ's left hand holds a cross and rests on Adam's shoulder (but where is Christ's left arm?), while his right arm grasps the right wrist of Eve—not of Adam. All of that is quite unique.

For the 1200s, we return to Jean de Joinville and the disenchanted knights of Louis IX's defeated Crusade (Fig. 2.8). The text of his Credo is specifically the Apostles' Creed, but in the version from the Carolingian 700s rather than the Roman 300s. That earlier version *possibly* but the later version *certainly* contains the double phrase "he descended into hell, on the third day he rose from the dead." For Jean de Joinville that double sentence becomes the single Article V of his Credo, but he separates it into two parts, each with its own image.

We already know the image he uses for "on

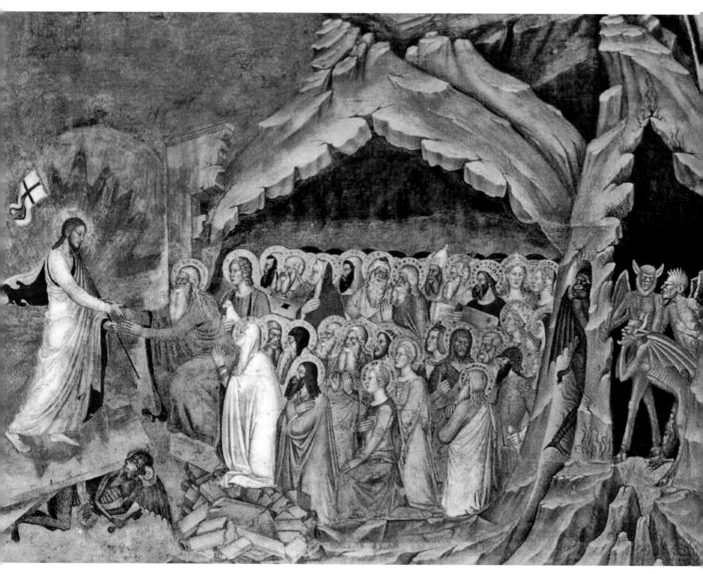

Figure 10.6

the third day he arose from the dead" (Fig. 2.8). Before that, however, he uses a very Western version of the Eastern Anastasis for the second part, "he descended into hell" (Fig. 10.5).

Hades, that monstrous people-eater is still residually present as a giant sharp-toothed jaw, but around are the fires of Hell and horned, goat-footed demons. Christ, with cruciform

halo and cross, leads out Adam—hand to wrist—followed by Eve, a monk, a soldier, and a nun.

Furthermore, the same process of doubling, separating, and renaming the East's universal vision continues into the West's Individual Type 4, Hovering Resurrection, in the 1300s. Recall the monumental image of this new Type 4 on the ceiling of the Spanish Chapel in Florence's Santa Maria Novella complex (Fig. 2.11). This Hovering Resurrection is on the ceiling's north quadrant immediately above the chapel's north wall. Above this main wall's altar niche is a huge, crowded wall-to-wall Crucifixion. To the left below it, Christ carries his cross to Calvary. To the right below it, Christ conducts a classic universal resurrection (Fig. 10.6), which is now, of course, a "Descent into Hell."

In other words, when the West's individual resurrection appears with Christ physically present in both its Type 3 and Type 4, the East's universal resurrection is serenely retained but permanently downgraded from "Ascent into Heaven for All" to "Descent into Hell for One." Anastasis and Resurrection are both present, but in this final step they are now separated into two events in the West, while in the East they always remain a single event.

This Western solution of retaining the universal resurrection tradition by renaming it the "Harrowing of Hell" or "Descent into Hades/Hell/Limbo," and thereby separating it permanently from Christ's now normative individual resurrection, continues throughout the second millennium of Christianity. This renamed separation is so successful that, even today, Western art historians, exhibition catalogues, and museum cards regularly use "Descent" or "Harrowing" for images originally, explicitly, and directly entitled "Anastasis" on the objects themselves.

Finally, there is a splendid example of this irrevocable final step present in the Exultet liturgy—not on an Exultet scroll, but on an Easter candlestick. Tall marble holders were beautifully carved as supports for the Easter candle, symbol of Christ as Light of the World. One such candlestick is preserved at Gaeta on the Tyrrhenian coast between Rome and Naples in a cathedral dedicated to the Assumption of Mary and the Martyrdom of St. Erasmus.

This monumental marble candleholder is dated around 1340. Its twelve horizontal layers, with four images each, are stacked on top of each other to form a cylinder whose four parallel columns of images are read vertically from top to bottom; two columns present life-of-Christ events and two give events from the life of Erasmus. (Erasmus/Erasmo/Elmo is the local patron saint of sailors; his name has been given to the mast-top electrical discharge known as "St. Elmo's Fire.") The twenty-four images in each two-column life sequence are read by alternating left to right, right to left, and so on, from top to bottom.[*]

[*] Nino Zchomelidse, *Art, Ritual, and Civic Identity in Medieval Southern Italy* (University Park: Pennsylvania Univ. Press, 2014), 202–24. We are very grateful to Professor Zchomelidse for so graciously giving us her own photos for Figures 10.7a, 10.7b.

Figure 10.7a

Figure 10.7b

In the life-of-Christ columns, two images of Anastasis/Resurrection appear on the fifth layer from the bottom—immediately after the Crucifixion image. On this layer, you see, first, Christ's universal resurrection, but here as the West's "Descent into Hell" (Fig. 10.7a), and then, second, Christ's individual resurrection as a Type 3, Emerging image (Fig. 10.7b).

✠ ✠ ✠

Where are we now, and what comes next? The contest or conflict between the individual and universal resurrection traditions comes to a climax in the iconography of southern Italy's illustrated Exultet scrolls between 950 and 1350. It is there we see most clearly the definitive moment when the West irrevocably chose the individual over the universal model as its Easter vision.

We can visualize that decisive Resurrection moment within the Exultet liturgy through these four representative developments:

1. The universal resurrection tradition is still used, but the place Hades becomes Hell and its Hades persona becomes Satan or at least both appear together (Fig. 9.6).

2. The universal vision splits into two images, so that the Trampling/Spearing Down is separated from either Raising Up or Leading Out—tentatively (Figs. 10.1ab), but then completely (Figs. 9.3ab, 9.4ab, 9.5ab).

3. The universal resurrection is not depicted, and the individual vision takes over as Easter's image (Fig. 10.2a–c).

4. The universal resurrection is depicted, but only as the "Descent into Hell" before the

individual resurrection itself (Figs. 10.3 and 2.5; 10.4 and 2.7; 10.5 and 2.8; 10.6 and 2.11; 10.7a and 10.7b).

Still and always, however, Western Christianity retains the universal resurrection tradition, but only as the "Harrowing of Hell" or "Descent into Hades/Hell/Limbo"—as anything, in fact, but not "Resurrection."

What happens to the universal resurrection tradition in Eastern Christianity during that same fateful period? The East develops major new Anastasis types beside the two inaugural ones already well known in this book (Chapter 6). But all such developments maintain or even intensify its universal emphasis, especially with the ascendancy of Eve to iconographic equality with Adam—as we see in the next chapter.

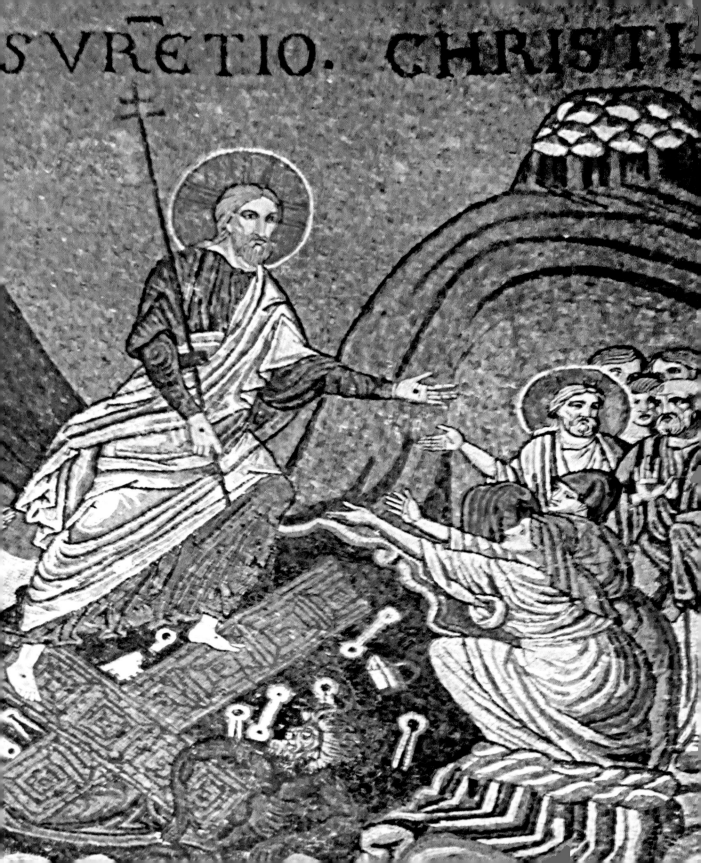

SVRĒTIO. CHRISTI

11

"O Dwellers in the Dust, Awake and Sing for Joy!"

*[In the Anastasis] those who had died ran toward me [Christ];
and they cried out and said, "Son of God, have pity on us. And
deal with us according to your kindness, and bring us out from
the bonds of darkness. And open for us the door by which we may
come out to you; for we perceive that our death does not touch
you. May we also be saved with you, because you are our Savior."
Then I heard their voice, and placed their faith in my heart.*

Syriac *Odes of Solomon* 24.15–20 (ca. 100)

THERE ARE, as you already know, two archetypal models of the universal resurrection tradition, and we have seen them repeatedly throughout this book:

Universal Type 1, Trampling Down and Raising Up, from around 700 onward (Figs. 1.5, 1.6, 1.8; 3.9; 4.3, 4.6; 5.6–9, 5.11; 6.2; 7.7–9; 8.10; 9.2, 9.6; 10.1b, 10.4, 10.6, 10.7a).

Universal Type 2, Trampling Down and Leading Out, from around 800 onward (Figs. 1.3; 6.7, 6.9; 7.6; 9.3b, 9.4b, 9.5b; 10.5).

Sometimes Raising Up and Leading Out are combined, so that Christ seems to move in two directions: toward Adam and Eve with his upper body for Raising Up and away from Adam and Eve with his lower body—watch his

feet—for Leading Out (Figs. 7.6; 9.5b).

In those two types, the Trampling Down may be atop a prostrated or chained Hades-persona and/or on the flattened gates of Hades-place, with shattered bolts and bars all around. The Trampling Down of death may even be completely omitted, but it is always understood as the negative side of the positive Raising Up or Leading Out. All other types are but variations on those two primordial types.

We turn next to Universal Type 3. In the standard Universal Types 1 and 2, Jesus usually looks at what he is doing or where he is going, so that his face is usually in profile to the viewer. But in Universal Type 3, Trampling Down, Raising Up/Leading Out, and Facing Viewer, he looks straight out quite deliberately at you, the viewer. His look announces that, here and now, *you too* are a member of humanity, a descendant of Adam and Eve, a participant in the universal resurrection. This new type is important for emphasizing such ongoing participation. Anastasis is about Adam and Eve, but not as actors only in the past. They represent all humanity—past, present, and future. You, the viewer, here and now in whatever time and place you are in, are always and ever personally included.

Here are two examples of the Universal Type 3 based on those two archetypal options of either Raising Up or Leading Out, each of which involves a mini adventure in "Seek and you shall find." The first example is Universal Type 3a, Trampling Down, Raising Up, and Facing Viewer, and this is our story about finding it.

⬧ ⬧ ⬧

As the Tigris River begins its southward flow from the mountains of eastern Turkey to the waters of the Persian Gulf, it detours straight eastward around the top of a plateau called Tur Abdin, the "Mountain of the Servants (of God)." For over one and a half millennia this is the ancient heartland of Syriac Orthodox Christianity, caught there between past and present, Kurds and Turks, despair and hope.

On Saturday, May 22, 1909, Gertrude Bell, surveying Tur Abdin architecturally, archaeologically, culturally, and politically, recorded in her *Travel Diary* that the Church at Hah (Arabic al-'Adra for her) was "occupied by a monk, a novice and a nun. The latter begged me to give them arms as a little time ago the Moslems came and said that order had been given that all Xians [Christians] were to be killed." Her 1911 book *Amurath to Amurath* calls that church, "the jewel of Tur Abdin" and gives much fuller details on her adventures there.*

What catches our attention in the archived photos from her visit to Hah is the Universal Type 3a image on the silver cover of the church's Gospel Lectionary. The church is certainly an architectural gem, but also very hot in the summer, so a permanent stone lectern holds the

* Gertrude Bell, *Amurath to Amurath* (William Heinemann: London, 1911), 319–22. Her book *Amurath to Amurath* (titles not places) is available from Project Gutenberg as its Release #52495. The Gertrude Bell Archive at Newcastle University, UK, contains a fascinating collection of her diaries, letters, and photographs; her Hah/Adra photographs are archived in Album M 1909 as M214–M239.

Gospel Lectionary facing the congregation for outdoor services. Other photos show the Gospel book off its lectern and held by the nun or the priest.* One hundred years later, accordingly, we follow Gertrude Bell to Tur Abdin.

On the morning of Thursday, June 3, 2010, we travel fifty-six miles across Syriac Christianity's sacred plateau from Mardin through Midyat to Qartmin, where Mor Gabriel, founded in 397, is one of the very few still functioning monasteries from that early period. We have an appointment at 10:00 A.M. with the archbishop of Tur Abdin, Metropolitan Timotheos Samuel Aktaş. White-bearded and robed in black cassock with crimson buttons, piping, and sash, he greets us in the formal reception room.

After introductory conversation—("How is Syriac Tur Abdin?" we ask. "It is up to Secretary Clinton," he responds.)—we explain our plans and request his permission to visit the Church of the Mother of God at Hah and photograph the Anastasis on the cover of its silver Gospel Lectionary. (We have Bell's photos of it on our computers.) All is graciously granted, along with the name and address of the village mukhtar at Hah. (We attend noon services with the monks and nuns in the monastic church and, in their frequent prayer prostrations, recognize how earlier Syriac liturgy flowed into later Muslim practice.)

By early afternoon, we are in another formal reception room, greeted again with the same

Syriac courtesy, generosity, and hospitality. The very large and very heavy Gospel Lectionary is ready for us on a desk, and we are allowed to open it, photograph it, and then focus on the cover (Fig. 11.1a). We are even invited to carry it outside to the stone lectern and hold it there ourselves as a deliberate reenactment of Gertrude Bell's century-old photographs.

The Anastasis image is in the center of a silver plate filled with delicate floral repoussé work in very low relief (Fig. 11.1b). The image itself is unique to our experience—it is a folk-art combination of standard Anastasis themes.

Christ's right hand carries a cross-topped spear, and although the gates of Hades/Hell are in cruciform pattern beneath his feet, he

Figure 11.1a

Figure 11.1b

Before we leave, we hear the story about the Twelve Magi who encamped at Hah and sent three onward to Bethlehem (Matt. 2:1). They return with the Child's swaddling clothes (Luke 2:7, 12), burn them, and divide the ashes, but find them morphed into twelve gold medallions. Next, our host graciously opens a shop across the street, and we have Magnums for lunch. But the most hopeful sight is five Syriac children standing in the gateway of the monastery.

Finally, what about date? The inscribed plate on the bottom of the silver cover was not yet present when Gertrude Bell photographed the book in 1909. Dr. Sebastian Brock, from the University of Oxford's Faculty of Oriental Studies, deciphered and translated the inscription for us: "From our father Mar Timotheos T'uma, Metropolitan of Tur Abdin and Beth Zabday, through the care of Monk Malke of Hah, in the year 1938 of the Christian [era]." His best guess for the image itself is the nineteenth century.

✠ ✠ ✠

The second example is Universal Type 3b, Trampling Down, Leading Out, and Facing Viewer, and this is our story about finding it. In April 2012, as you recall from the opening paragraphs of this book, we are in the Troodos Mountains of Cyprus to visit a series of frescoed churches from the twelfth to sixteenth century—for, of course, their Anastasis images. There is also one separate icon that is very special for us, because it was the image that first drew us to Cyprus.

does not stand on them. His left hand grasps Adam's wrist (and a banner?); beneath Adam is Cerberus, the hound of Hell (recall Figs. 5.8, 5.9); and behind Adam is Eve—but barely present. At top are six more risen figures, but only David and Solomon are identified by crowns.

We are struck by one feature of this Anastasis image. At Mor Gabriel, Metropolitan Aktaş, abbot and archbishop, wears the black hood with white crosses of a Syriac monk (the *eskimo*). On the silver Anastasis, so does Jesus on his halo.

We know it is in the Church of the Panagia tis Amasgou, near the village of Monagri (*Panagia* is "Mary Most Holy," but *Amasgou* is still a puzzlement).

Monagri is just off the main road south to Limassol, so, still jet-lagged that Tuesday, April 24, we decide that finding our icon is enough for this first afternoon. Our superb guidebook locates the church on the west bank of the winter river Kouris and even shows the tiny edifice fully isolated amid a somewhat vertiginous landscape.*

For a full hour, our driver, Sharon, drives us up and down unpaved roads trying to correlate the picture in the book with the reality on the ground before returning to Monagri for more precise directions. Then we get it. Our book is from 1985, but the church is completely surrounded by a new monastery for nuns built in 1991. It is, in other words, right here hidden within the courtyard of this big building we keep passing.

The complex is now a pilgrimage site, so gaining access is easy—but the icon is not in the church. We check the gift shop, buy a Greek book on the church, see a full-page reproduction of the icon, and take it to an English-speaking nun.

Here is an accurate if abbreviated summary of the conversation between Dominic and Sister No-Nonsense:

* Andreas Stylianou and Judith A. Stylianou, *The Painted Churches of Cyprus: Treasures of Byzantine Art* (London: Trigraph, for the A. G. Leventis Foundation, 1985), 238–39.

DOMINIC: Where is the icon we see in this book?

SISTER: It is in the church.

DOMINIC: No, Sister, it is not. We looked.

SISTER: Then it is not here.

DOMINIC: But, Sister, it is in this book about your church.

SISTER: Why do you want to see it?

DOMINIC: We are writing a book on the Anastasis.

SISTER: Why are you doing that?

DOMINIC: I am a biblical theologian.

SISTER: But you are a layperson.

DOMINIC: I was a monk and a priest for a long time.

SISTER: Why did you stop?

DOMINIC: [*looks at Sarah*]

SISTER: Don't blame her. That's what Adam did to Eve. It's your fault, not hers.

Recognizing defeat, we leave amid repeated assertions that there is no such icon in this convent or this church.

The following Monday, at the Byzantine Museum in Nicosia/Lefkosia, we ask Evangelia, an appropriately named curator, about the icon, showing her the reproduction in the Greek book from the church. She telephones a Byzantine expert who insists that it is in the monastery, locked in an upstairs chapel room, and that the mother superior has the key. So it was there all the time but, unfortunately, we are to return to Larnaca Airport the next day.

Still, having been with Sharon and John Ioannou every day for a week, we are now clients, guests, and friends, so the full force of local Mediterranean networking kicks in immediately. John knows the baker who delivers buns to the gift shop's snack bar at the monastery. He contacts the mother superior, and Sharon and John take us back to the Panagia tis Amasgou on our way to Larnaca Airport.

The icon "not there" on our first Tuesday on Cyprus is miraculously "there" on our last one. It stands along with other icons on a high shelf in a locked corner room on the second floor of the monastery. We are allowed to hold and photograph it (Fig. 11.2). It is well worth the wait.

Christ—note his wounds—stands atop the badly abraded cruciform gates of Hades. His left hand holds the usual processional cross. Adam and Eve are to the left; David, Solomon, and John the Baptist, to the right. All of that is quite standard, but the face of Christ is strikingly unusual. Although he is Leading Out from Hades, he looks straight out at the viewer rather than back at Adam and Eve or forward where he is going. In fact, Christ's face dominates the entire icon. This Universal Type 3b, Trampling Down, Leading Out, and Facing Viewer, dates between 1175 and 1200.

✠ ✠ ✠

Across the full Anastasis tradition Christ initially grasps Adam alone but eventually both Adam and Eve. A very surprising Universal Type 4, Trampling Down, Raising Up/Leading Out, but Not Touching is almost a counterpoint to the rest of that entire tradition. In this Type 4, Christ grasps neither Adam nor Eve, but simply holds out his wounded hands toward them, as if to say this is more than enough, this itself is Raising Up or Leading Out.

During the 1130s and 1140s in Sicilian Palermo, the Norman ruler Roger I, from the French Hauteville dynasty, built his palace chapel as an integrated combination of Latin West in the nave, Byzantine East in the sanctuary, and Saracen South on the ceiling.

Figure 11.2

Figure 11.3

Whatever one makes of his dream about this Christian-Muslim imperialism, the final mosaics in his Cappella Palatina are still breathtakingly beautiful.

We spend the first week of July 2015 among the Norman mosaics in Palermo, Cefalù, and Monreale—these abide, these three, but the greatest of these is Monreale. There, the Cathedral of Mary's Assumption, built by Roger's son William II in the 1180s, equals the Cappella Palatina in quality, but vastly surpasses it in quantity.

This magnificent basilica is oriented to the east and has shallow transepts to north and south at that eastern end. Inside the arch of the northern transept—at the far left as you enter

the church—three levels of mosaic conclude the life-of-Christ series. The top one depicts the Disrobing, Crucifixion, Deposition, Burial, and Anastasis; the middle one has the Empty Tomb, Mary Magdalene, and Emmaus (four scenes); and the bottom one shows Thomas, Lake of Galilee, Ascension, and Pentecost.

The Anastasis—at top right—is the hardest to find and even to see when found (Fig. 11.3). The Latin caption reads RESVRETIO CHRISTI, with an abbreviation sign over that second RE. The Trampling Down is quite traditional: Hades is pinned down by the narrow gates in cruciform shape with locks, bolts, and keys scattered all around. To the left is a group in which three kings are emphasized, and to the right is another group with outstretched arms.

Christ strides forcibly to the right atop those cruciform gates, his wounds clearly visible, a cross in his wounded right hand, and wearing a halo with cross. But instead of grasping any hands, his own wounded left hand simply stretches out toward the group to the right. We expect Adam and Eve as the front two figures, but instead we have here two female disciples (Matt. 28:9–10). Behind them are John the Baptist and, if that bald head is indicative, the apostle Paul. In the group at viewer left, the two royal generations of David and Solomon have morphed into three royal generations of the Magi.

We know very few examples of this Type 4, but it seems too deliberate not to be recognized as a type within the Anastasis tradition or even

as an antitype to that tradition, at least as far as any touching between divinity and humanity is allowed.

✠ ✠ ✠

For us at least, the final Universal Type 5, Trampling Down, Raising Up/Leading Out, but Grasping Both is a climax to the half-millennium development of the universal resurrection tradition from 700 to 1200. It is the belatedly appropriate ascendancy of Eve to equality with Adam as an ancestor and personification of humanity. In Type 4 Christ grasps neither Adam nor Eve, but in Type 5 he grasps both Adam and Eve. Think of it this way across the full universal tradition.

First, both Adam and Eve are usually present in Anastasis imagery. Still, although there are very few examples in which Adam appears without Eve (recall Fig. 4.3), there are certainly none where Eve appears without Adam. Next, Eve usually stands behind Adam and is somewhat obscured by him. Further, while Adam is bare-handed, Eve's hand is often covered, so that Christ could not touch her directly in any case (recall Fig. 6.2).

You may have already noticed one major outlier to the Anastasis's patriarchal prejudice in favor of Adam over Eve. In this depiction, Christ's right hand grasps the right wrist of Eve, not that of Adam. Instead, Christ's left hand holds the symbolic cross as it rests on Adam's shoulder, but his intervening left arm is not filled in (Fig. 10.4).

Finally, however, the Anastasis tradition produces a new Type 5 in which Christ grasps both Adam and Eve in an equal-opportunity version of the universal resurrection tradition. This also has two subtypes with Adam and Eve either on the same side of Christ (Type 5a) or—far more frequently—split one on either aside (Type 5b).

⋈ ⋈ ⋈

We already know one fourteenth-century example of Universal Type 5a, Trampling Down, Raising Up/Leading Out, but Grasping Both, with Adam and Eve on the same side of Christ. But as you recall, it is depicted as the Western "Harrowing of Hell" or "Descent into Hell." Most of the scene is filled with frightened demonic forces fighting against the liberation by Christ. Despite damage, repair, and some connective confusion, Christ's left hand grasps both of Eve's and his right hand grasps the right hand of Adam (Fig. 10.7a).

Be that as it may, the next example is also from the fourteenth century. It is much clearer, but, like others earlier in this chapter, is also rather difficult to access—and therefore makes a good story.

In 1945, Ivo Andrić, a Roman Catholic Bosnian living in Serbian Orthodox Belgrade, wrote his Nobel Prize–winning masterpiece, *The Bridge on the Drina*, about the Mehmed Paša Sokolović Bridge over the Drina River in the village of Višegrad on the road from Bosnian Sarajevo to Serbian Belgrade. Delicately, and even tenderly, the novel spans four hundred years of imperialism as the river separates and the bridge connects Muslims and Christians on either side, first under the Ottoman Turkish Muslims and then under the Austro-Hungarian Christians. (Welcome to the Balkans!)

On Friday, April 29, 2011, that river-and-bridge metaphor comes alive for us as the New Bridge over the Ibar River at Mitrovica in the independent ("breakaway" for Serbia) Republic of Kosovo. With Christian Serbs on the river's north bank and Muslim Albanians on its south bank, the bridge is controlled by NATO forces through lightly armed Italian *carabinieri* police and heavily armed Kosovo Force (KFOR or K4) troops.

Going south from Belgrade, we stop at a series of major Serbian monasteries built between the twelfth and fifteenth centuries—for their frescoed churches and, of course, their Anastasis images. But our Serbian Orthodox driver warns us that he cannot take his Belgrade-licensed Audi A6 safely beyond the middle of the Ibar Bridge into Kosovo. (We are already an hour south of the border crossing at Jarinje!) On schedule at 2:00 P.M., and in the precise center of the bridge, he transfers us and our luggage to an Albanian Muslim driver's van—with reverse process set for the way back to Belgrade.

In 2011, the "newborn" Kosovan capital, Priština, is a massive international construction site, and distance is no indication of time needed for travel. The next day we start with a visit to the nearby Gračanica Monastery before head-

Figure 11.4

stantinople's full-length standing image of Mary as the "Way Pointer," holding the Child with her left arm and indicating that he is the Way with her right hand. In that church, on the underside of the northern vault—one of the four supporting the central dome—is a tall narrow Anastasis (Fig. 11.4).

At bottom right two bright-winged angels chain up a dark-winged Hades/Satan with locks and keys flying around in all directions. To the left, John the Baptist addresses a group with no royal crowns; there is only a single patriarchal tiara present. The center is dominated by a very large set of cruciform gates atop which Jesus is standing. He is bending over completely to the left toward Adam, Eve, and Abel. Christ grasps the wrists of both Adam and Eve, and because both of Christ's hands are occupied, an angel carries his cross at top right.

This example of Universal Type 5a (Fig. 11.4) depicts a two-handed Trampling Down and Raising Up scene. The next image is an example of a two-handed Trampling Down and Leading Out scene. It is also the only other example of this Anastasis Type 5a that we have seen in situ, and it is a modern Easter icon.

You recall that in 2014 we spent a week among the "painted churches" in the Bucovina region of northeastern Romania (Chapter 6). Our base was Suceava, capital of the principality of Moldavia from the 1300s to the 1500s. On Friday, May 9, our first full day, we were about ten miles from town in the seventeenth-century Dragomirna Monastery. It was less than three

ing due west toward Peć. There, in the Serbian patriarchate's four-church complex, we find *our* first example of Universal Type 5a.*

The Peć Church of Mary Hodegetria, built between 1324 and 1337, is named after Con-

* The *earliest* examples of Universal Type 5a are in folios 8r (on Psalm 16:10) and 90r (on Apostles' Creed) of the Utrecht Psalter, University Library MS bibl. 484. This manuscript, dated between 816 and 823, is magnificently displayed and annotated online at http://bc.library.uu.nl/utrecht-psalter.html. Utrecht 8r is later copied into Harley Psalter 8r (1010–1025), Eadwine Psalter 1024r (1155–1160), and Anglo-Catalan Psalter 24r.

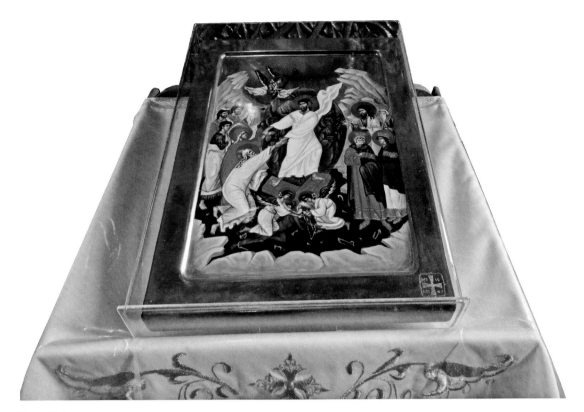

Figure 11.5

weeks after Easter and, in the monastic Church of the Descent of the Holy Spirit, the feast's icon was set for veneration in front of the iconostasis (Fig. 11.5).

The scene, save for Leading Out rather than Raising Up, is similar to the preceding Peć example of Universal Type 5a: two angels bind Hades; Adam, Eve, and Abel are to viewer left; three Magi/kings and John the Baptist are to the right; and an angel above carries Christ's cross as both of his hands are occupied.

✠ ✠ ✠

Adam and Eve finally receive equal treatment in Anastasis Type 5a, with both on the same side of Christ. But this is a somewhat awkward scenario for Christ, so it is no surprise that Type 5b, with one on either side, is much more popular. This places Christ in the center and allows a balanced image with Adam on one side and Eve on the other.

The final arrival of this Universal Type 5b may have been helped by earlier images in which Adam and Eve are often on either side, but only Adam is grasped by Christ. We know such an image from as early as the 840s and it is quite common thereafter, *but* the fact that Adam and Eve each get equal sides does not mean that each gets equal grasps (recall Fig. 7.8)—until Universal Type 5b arrives.

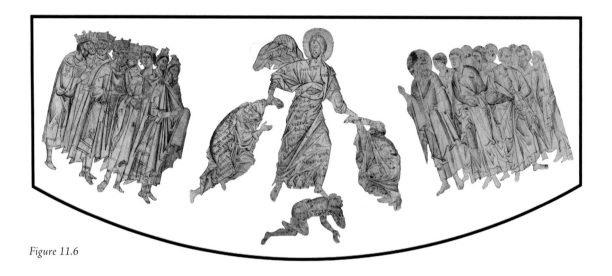

Figure 11.6

We also already know the most famous example of Universal Type 5b, Trampling Down, Raising Up/Leading Out, but Grasping Both, with Adam and Eve on opposite sides. This is in the Chora Church in Istanbul, dated between 1315 and 1321 (Fig. 1.8). There is, however, an earlier example of this Type 5b from the 1230s, but it is extant only in a copy by an artist with clear drawings but unclear intentions. We can conjecture a scenario like this.

In 1204, Enrico Dandolo, Doge of Venice, blind in more ways than one, hijacked the Fourth Crusade to destroy Christian Constantinople rather than capture Muslim Jerusalem. Byzantine treasures and traditions were then looted and carried to Venice and the West.

Sometime after that feral catastrophe, an artist stands in front of monumental life-of-Christ frescoes in some newly Byzantinized Western church. As he assembles his master book, he is apparently less interested in narrative content than in character depictions and facial expressions. Instead of copying the entire Anastasis onto a single page horizontally, he breaks it apart into thirds and places them on three separate pages. These and his other drawings were later subsumed into a larger codex and entirely overwritten textually; they are now preserved in the Herzog August Library at Wolfenbüttel in northcentral Germany (Cod. Guelf. 61.2 Aug. 8°, folios 90r, 90v, 92v).

The folios in this "Wolfenbüttel Master Book" are about 6½ by 7½ inches each, and the Anastasis is dismembered like this: the group to viewer's right is on folio 90r, the group to viewer's left with Adam below them is on folio 90v, and finally Christ, Eve, and Hades are on folio 92v. Despite this dismemberment, the artist copied exactly, and his three pages can easily be reassembled into a single scene (Fig. 11.6).

Our reassembled Anastasis is basically identical to the Chora scenario (Fig. 1.8), but is a century earlier than it. We can accordingly date the origins of Universal Type 5b to the end of the 1100s, but from then onward this equal-opportunity Anastasis becomes very popular.

✠ ✠ ✠

Earlier, when discussing the three ninth-century illustrated Psalters, we mentioned another three eleventh-century ones based on them or their models at Constantinople (Chapter 8). In all these Psalters, Eve is still in second place but, despite that inequality, we conclude this chapter with an image entitled "Anastasis" but depicting Christ as *Lord of the Resurrection Dance*. It is an identical image found in both the Barberini Psalter and the Theodore Psalter that is not present in any of the ninth-century models.

The Barberini Psalter, dated to 1095, is preserved in the Vatican Library (BAV Barb. Gr. 372), and its "Anastasis" is so entitled at top right (folio 187r). Christ, within a mandorla, holds a scroll in his left hand and grasps Adam's wrist with his right hand. Then, in this unique depiction, Adam grasps Eve, and Eve grasps Abel in an ascending dance. Notice that of those three only Adam has a halo (Fig. 11.7).

The three figures arise from three individual lidded sarcophagi. Adam is completely free, and his sarcophagus is far down at the bottom. Eve is almost out of hers, and Abel is only beginning to exit his. There is, however, a fourth lid-

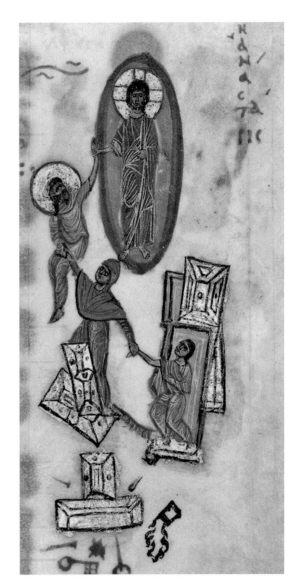

Figure 11.7

ded but opened sarcophagus behind Abel's as if to say *Christ is the dance, and the dance goes on.*

The Theodore Psalter, dated to 1066, is preserved in the British Library (Add. Ms. 19352),

and its Resurrection "dance" is also named "Anastasis" (folio 146r). The image is identical to the one in the Barberini Psalter save that here Adam lacks a halo. Both images are connected by markers to the same psalm verse.

At the top left in Figure 11.7, for example, that wavy line points to these verses: "Let them thank the Lord for his steadfast love, for his wonderful works to humankind. For he shatters the doors of bronze, and cuts in two the bars of iron" (Ps. 107:15–16). The psalm celebrates the deliverance of humanity, indeed of sinful humanity (107:11), and the image depicts it as a dance.

✠ ✠ ✠

Where are we now, and what comes next? We began this project at the start of the third Christian millennium (Chapter 1). We recognized immediately that the individual resurrection tradition (Chapter 2) and the universal resurrection tradition (Chapter 11) diverge as the official and normative Easter visions of, respectively, Western and Eastern Christianity. That is set by the second Christian millennium, but what about the first?

Christ's individual resurrection imagery arrives by 400 and, granted the necessary development of his physical presence, this could easily become Christianity's common Easter image. Christ's universal resurrection imagery arrives by 700 and, alternatively, it could become the common Christian icon for Easter. It already has Christ physically present over a century

before the individual resurrection does so.

It is already striking that the first examples of the universal imagery are from the West (Chapters 4 and 5) and the first examples of the individual imagery, with Christ physically emerging, that is, moving with half his body still in and half already out of the tomb, appear in the East (Chapter 8).

In that first millennium, it is possible to imagine that either the individual or the universal model becomes the standard common image for all of Christianity. It is also possible to imagine a special double model for Easter as Christianity's climactic moment. The Resurrection could involve both Christ's universal liberation of humanity to Heaven *and* his individual revelation to the disciples on Earth.

All such possibilities are eventually precluded not by theological or iconographic considerations, but by social and political reasons—by the West's destruction of Constantinople on April 13, 1204, during the Fourth (Pseudo-) Crusade. At Easter of 2004, however, the pope of Rome, John Paul II, and the patriarch of Constantinople, Bartholomew I, reconciled in "the spirit of reconciliation of the resurrection." But, of course, their respective Easter images are not yet reconciled and, indeed, even their disagreement goes far too often unrecognized.

Still, all we have seen in this book so far raises two crucial questions, an important one for our next chapter and an even more important one for the last chapter. Here, first, is the question for our next chapter.

Granted the divergence between West and East over Easter's theology and imagery, why is that of any great importance? Is it not simply another and more localized example of Rudyard Kipling's lines, overquoted since 1889, that "East is East and West is West, and never the twain shall meet, / Till Earth and Sky stand presently at God's great Judgment Seat"? Is this maybe an ordinary regional difference, no more significant than Latin for the West and Greek for the East?

The importance becomes clear if we rephrase the questions. Is the individual resurrection tradition *or* the universal resurrection tradition in greater continuity and closer conformity with the vision of Easter in the New Testament? What do those first Christian Jews imagine with that term "Resurrection"? What, for example, does Paul imagine when he refers to Christ's "Resurrection" in his letters? What has the West lost and the East kept of Christianity's original Easter vision?

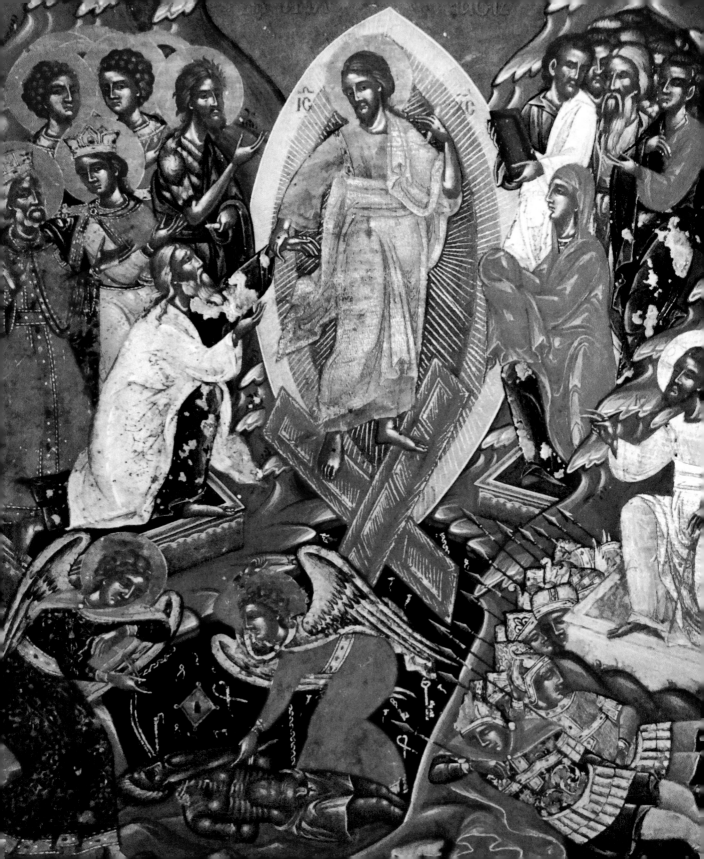

12

"Declared Son of God with Power by the Resurrection of the Dead Ones"

*They declared Augustus immortal, and Livia bestowed a million
sesterces upon a certain Numerius Atticus, a senator and ex-praetor,
because he swore that he had seen Augustus ascending to heaven after
the manner of which tradition tells concerning Proculus and Romulus.*

CASSIUS DIO, *Roman History*, 56.46.1–2 (CA. 200)

IMAGINE THAT you are a learned Jewish sage at the end of the first century, and you happen across the story of the Empty Tomb in Mark 16:1–8, whether from Christian Jewish apologetics or non-Christian Jewish polemics. The question is not whether you believe its content, but how you understand its claim. Within your own specific Jewish tradition and within the general Greco-Roman culture, what does this narrative mean, intend, propose?

You know that God can exalt extremely holy individuals to life in Heaven, despite your tradition's official absence of claims for an afterlife, which is seen as pure pagan impertinence. You know at least three such cases of heavenly exaltation from your own Jewish tradition.

One example is Enoch, who "walked with God; then he was no more, because God took him" (Gen. 5:24). There is only a little more detail added in the first century in a book variously entitled the *Book of Secrets*, *2 Enoch*, or *Slavonic Enoch*:

When Enoch had talked to the people, the Lord sent out darkness onto the earth, and there was darkness, and it covered those men standing with Enoch, and they took Enoch up onto the highest heaven, where the Lord [is]; and he received him and placed him before his face, and the darkness went off from the earth, and light came again. (67:1)

Enoch disappears during darkness. This is surely the bare minimum of information: no corpse, no tomb, no vision.

Another example, Elijah, is similar but with more dramatic detail. Elijah "ascended in a whirlwind into heaven" as witnessed by his disciple Elisha (2 Kings 2:11). In this case, there is a search for Elijah, but he is not found anywhere (2:16–18).

The final example has the most detail of all three stories. Those previous cases concerned heavenly departure without any earthly burial. The case of Moses occurs in some tension with—or maybe even after—death and burial.

In the biblical account, Moses "died there in the land of Moab, at the Lord's command. He was buried in a valley in the land of Moab, opposite Beth-peor, but no one knows his burial place to this day" (Deut. 34:5–6). Biblical commentators could not ignore the explicit "died" and "was buried," but they could still wonder why "no one knows his burial place to this day." That mention of an unknown tomb indicates something mysterious, and in the first century it is inter-

preted as ascension by both the Jewish historian Josephus and the Jewish philosopher Philo.

In his *Jewish Antiquities*, Josephus admits that Moses "has written of himself in the sacred books that he died, for fear lest they should venture to say that by reason of his surpassing virtue he had gone back to the Deity" (4.326b). But he also records that, instead of death and burial, "a cloud suddenly descended upon Moses and he disappeared in a ravine" (4.326a), so that some people claimed he "had been taken back to the Divinity" (3.97).

In his *Life of Moses*, Philo has the same ambivalence in his account of what happened when Moses "was about to depart from hence to Heaven, to take up his abode there, and leaving this mortal life to become immortal, having been summoned by the Father" (2.288). Just before his Ascension,

when he was now on the point of being taken away, and was standing at the very starting place, as it were, that he might fly away and complete his journey to heaven, he was once more inspired and filled with the Holy Spirit, and while still alive, he prophesied admirably what should happen to himself after his death, relating, that is, how he had died when he was not as yet dead, and how he was buried without any one being present so as to know of his tomb, because in fact he was entombed not by mortal hands, but by immortal powers, so that he was not placed in the tomb of

his forefathers, having met with particular grace which no man ever saw. (2.291)

As a learned Jewish sage, you would approach the Resurrection with these stories from Hebrew tradition in mind. You would recognize that Mark 16:1–8 intends to surpass those sainted predecessors by escalating from "no tomb" for Enoch and Elijah, to "unknown tomb" for Moses, to "empty tomb" for Jesus. As a learned Jewish sage, you reject emphatically the claim that, with Jesus, someone greater than Moses is here. But to reject, of course, you must first understand the point of an empty-tomb story.

Furthermore, you also recognize the meaning—and claim—of Mark 16:1–8 from the wider Greco-Roman narrative world. You know the historical romance "Chaereas and Callirhoe," set in Sicilian Syracuse around 400 BCE, but written by Chariton of Aphrodisias in the mid-first century CE, in which Chaereas, who was tricked into thinking his wife, Callirhoe, was unfaithful, killed her in a fit of rage. After she was buried, Chaereas,

sat up waiting for the dawn and when it came went to the tomb . . . found the door stone moved and the entrance clearly visible. . . . One of the bystanders said, "The grave gifts have been stolen; it is the work of tomb robbers. But where is the corpse?" . . . Chaereas, however, looked up to the heavens and raised his hands, cry-

ing, "Which of the gods hates me so much that he has taken Callirhoe from me? . . . Nor did I realize that I had a goddess as a wife who was more sublime than we mere mortals." (3.3)

You also know, of course, that as the plot unfolds Callirhoe was originally not dead, but only comatose, and was abducted from her tomb by grave robbers. With such a story in mind, you might presume a similar fate for Jesus. Whether he was dead or comatose, his disciples must have taken his body from the tomb—hence its emptiness.

But, despite emphatic disbelief, as a Jewish sage you understand fully that the empty-tomb story in Mark 16:1–8 *claims* that Jesus has ascended to God in Heaven, and since empty tomb surpasses unknown tomb, the hero/founder of Judaism is surpassed by the hero/founder of Christianity.

✠ ✠ ✠

Imagine next that you are a Roman philosopher rather than a Jewish sage, and you happen—most unlikely, we admit—to read Matthew 28:1–20. Once again, disbelief and even ridicule are immediate, but both reactions presume comprehension. You recognize that Matthew's three motifs of *mystery*, *vision*, and *mandate* about Jesus's departure from Earth to Heaven track all too exactly with the same traditional story about Romulus (Plutarch, *Life of Romulus*, 27–28).

First, there is the *mystery* about the disap-

pearance of both Jesus and Romulus. For Jesus it is that empty-tomb story (Matt. 28:1–8). Romulus simply "disappeared suddenly, and no portion of his clothing remained to be seen . . . since he had been caught up to heaven, and was to be a benevolent God for them instead of a good king" (27.4).

Next, disappearance leads to reappearance, as the mystery is explained and confirmed by a *vision*. Two female disciples have a vision of Jesus fully alive (Matt. 28:8–10). So also with Romulus. Julius Proculus, "a man of noblest birth, and of the most reputable character, a trusted and intimate friend also of Romulus" swears solemnly in the Forum that, "as he was traveling on the road, he had seen Romulus coming to meet him, fair and stately to the eye as never before, and arrayed in bright and shining armor" (28.1).

Finally, Jesus meets the eleven male disciples in Galilee and gives them their *mandate* for the world and reassurance of his continued presence in it (Matt. 28:11–20). Proclus also carries a mandate and promise from Romulus: "Tell the Romans that if they practice self-restraint, and add to it valor, they will reach the utmost heights of human power. And I will be your propitious deity [named] Quirinus" (28.2).

In summary, both Jewish covenantal tradition and Roman imperial tradition would recognize easily—even if reject completely—the claims made in Mark 16 and Matthew 28. Jesus, as hero/founder of the Christian sect, was assumed into Heaven as greater than Moses, hero/

founder of the Jewish religion, and Romulus, hero/founder of the Roman Empire. Greater too than Caesar Augustus, mentioned in this chapter's epigraph.

The common matrix for all such cases is that, one way or another, a heroic individual *disappears mysteriously* from Earth and *reappears recognizably* from Heaven. In the Jewish tradition it is about heroic sanctity; in the Roman tradition it is about heroic military power.

✠ ✠ ✠

Granted that general matrix for unique individuals undergoing transcendental disappearance-and-reappearance patterns in both Jewish and Greco-Roman stories, there is one very surprising aspect about Jesus's own empty-tomb and risen-vision traditions. Non-Christian Greco-Roman readers of Matthew might wonder why what is clearly a story about Jesus's Ascension or Assumption, *apotheōsis* (in Greek) or *divinatio* (in Latin), is called his Resurrection. Why does the angel say that Jesus "has been raised" and tell the female disciples to tell the male disciples that "he has been raised from the dead" (28:6–7)? Why "resurrected" rather than "exalted," "ascended," or "assumed" into Heaven?

Non-Christian Jewish readers would have at least a better idea why Jesus's departure and return is called his Resurrection rather than his Ascension. They would notice that Jesus was not "raised" (*ēgerthē*) alone, as in Matthew 28:6–7, but that others were "raised" (*ēgerthē*) with him, as in Matthew 27:52.

Furthermore, although the resurrected Jesus appeared immediately to only two disciples in Jerusalem (Matt. 28:9–20), those resurrected sleepers "appeared to many" in Jerusalem (27:53). In Matthew, at least, the empty-tomb and risen-vision traditions are not just individual and personal for Jesus alone, but communal and corporate for Jesus and others. What would this mean for Christian Judaism as accepted faith and even for non-Christian Judaism as negated claim in that early first-century setting?

Ascension and Resurrection refer to divergent theological visions within at least pre-Christian Pharisaic Judaism, because "ascension" is for an individual—like Enoch or Moses or Elijah—but "resurrection" is for all of humanity. Put bluntly, Jewish tradition never imagines an individual "resurrection" for one, but only a universal "resurrection" for all. How does this happen, and what does it mean?

Israel's faith was in a Creator God of distributive justice—read, for example, Psalm 82—but its experience, on the Levantine coast between superpowers warring first on a north–south and then on an east–west axis, was in a world of imperial injustice and political oppression. Such cognitive dissonance between internal faith and external experience remains tolerable only through an absolute conviction that "someday" or "in days to come" or "at the end of days" God will eventually transform war's violent injustice into peace's nonviolent justice—here below upon a transformed earth. Above all else, "in those days," at this future time, God will not just

transfigure the destiny of Israel, but that of the whole earth.

This expectation of God's kingdom on earth is a vision of God's climactic, final, or eschatological rule here below (*eschaton* is Greek for "final" or "last"). It is God's Extreme Makeover: World Edition. It is God's Great Divine Cleanup of the World. It is not, of course, about the earth's destruction, but about its transformation.

In the 700s BCE, for example, the prophets Isaiah and Micah repeat almost verbatim the same visionary expectation of a universal peace "in days to come . . . for all the nations . . . many peoples" (Isa. 2:2–3; Mic. 4:1–2):

> God shall judge between the nations, and shall arbitrate for many peoples; they shall beat their swords into plowshares, and their spears into pruning hooks; nation shall not lift up sword against nation, neither shall they learn war any more. (Isa. 2:4; Mic. 4:3)

Furthermore, adds Micah, "They shall all sit under their own vines and under their own fig trees, and no one shall make them afraid" (4:4).

Then, to celebrate this world transfigured by universal peace, God will throw a cosmic banquet in Jerusalem, a universal feast "for all peoples, a feast of rich food, a feast of well-aged wines, of rich food filled with marrow, of well-aged wines strained clear." God "will destroy on this mountain the shroud that is cast over

all peoples, the sheet that is spread over all nations; God will swallow up death forever" (Isa. 25:6–7).

This eschatological dream of universal peace is an ecstatic vision for the whole earth, for "peoples," for "the inhabitants of many cities," for "many peoples and strong nations," for "nations of every language" (Zech. 8:21–23). This is, clearly, a universal vision, but it seems only about a future peaceful world. What about its past? Justice and peace sound lovely for all who will live in their future presence. But how does that help all who suffered in their past absence?

✠ ✠ ✠

A half millennium after Isaiah and Micah, this eschatological dream of paradise regained is still alive and strong, but now with those just-noted and very obvious questions added to it. If there are to be justice and peace for the future, what about justice and peace for the past? How can there be a divine feast for the universal living that excludes the universal dead? Or, as we might put it, will God not need a divine Peace and Reconciliation Commission with the entire human race, past and future, living and dead?

Furthermore, as you read through those biblical visions of earth's ultimate or eschatological renewal, they seem to imagine an instant's lightning strike of divine intervention for whose imminent advent Israel can prepare, pray, and hope—but one it does not actively initiate and in which it does not creatively participate.

Jesus's kingdom of God, however, represents a paradigm shift, tradition swerve, or disruptive innovation within this contemporary matrix. For Jesus, the kingdom is already present, but only if, when, and as humans accept it, participate in it, collaborate with it, enter into it, and take it upon themselves. It is, in other words, a process over human time and not just an instant in divine time.

Similarly, therefore, with the universal resurrection as part of God's kingdom on earth. It too is process and not just instant; it is program and not just instantaneous event. It begins with Jesus, but cannot be individual for him alone. It must be universal for all those who have died before him. Easter is not an individual "Ascension" for Jesus, but the start of the universal "Resurrection" with Jesus.

This, for example, is why Paul argues in 1 Corinthians that Christ's Resurrection and the universal resurrection stand or fall together: "If there is no resurrection of the dead (*anastasis nekrōn*), then Christ has not been raised" (15:13). Paul—as a Christian Jewish Pharisee—could never isolate Christ's Resurrection as a special, individual privilege for him alone. That would be an "Ascension." Christ's "Resurrection" is something far, far greater than that. It is the Resurrection of all humanity in, with, by, and through Christ.

Again, therefore, in the correct translation of Romans 1:4, Paul declares that Christ "was declared to be the Son of God with power . . . by the resurrection of the dead ones (*anastasis nekrōn*)." Paul does not say "by his resurrection

from among the dead ones" or "by his resurrection from death" or, most simply, "by his resurrection." He repeats that Greek phrase "resurrection of the dead ones" in 1 Corinthians 15:12, 13, 21, 42. Paul is describing a universal rather than an individual resurrection of Christ.

In answer to this chapter's question, therefore, the Eastern image of Christ's universal resurrection is in closer conformity to and continuity with the original Christian-Jewish meaning of "Resurrection" than is the Western—contradictory—image of Jesus's individual resurrection.

<center>✠ ✠ ✠</center>

Where are we now, and what comes next? As we already know (Prologue) and have just seen here in more detail, the indirect tradition of Christ's Resurrection appears in both the empty-tomb and risen-vision traditions. Taken together as mysterious disappearance to Heaven and attested reappearance on Earth, they are immediately recognizable as standard wonders within Jewish and Roman cultural possibilities.

Still, granted that cultural matrix, there is one striking anomaly about calling Christ's

vindication not just exaltation, assumption, *apotheōsis*, or *divinatio*, but precisely Resurrection or Anastasis. Especially in Judaism, you could have an individual "ascension," but only a universal "resurrection." That *anastasis nekrōn*, or "resurrection of the dead ones," was, especially for first-century Pharisaic Jews, the first order of business "on that day" when God would transform the world by changing violence to peace and injustice to justice.

In other words, Christ's universal resurrection tradition and its Anastasis iconography are in better continuity and closer harmony with the Christian Judaism of the New Testament than is the individual resurrection tradition and its imagery. The East retained and the West rejected the original Easter vision.

We have still to face the final and most important set of questions—in the next and final chapter. Even if Christ's universal resurrection rather than his individual resurrection is more consistent with the Gospels' inaugural vision of Easter, *what does it mean?* Further, is that meaning relevant for all of humanity or for only part of Christianity? Bluntly, how does Anastasis impact human evolution?

ΛΑΓΟΣ ΓΕΩΡΓΙΟΣ ΚΩΝ. ● >>	3
ΜΑΛΑΜΟΣ ΣΠΥΡΙΛΩΝ ΑΝΑΣΤ. >>	6
ΜΑΛΑΜΟΥ ΛΟΥΚΙΑ ΣΠΥΡ. >>	
ΜΑΛΑΜΟΥ ΔΗΜΗΤΡΑ ΑΝΑΣΤ. >>	3
ΜΑΛΑΜΟΣ ΙΩΑΝΝΗΣ ΑΝΑΣΤ. >>	
ΜΑΡΙΟΣ ΠΑΝΑΓΙΩΤΗΣ ΔΗΜΟΥ >>	6
ΜΑΡΙΟΥ ΠΑΝΩΡΑΙΑ ΔΗΜ. >>	4
ΜΑΣΤΟΓΙΑΝΝΗΣ ΝΙΚΟΛ. ΛΟΥΚ. >>	
ΜΑΣΤΟΓΙΑΝΝΗ ΕΛΙΣΑΒ. ΛΟΥΚ. >>	2
ΜΙΧΑΣ ΓΕΩΡΓΙΟΣ ΝΙΚΟΛ. >>	6
ΜΙΧΑΣ ΗΡΑΚΛΗΣ ΙΩ. >>	6
ΜΠΑΛΑΓΟΥΡΑΣ ΝΙΚΟΛΑΟΣ ΙΩ. >>	4
ΜΠΑΛΑΓΟΥΡΑ ΘΕΟΧΟΥ ΠΑΝ. >>	
ΜΠΑΜΠΑΝΟΠΟΥΛΟΥ ΧΡΥΣ. Β. >>	4
ΜΠΑΜΠΑΝΟΠΟΥΛΟΥ ΣΟΦ. Β. >>	
ΜΠΑΡΛΟΥ ΤΑΣΙΑ ΧΡΙΣΤΟΦ. >>	4
ΜΠΑΡΛΟΥ ● ΛΟΥΚΙΑ ΠΑΝ. >>	2
ΜΠΑΡΛΟΥ ΤΑΣΟΥΛΑ ΠΑΝ. >>	
ΜΠΑΡΛΟΥ ΑΒΑΠΤΙΣΤΟΝ ΠΑΝ. 5 ΜΗ.	
ΜΠΑΡΛΟΥ ΕΛΕΝΗ ΛΟΥΚ. ΕΤΩΝ	
ΜΠΑΣΔΕΚΗ ΓΑΡΥΦΑΛ. ΑΝΑΣΤ. >>	3
ΜΠΑΣΔΕΚΗ ΕΛΕΝΗ ΑΝΑΣΤ. >>	
ΜΠΑΣΔΕΚΗ ΑΝΘΟΥΛΑ ΕΥΘ. >>	8

13

"So Hope for a Great Sea-Change"

History says, Don't hope
On this side of the grave.
But then, once in a lifetime
The longed-for tidal wave
Of justice can rise up
And hope and history rhyme.

SEAMUS HEANEY, *The Cure at Troy**

To PROBE THIS QUESTION of meaning as the climactic problem in our investigation of the historic East-West split in Easter vision, we begin with an experience from almost midway in our exploration. We are in Greece between May 16 and 23, 2010, a week split evenly between Athens and Thessaloniki for research on first-century Pauline sites at Corinth and Philippi as well as the eleventh-century Byzan-

tine monasteries of Daphni and Hosios Loukas. That first Sunday afternoon in Athens we learn a word not in the New Testament's ancient vocabulary: *apergia*, the Greek word for "strike" (Fig. 13.1).

We meet our driver, Kostas Memos, in the lounge of the Hilton to plan the week's schedule. "You cannot do any archaeological sites or museums on Thursday, May 20," he warns us, "because there is a nationwide strike that day. But we could do Hosios Loukas then, because the church never goes on strike."

* Seamus Heaney, *The Cure at Troy: A Version of Sophocles'* Philoctetes (New York: Noonday, 1991), 77.

On Thursday, May 20, with no trains or buses running, we crawl out of Athens on the main toll road north. In any case, it is always fascinating to drive through a landscape you know well as history—Marathon and Thebes, Delphi and Parnassos—and watch its names appear on road signs as geography. Eventually we leave the toll road and head west toward the Monastery of Blessed Luke (Hosios Loukas), a local tenth-century hermit/healer. This UNESCO World Heritage complex is a glorious site inland from the Gulf of Corinth at the northern edge of Mt. Elikonas.

The *katholikon*, or main monastic church of the complex, is oriented to the east, and among its narthex lunettes is a mosaic clearly entitled "Anastasis" in Greek; for us it is a Universal Type 3b, Trampling Down, Leading Out, and Facing Viewer (Fig. 13.2).

Christ strides forcibly to the left with a liturgical cross in his right hand. His left grasps Adam's right hand and lifts him from his sarcophagus—note his standard half-kneeling position (recall Chapter 6). Eve is standing

Figure 13.1

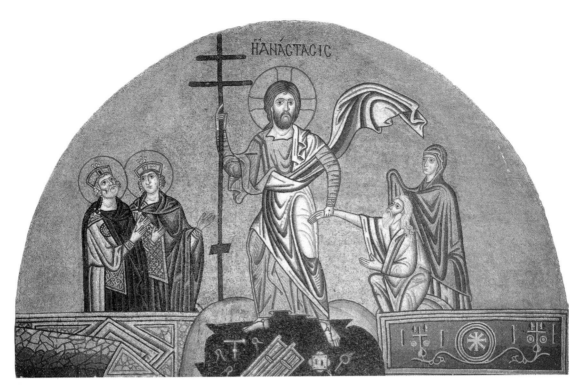

HĀNÁCTACIC

Figure 13.2

behind Adam with her extended hand covered (Chapter 11). David and Solomon balance them to viewer left. For the Trampling Down, there is no Hades figure but only the scattered locks and flattened gates of Hades (the place). Christ's wounds are quite visible.

When we get back to the car, Kostas asks a favor. "I come this way often with clients on day trips to Delphi, and I always ask them if I can make one extra stop before returning to Athens. It is my church, about ten kilometers from here." We agree immediately, and Kostas drives us to the brow of a hill from which we can see a town of about five thousand nestled serenely below us (Fig. 13.3). This is the town of Distomo, which has a tragic but not altogether unique history.

Kostas tells us the story briefly, quietly, and emotionally. Later, we fill it out for ourselves. On Saturday, June 10, 1944, in reprisal for an anti-German ambush by local partisans, the 4th Armored Police Division of the Waffen SS entered Distomo. Its commander, twenty-six-year-old Fritz Lautenbach, allowed his men three days of murderous savagery before razing the village to the ground. By June 15, Sture Linnér, Swedish head of the International Red Cross in Greece, was on site with assistance:

> In the village, the last remnants of the houses were still burning. Hundreds of dead bodies of people of all ages, from elderly to newborns, were strewn around

Figure 13.3

on the dirt. Several women were slaughtered with bayonets, their wombs torn apart and their breasts severed; others were lying strangled with their own intestines wrapped around their necks.*

Still listening to Kostas, we turn around silently, very silently, from the modern town below us to the memorial mausoleum atop the

hill (Fig. 13.4). The horizontal slab to the left has shallow reliefs of the actual massacre; that to the right has the names of all those murdered. They are arranged on eight panels, alphabetically by families and within families by age. Even without knowing Greek, the indiscriminate slaughter is obscenely clear.

We spend an hour reading and recording all the names, but here we will look at just one panel with twenty-nine names. Focus on the five individuals on lines 8 to 4 from the bottom in the family named MPARLOY (Fig. 13.5).

* Excerpt of much longer but nonpaginated translation from Sture Linnér, *Min Odysse* (Stockholm: Norstedt, 1982) online at http://www.greece.org/blogs/wwii/?page_id=211.

First, look at that fifth line up from the bottom, with its MPARLOY child of five months. The name is given as ABAPTISTON, "not yet baptized." Its gender is not clear, as the abbreviation PAN—"dedicated to Mary"—could be terminated either feminine or masculine. But even this is not the youngest murdered infant. On another panel, among the Zakka family, is a two-month-old ABAPTISTON child.

Second, all the other names in the MPARLOY family are female. LOUKIA and ELENĒ are feminine names. TASIA and TASOULA are abbreviations for ANASTASIA, another feminine name.

Our car remains very, very quiet for the two-and-a-half-hour drive back to the hotel. We started the day with the Blessed Loukos and ended it with the murdered Loukia. We started

Figure 13.4

```
ΛΙΤΣΟΥ ΑΣΗΜΩ ΙΩ.            ΕΤΩΝ  63
ΛΟΥΚΑΣ ΓΕΩΡΓΙΟΣ ΕΥΣΤ.      >>    62
ΛΟΥΚΑ ΠΑΝΩΡΑΙΑ ΓΕΩΡ.       >>    41
ΛΟΥΚΑ ΧΡΥΣΟΥΛΑ ΑΝΑΣΤ.      >>    23
ΛΟΥΚΑΣ ΙΩΑΝΝΗΣ ΑΝΑΣΤ.      >>     2
ΛΟΥΚΑ ΑΡΤΕΜΙΣΙΑ ΑΝΑΣΤ.     >>    85
ΛΑΓΟΣ ΓΕΩΡΓΙΟΣ ΚΩΝ.        >>    31
ΜΑΛΑΜΟΣ ΣΠΥΡΙΔΩΝ ΑΝΑΣΤ.    >>    67
ΜΑΛΑΜΟΥ ΛΟΥΚΙΑ ΣΠΥΡ.       >>     8
ΜΑΛΑΜΟΥ ΔΗΜΗΤΡΑ ΑΝΑΣΤ.     >>    38
ΜΑΛΑΜΟΣ ΙΩΑΝΝΗΣ ΑΝΑΣΤ.     >>     9
ΜΑΡΙΟΣ ΠΑΝΑΓΙΩΤΗΣ ΔΗΜΟΥ    >>    68
ΜΑΡΙΟΥ ΠΑΝΩΡΑΙΑ ΔΗΜ.       >>    41
ΜΑΣΤΟΓΙΑΝΝΗΣ ΝΙΚΟΛ. ΛΟΥΚ.  >>    71
ΜΑΣΤΟΓΙΑΝΝΗ ΕΛΙΣΑΒ. ΛΟΥΚ.  >>    29
ΜΙΧΑΣ ΓΕΩΡΓΙΟΣ ΝΙΚΟΛ.      >>    60
ΜΙΧΑΣ ΗΡΑΚΛΗΣ ΙΩ.          >>    66
ΜΠΑΛΑΓΟΥΡΑΣ ΝΙΚΟΛΑΟΣ ΙΩ.   >>    49
ΜΠΑΛΑΓΟΥΡΑ ΘΕΟΧΟΥ ΠΑΝ.     >>    71
ΜΠΑΜΠΑΝΟΠΟΥΛΟΥ ΧΡΥΣ. Β.    >>    46
ΜΠΑΜΠΑΝΟΠΟΥΛΟΥ ΣΟΦ. Β.     >>     6
ΜΠΑΡΛΟΥ ΤΑΣΙΑ ΧΡΙΣΤΟΦ.     >>    44
ΜΠΑΡΛΟΥ ΛΟΥΚΙΑ ΠΑΝ.        >>    29
ΜΠΑΡΛΟΥ ΤΑΣΟΥΛΑ ΠΑΝ.       >>     4
ΜΠΑΡΛΟΥ ΑΒΑΠΤΙΣΤΟΝ ΠΑΝ.  5 ΜΗΝ.
ΜΠΑΡΛΟΥ ΕΛΕΝΗ ΛΟΥΚ.        ΕΤΩΝ   9
ΜΠΑΣΔΕΚΗ ΓΑΡΥΦΑΛ. ΑΝΑΣΤ.   >>    32
ΜΠΑΣΔΕΚΗ ΕΛΕΝΗ ΑΝΑΣΤ.      >>     3
ΜΠΑΣΔΕΚΗ ΑΝΘΟΥΛΑ ΕΥΘ.      >>    80
```

Figure 13.5

with a magnificent mosaic Anastasis and ended with a murdered Tasia and Tasoula, named after it but not saved by it.

The name we give to horrors like the Distomo Massacre is *barbarism*, and we think that, even in warfare, *civilization* should protect us from such savagery. But what protects us from civilization itself? When we look at individuals and groups, nations and empires, their long and detailed histories can proclaim the accumulated wisdom of civilization's magnificent progress. But what happens when we examine civilization in a succinct account of our *species* as a whole across time and space?

✠ ✠ ✠

As *Homo sapiens*, we are the only extant humans left on earth. Our scientific name says we are of the genus *Homo* and the species *sapiens* (*sapiens* is Latin for "wise," so our name is somewhere between irony and oxymoron). Around seventy thousand years ago, our particular species left Africa, spread across the globe, and around 9,000 BCE created the first instance of the agricultural revolution.

Between the mountains that arc from the Levantine coast to the Persian Gulf and the deep desert that lies to the south is an area known as the Fertile Crescent. It was here that *Homo sapiens* first domesticated grains and animals and then settled down to irrigated farming on the alluvial floodplains of the Tigris and Euphrates. We call that process the birth of civilization, and we call Mesopotamia, the land between the rivers, the "cradle of civilization." How does civilization look, then and now?

How does it look in Genesis 4 as the best, if shortest, summary of the Neolithic or agricultural revolution described more fully by anthropologists and historians? In Genesis 4, the story of this agricultural revolution becomes the story of conflict between two primordial brothers, the farmer Cain and the shepherd Abel, as the first-born of all humanity. (In the Sumerian original, it is between two divine brothers, Enkimdu the farmer and Dumuzid the shepherd.)

Cain murders Abel, although God warns him that "sin" has arrived like a feral beast crouching outside the tent flap, but that it can and must be defeated (4:1–7). This, by the way, is the first mention of "sin" in the Bible; it is in the singular, and it involves not just fratricidal but evolutionary violence.

We can see from Genesis 4 that, as farming replaces herding, civilization begins, and so does escalatory violence. It is not imagined here as international warfare, of course, but as a desert blood feud. God warns that if anyone kills Cain, his tribe will exact "a sevenfold vengeance." God tries to avert this escalatory violence by putting "a mark on Cain, so that no one who came upon him would kill him" (4:15).

As civilization expands, weapons are developed to help protect the settled agricultural properties. Cain builds the first city (4:17), and five generations later we meet Lamech, one of whose sons "made all kinds of bronze and iron tools" (4:22). Genesis 4 gives us further evidence that violence escalates as civilization grows. "Lamech said to his wives: 'Adah and Zillah, hear my voice; you wives of Lamech, listen to what I say: I have killed a man for wounding me, a young man for striking me. If Cain is avenged sevenfold, truly Lamech seventy-sevenfold'" (4:23–24). Hitting accelerates into killing, and sevenfold spirals into seventy-sevenfold vengeance.

To summarize civilization's advent in Genesis 4: farmer kills shepherd and builds the first city, bronze and iron arrive, and violence escalates exponentially. As humans acquire settled agricultural land, they must protect it from outsiders, and they create ever better weapons to do so more effectively. That is how our species and its invention of civilization looked then. How does it look now about three thousand years later?

In *A Short History of Progress*, Ronald Wright notes: "From the first chipped stone to the first smelted iron took nearly 3 million years; from the first iron to the hydrogen bomb took only 3,000." He concludes with this prophetic challenge: "Now is our last chance to get the future right."*

Yuval Noah Harari, in *Sapiens: A Brief History of Humankind*, says: "We are on the threshold of both heaven and hell, moving nervously between the gateway of the one and the anteroom of the other. History has still not decided where we will end up, and a string of coincidences might yet send us rolling in either direction." He concludes with this rhetorical question: "Is there anything more dangerous than dissatisfied and irresponsible gods who don't know what they want?"† Both Wright and Harari emphasize the problem of escalatory violence and its time line across the history of human civilization up to and including our own time. Both wonder and warn explicitly about the future trajectory of such a record.

* Ronald Wright, *A Short History of Progress* (New York: Carroll & Graf, 2004), 14, 132.

† Yuval Noah Harari, *Sapiens: A Brief History of Humankind* (New York: HarperCollins, 2015), 375, 416.

We may, of course, dismiss all such dire warnings about the destiny of our species, as did the contemporaries of Cassandra when she warned of the fate of Troy or those of Jeremiah when he prophesied about the fall of Judah. Still it is wise (*sapiens* in Latin) to remember that both Cassandra and Jeremiah got it right.

If civilization saves us from barbarism, what will save us from civilization? If escalatory violence is civilization's drug of choice, is a redemptive intervention possible? If the normalcy of civilization is not the inevitability of human nature, what would postcivilization look like? Granted that our species can now destroy itself atomically, biologically, chemically, demographically, and ecologically—and is only up to *e* in the alphabet—*what does Anastasis offer to Evolution?*

✠ ✠ ✠

When we look at the universal resurrection tradition through our modern lens—one that takes into account our history as a species, with war and peace, strife and lull, but always with ever escalating violence available and usable, we start to see how Easter's universal vision speaks not just within Christianity, but within human evolution.

First, the conquest of death. Death is represented by a prostrate Hades persona, personification of death and keeper of its prison; by the flattened gates of the place Hades; and by locks, bolts, and bars flying off in all directions. Hades as a place is often shown below or inside a split-open mountain.

Second, the deliverance of humanity. Humanity is represented by Adam and Eve, archetypal parents of all humanity in the biblical parable of Genesis 2–3. They are not just two individuals, but our embodied species and *Homo sapiens* personified.

Third, the liberation by, with, and through Jesus. On the one hand, this Christ figure is clothed in magnificent robes, is suffused with transcendental glory (*mandorla*), and is moving forcibly with streaming garments. On the other hand, Christ has a cross-inscribed halo and stands atop the gates of Hades set in cruciform shape; his wounds are visible, and he carries a ceremonial cross. This is so important that, when both hands are occupied with Adam and Eve, an angel carries the cross for him.

In summary, this Anastasis image proclaims a historical event located in time and place, namely the execution of Jewish Jesus by Roman Pilate, as the transcendental deliverance of our species from death. How is this not sheer religious impertinence or, worse, Christian intransigence? But, once again, prior to belief or disbelief, acceptance or rejection, *what does it even mean?* Begin with the historical event of the Crucifixion to understand the meaning of this claim about universal resurrection.

At the start of the first century, Jesus's homeland is under imperial Romanization as civilization's current consummation around the Mediterranean Sea. Armed rebellions in 4 BCE and in 66–74 CE bring savage retribution from the Syria-based legions guarding Rome's

Euphrates frontier. In Jerusalem, the former revolt results in two thousand crucifixions, the latter, five hundred a day until the trees give out. But between those *armed* revolts, there are multiple large-scale examples of successfully organized *nonviolent* resistance against Roman governors and even a Roman emperor.

Next, recall Jesus's challenge of the long-awaited kingdom of God as already present in a process of divine and human collaboration over time rather than in an instant of divine intervention in time (Chapter 12). Jesus then interprets this collaborative kingdom of God as involving *nonviolent* resistance against the *violent* injustice of oppression—in this case by the forced Romanization of the Jewish homeland. On this point, trust Pilate, because he got Jesus precisely right—as follows.

Confronted with *violent resistance*, Rome executes the leader and as many of his closest companions as it can capture: "A man called Barabbas was in prison with the rebels who had committed murder during the insurrection" (Mark 15:7).

Confronted with *nonviolent resistance*, Rome executes the leader and ignores his top companions: "The authors of sedition and tumult, or those who stir up the people, shall, according to their rank, either be crucified, thrown to wild beasts, or deported to an island" (*The Opinions of Julius Paulus Addressed to His Son*, 5.22.1).

Pilate executes Jesus legally, officially, and publicly, for *resistance* against Roman law and order, but he does not round up his closest companions because his resistance is *nonviolent*. Pilate follows normal Roman procedure with an *activist* who "stirs up the people by teaching throughout all Judea, from Galilee where he began even to this place" (Luke 23:5).

✠ ✠ ✠

In the Crucifixion story, what we have is a parable against civilization. The kingdom of Rome is a typical kingdom within the normal protocols of this world and, as such, it is based on violent force and imperial coercion. It is simply the normalcy of civilization in Mediterranean place and first-century time. But the kingdom of God is an antitypical kingdom in that it does not even allow violent "fighting" to free Jesus from execution—recall John 18:26. So the Crucifixion and Resurrection story is not simply about Jesus clashing with or triumphing over Pilate, but about a hopeful option for humanity to find a way out of the violence-based civilization it has created for itself.

Imagine the trajectory of escalatory violence in the evolution of *Homo sapiens* so far. Think about the future of a species that never creates a weapon it does not use or invent one weaker than what it replaces. Imagine now the full *trajectory*—from past through present into future—of such a species. What can stop it from eventually destroying itself? What can intervene and detour it on its trajectory toward ultimate annihilation?

This is the function and meaning of the universal resurrection image. Violent revolt

against violent injustice is understandable, but even if defensible, it causes the escalatory spiral to continue or even intensify. Pacifism is a sacred witness to nonviolence, but even if it is viable for enough people, it may also invite more of what it opposes and worse than it expects. Nonviolent resistance, planned, organized, controlled, and universalized, *hopes* to detour the trajectory of escalatory violence along a route other than what now *looks* inevitable.

All great religions offer humanity parables bigger than themselves. So also here. When Christ, rising from the dead after being executed for nonviolent resistance against violent imperial injustice, grasps the hands of Adam and Eve, he creates a parable of possibility and a metaphor of hope for all of humanity's redemption.

Even though Christ is crucified for his nonviolent resistance, this Crucifixion and Resurrection imagery challenges our species to redeem our world and save our earth by transcending the escalatory violence we create as civilization's normal trajectory. And the universal resurrection imagery makes it clear that we are all involved in this process. Nonviolent resistance is alone capable of saving us from species death by detouring human evolution along a different trajectory from the violent spiral of inevitable self-destruction.

✠ ✠ ✠

To conclude this book's celebration of Anastasis iconography and this chapter's challenge of evolutionary options, we recall our 2015 visit

to Moscow's Russian State Historical Museum for the Khludov Psalter (Chapter 7). Early on Friday morning, May 22, we walked over toward Red Square.

As we approach the square's Resurrection Gate, the chant of Russian Orthodox services from the shrine chapel outside it merges with that from the Kazan Cathedral just inside. Both buildings were demolished by Stalin in the 1930s to facilitate the entrance of mobile weaponry into Red Square for May Day military parades. Both were restored to exact facsimile in the 1990s. (But does precise replication foster political repentance or cause historical amnesia?)

Our visit happens to be less than two weeks after the May Day military parade, a Soviet tradition reborn on May 9, 2015, to commemorate the seventieth anniversary of the Russian victory in the Great Patriotic War of 1941–45 (known elsewhere as World War II, 1939–45). With the Resurrection Gate rebuilt, Russia parades its military power with vehicles and weapons in Red Square for internal celebration and external intimidation through the northwestern opening on the opposite side of the State Historical Museum.

As we stand in Red Square shortly after this parade, we are reminded that this place was once about trade, not missiles and war. To our right is the Kremlin Wall, with Lenin's mausoleum merging red with red in front. To our left, in sharp contrast, is the honey-colored stone of the giant GUM department store.

Nothing remains now from that May Day display of military power, but we can easily imagine it from the myriad images seen before we left home. We look here at a Reuters parade photo, since it shows clearly that Resurrection Gate in the background (Fig. 13.6, we added the green circle to the right, between the arches).

The photo looks toward the north where Red Square is dominated by the State Historical Museum—the south is dominated by the equally iconic St. Basil's Cathedral. The heavy mobile military hardware arrives from photo left, straightens out first, and then wheels photo left again to pass the reviewing stand at Lenin's Tomb against the Kremlin Wall.

In the foreground are seven SU-100 tank destroyers followed by mechanized infantry carriers. In the background are the State Historical Museum, to the left, and the twin arches of the Resurrection Gate, to the right. Focus now on that green circle we added to a mosaic icon in between the gate's twin openings (Fig. 13.6).

After entering the gate, we turn around to take photos from the inside. Only then do we see the reason for its name as the Resurrection Gate. Between the two entryways is a

Figure 13.6

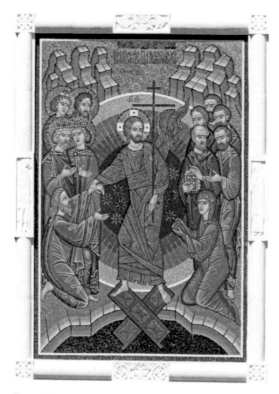

Figure 13.7

large mosaic Anastasis entitled, in Old Church Slavonic, "The Resurrection of Our Lord Jesus Christ" (Fig. 13.7).

On top of a split-open earth, Christ, with a cross-inscribed halo, stands on the gates of Hades arranged in deliberate cruciform shape,

holds a slim patriarchal cross in his left hand, and has wounds visible on hands and feet. That is a fourfold emphasis on the unity of Crucifixion and Anastasis. Adam and Eve are on either side of Christ, but only Adam's wrist is grasped by Christ. It is a Universal Type 3b, Trampling Down, Leading Out, and Facing Viewer.

Behind Adam, first David and Solomon, then Abel and John the Baptist are identified in the usual way. Foremost among the group behind Eve is the apostle Paul—identified by bald head and closed book. (Eastern Christian imagery often makes Paul the twelfth apostle at the Last Supper and the Ascension in a triumph of liturgy over history.) Is that Peter beside him? In any case, Christ's mandorla envelops all of them.

We end our book with these two images—the military image of salvation *by* death (Fig. 13.6) and the Anastasis image of salvation *from* death (Fig. 13.7). This is not simply about Russia and Christianity or even about state, nation, people and temple, church, mosque. It is about two possible ongoing trajectories in the evolution of our species, that is, about *Homo sapiens* as wise or unwise. It is about the great sea-change when hope and history rhyme or Anastasis and Evolution coalesce, "as in heaven, so on earth."

Sources of Figures

Figure 0.1. Diagram of Indirect and Direct Resurrection Traditions.

Figure 0.2. Ivory Casket. Farfa Abbey, Fara Sabina, Italy. Used with gracious permission.

Figure 0.3. Last Judgment. Chapel in Monastery of St. Moses the Abyssinian (Deir Mar Musa al-Habashi), near Nebek (al-Nabk), southwestern Syria.

Figure 1.1. Dark Church (Karanlik Kilise). Open-Air Museum, Göreme, Cappadocia, Turkey.

Figure 1.2. Sign for the Dark Church (Karanlik Kilise). Open-Air Museum, Göreme, Cappadocia, Turkey.

Figure 1.3. Anastasis Dark Church (Karanlik Kilise). Open-Air Museum, Göreme, Cappadocia, Turkey.

Figure 1.4. Life-of-Christ series. Old Buckle Church (Tokali Kilise). Open-Air Museum, Göreme, Cappadocia, Turkey.

Figure 1.5. Old Buckle Church (Tokali Kilise). Open-Air Museum, Göreme, Cappadocia, Turkey.

Figure 1.6. New Buckle Church (Tokali Kilise). Open-Air Museum, Göreme, Cappadocia, Turkey.

Figure 1.7. Rear, Church of the Savior in Chora (Kariye Müzesi), with apse of *parecclesion* at left, Istanbul, Turkey.

Figure 1.8. Apse of *parecclesion*, Church of the Savior in Chora (Kariye Müzesi), Istanbul, Turkey.

Figure 2.1. Central fragment of sarcophagus. Museo Pio Cristiano, Vatican Museums, Inv. 31523. © Rome101.com. Courtesy of William Storage & Laura Maish.

Figure 2.2a. Front of sarcophagus. Museo Pio Cristiano, Vatican Museums, Inv. 31525. © Rome101.com. Courtesy of William Storage & Laura Maish.

Figure 2.2b. Central image of sarcophagus. Museo Pio Cristiano, Vatican Museums, Inv. 31525. © Rome101.com. Courtesy of William Storage & Laura Maish.

Figure 2.3a. Traditional reburial sarcophagus of Mary Magdalene. Crypt in Basilica of Mary Magdalene, St.-Maximin-la-Sainte-Baume, France. Courtesy of Bridgeman Images, XIR741485.

Figure 2.3b. Sarcophagus of St. Sidonius. Crypt in Basilica of Mary Magdalene, St.-Maximin-la-Sainte-Baume, France.

Figure 2.4a. Bottom image on west face or Crucifixion side of the Cross of the Scriptures facsimile. Clonmacnoise, Co. Offaly, Ireland.

Figure 2.4b. Bottom image on west face or Crucifixion side of the High Cross. Durrow, Co. Offaly, Ireland.

Figure 2.5. Stuttgart Psalter, folio 157r. Württembergische Landesbibliothek, Stuttgart, Germany. Cod. bib. lat. fol.23. Used with permission of the Württemberg State Library.

Figure 2.6. Top of Mark page, Reichenau Gospels. Bavarian State Library, Munich, Cod. lat. 4454, folio 86v. Courtesy of World Digital Library.

Figure 2.7. Nicholas of Verdun, altarpiece, Chapel of St. Leopold, Augustinian Monastery, Klosterneuburg, Austria. Courtesy of Lessing Archive.

Figure 2.8. Jean de Joinville's *Credo*, folio 7v. Bibliothèque nationale de France, Paris, NAF MS 4509. © BnF. Used with permission.

Figure 2.9. Ripoll Bible, folio 370r. Vat. lat. 5729. © 2015 Biblioteca Apostolica Vaticana. Used with permission of Biblioteca Apostolica Vaticana with all rights reserved.

Figure 2.10. Resurrection page, Stammheim Missal. St. Michael Abbey, Hildesheim, Germany. J. Paul Getty Museum, MS 6, folio 111r. Courtesy of the Getty's Open Content Program.

Figure 2.11. Andrea di Bonaiuto da Firenze, north quarter of ceiling, Spanish Chapel. Santa Maria Novella, Florence.

Figure 2.12. End of crossbar (viewer right) on west face or Crucifixion side of Muiredach's Cross. Monasterboice, Co. Louth, Ireland.

Figure 3.1. Diagram (simplified) of the Church of the Holy Sepulchre, Jerusalem.

Figure 3.2. Model of the Constantine edicule in the Church of the Holy Sepulchre, Jerusalem. Archaeological Museum of Narbonne, Room 11, Inv. 869.27.1. © Catherine Lauthelin, Narbonne Museums, city of Narbonne. Used with permission.

Figure 3.3. Raffaele Garrucci, *Storia della Arte Cristiana, nei Primi Otto Secoli della Chiesa*, Vol. 6, Plate 480, No. 14. Courtesy of Digital Resources, Heidelberg University Library (Creative Commons License).

Figure 3.4. Reider Panel (Reidersche Tafel). Bavarian National Museum, Munich, Inv. 147. Courtesy of Wikipedia Commons.

Figure 3.5. One of four equal sides from an ivory casket (Maskell Ivories). British Museum, London, Inv. 1856.0623.5. © Trustees of the British Museum. Used with permission.

Figure 3.6a. Rabbula Gospels. The Biblioteca Medicea Laurenziana, Florence, ms. Plut. 1.56, c. 13r. Used with permission of MiBACT. Further reproduction by any means is prohibited.

Figure 3.6b. Rabbula Gospels. The Biblioteca Medicea Laurenziana, Florence, ms. Plut. 1.56, c. 13r (extract). Used with permission of MiBACT. Further reproduction by any means is prohibited.

Figure 3.7a. Pilgrimage reliquary. Museo Sacro della Biblioteca, Vatican Museums, Inv. 1883ab.

Figure 3.7b. Image of Anastasis Rotunda and tomb edicule (from Figure 3.7a).

Figure 3.8. Pilgrim Flask. Dumbarton Oaks Library, Inv. BZ.1948.18. © Dumbarton Oaks, Byzantine Collection, Washington, DC. Used with permission.

Figure 3.9. Easter Banner. Tomb edicule, Church of the Holy Sepulchre, Jerusalem.

Figure 4.1. Oratory of the Forty Martyrs & Church of Santa Maria Antiqua, Forum, Rome. Courtesy of Wikipedia Commons.

Figure 4.2. Entrance to Oratory of Forty Martyrs. Anastasis at extreme right of fresco.

Figure 4.3. Anastasis on Oratory of the Forty Martyrs. Forum, Rome. From Joseph Wilpert, *Die römische Mosaiken und Malereien* (1916) 4.167, #1. Courtesy of Digital Resources, Heidelberg University Library (Creative Commons License).

Figure 4.4. Outline of Anastasis on Oratory of the Forty Martyrs. Forum, Rome.

Figure 4.5. Diagram of Oratory of Forty Martyrs, Palatine Ramp, and Church of Santa Maria Antiqua. Forum, Rome.

Figure 4.6. Anastasis in Church of Santa Maria Antiqua. From Joseph Wilpert, *Die römische Mosa iken und Malereien* (1916) 4.168, #2. Courtesy of Digital Resources, Heidelberg University Library (Creative Commons License).

Figure 4.7. Outline of Anastasis in Church of Santa Maria Antiqua. Forum, Rome.

Figure 5.1a. Joseph, from Nativity scene on the east-wall mosaic in the Oratory of Pope John VII. Old St. Peter's Basilica, Rome. Presently in the Pushkin State Museum of Fine Arts, Moscow.

Figure 5.1b. Mary-Queen, from Dedication scene on the east-wall mosaic in the Oratory of Pope John VII. Old St. Peter's Basilica, Rome. Presently in San Marco Convent/Museum, Florence.

Figure 5.1c. Joseph, Mary, Christ-Child, angel, gift, from Magi scene on the east-wall mosaic in the Oratory of Pope John VII. Old St. Peter's Basilica, Rome. Presently on Gift Shop wall, Church of Santa Maria in Cosmedin, Rome.

Figure 5.2. Vatican Library, Vat. lat. 8404, folios 113v-114r. © 2015. Used with permission of Biblioteca Apostolica Vaticana, with all rights reserved.

Figure 5.3. Vatican Library, Vat. lat. 8404, folios 113v-114r. © 2015. Used with permission of Biblioteca Apostolica Vaticana, with all rights reserved.

Figure 5.4. Vatican Library, Cod. Barb. lat. 2733, folios 94v-95r. © 2015. Used with permission of Biblioteca Apostolica Vaticana, with all rights reserved.

Figure 5.5. Vatican Library, Cod. Barb. lat. 2732, folios 76v-77r. © 2015. Used with permission of Biblioteca Apostolica Vaticana, with all rights reserved.

Figure 5.6. Vatican Library, Archivio del Capitolo di San Pietro in Vaticano, A64 ter, folios 31v-32r (final section). © 2015. Used with permission of Biblioteca Apostolica Vaticana, with all rights reserved.

Figure 5.7. Vatican Library, Cod. Barb. lat. 2732, folios 76v-77r (final section). © 2015. Used with permission of Biblioteca Apostolica Vaticana, with all rights reserved.

Figure 5.8. National Central Library of Florence (Biblioteca Nazionale Centrale di Firenze), Ms II.III.173, folios 103v–104r (final section). © BNCF. Used with permission of the Biblioteca Nazionale Centrale di Firenze.

Figure 5.9. Ambrosian Library, Milan (Veneranda Biblioteca Ambrosiana di Milano), Cod. A 168 inf. folios 96v–97r (1621). © Veneranda Biblioteca Ambrosiana—Milano/De Agostini Picture Library. Used with permission.

Figure 5.10. Position of Anastasis. San Zeno Chapel, Basilica of Santa Prassede, Rome.

Figure 5.11. Mosaic of Anastasis. San Zeno Chapel, Basilica of Santa Prassede, Rome.

Figure 6.1. Outside south wall. Church of St. George, Voronet Monastery, Bucovina, Romania.

Figure 6.2. Anastasis on outside south wall. Church of St. George, Voronet Monastery, Bucovina, Romania.

Figure 6.3a. Obverse, gold medallion of Constantius I Chlorus. British Museum, London, Inv. 1928.0208.1. © Trustees of the British Museum. Used with permission.

Figure 6.3b. Reverse, gold medallion of Constantius I Chlorus. British Museum, London, Inv. 1928.0208.1. © Trustees of the British Museum. Used with permission.

Figure 6.4a. Obverse, coin of Theodosius I. Courtesy of the American Numismatic Society (ANS 1944.100 .25900.obv.2785).

Figure 6.4b. Reverse, coin of Theodosius I. Courtesy of the American Numismatic Society (ANS 1944.100 .25900.rev.2785).

Figure 6.5a. Obverse, coin of Theodosius I. Courtesy of the American Numismatic Society (ANS 1944.100 .25512.obv.2785).

Figure 6.5b. Reverse, coin of Theodosius I. Courtesy of the American Numismatic Society (ANS 1944.100 .25512.rev.2785).

Figure 6.6. Silver relic casket. Vatican Museum. Museo Sacro della Biblioteca, Vatican Museums, Inv. 985. © 2016 BAV. Used with permission of Biblioteca Apostolica Vaticana, with all rights reserved. From Leonard von Matt, *Art Treasures of the Vatican Library*, 1970. Figure 70.

Figure 6.7. Top left side of silver relic casket. Museo Sacro della Biblioteca, Vatican Museums, Inv. 985. From Joseph Wilpert, *Die römische Mosaiken und Malereien* (1916) 2.895,#420 ("Christi Höllenfahrt, Aus Sancta Sanctorum"). Courtesy of Digital Resources, Heidelberg University Library (Creative Commons License).

Figure 6.8a. Obverse, coin of Constans I. Courtesy of the American Numismatic Society (ANS 1944.100.23192 .obv.2785).

Figure 6.8b. Reverse, coin of Constans I. Courtesy of the American Numismatic Society (ANS 1944.100.23192 .rev.2785).

Figure 6.9. Top of rear entrance wall. Cathedral of Santa Maria Assunta, Torcello Island, Venetian Lagoon, Italy.

Figure 7.1. Khludov Psalter, folio 44r, on Psalm 44.23 & 26 (NRSV). © State Historical Museum of Russia, Moscow, Cod Gr D 129. Used with permission.

Figure 7.2. Khludov Psalter, folio 6r, on Psalm 7.6 (NRSV). © State Historical Museum of Russia, Moscow, Cod Gr D 129. Used with permission.

Figure 7.3. Khludov Psalter, folio 9v, on Psalm 10.12 (NRSV). © State Historical Museum of Russia, Moscow, Cod Gr D 129. Used with permission.

Figure 7.4. Khludov Psalter, folio 78v, on Psalm 78.65 (NRSV). © State Historical Museum of Russia, Moscow, Cod Gr D 129. Used with permission.

Figure 7.5. Khludov Psalter, folio 26v, on Psalm 31.4–5 (NRSV). © State Historical Museum of Russia, Moscow, Cod Gr D 129. Used with permission.

Figure 7.6. Khludov Psalter, folio 63r, on Psalm 68.1 (NRSV). © State Historical Museum of Russia, Moscow, Cod Gr D 129. Used with permission.

Figure 7.7. Khludov Psalter, folio 63v, on Psalm 68.6. (NRSV). © State Historical Museum of Russia, Moscow, Cod Gr D 129. Used with permission.

Figure 7.8. Khludov Psalter, folio 82v, on Psalm 82.8 (NRSV). © State Historical Museum of Russia, Moscow, Cod Gr D 129. Used with permission.

Figure 7.9. Paris Psalter, folio 19v, on Psalm 107:14–16. (NRSV). Bibliothèque nationale de France, Ms Grec, 20. © BnF. Used with permission.

Figure 8.1. Map of Mount Athos, the Holy Mountain (*Agion Oros*), easternmost of the Chalkidiki peninsulas, Macedonia, Greece.

Figure 8.2. Holy Monastery of the Pantokrator, Mount Athos, Greece (view from east).

Figure 8.3. Official Permit (*Diamonitirion*) to enter Athos's *Agion Oros*, from 25th to 28th May 2016.

Figure 8.4. Ferry approaches Holy Monastery of St. Panteleimon, Russian Orthodox Monastery (Rossikon), Mount Athos, Greece.

Figure 8.5. Pantokrator Psalter, folio 89r, on Psalm 69:28 (NRSV). © Pantokrator Monastery, Ms. Gr. 61, Mount Athos, Greece. Used with permission.

Figure 8.6. Pantokrator Psalter, folio 30v, on Psalm 31:4-5 (NRSV). © Pantokrator Monastery, Ms. Gr. 61, Mount Athos, Greece. Used with permission.

Figure 8.7. Pantokrator Psalter, folio 109r, on Psalm 78:65 (NRSV). © Pantokrator Monastery, Ms. Gr. 61, Mount Athos, Greece. Used with permission.

Figure 8.8. Pantokrator Psalter, folio 26v, on Psalm 12:5 (NRSV). © Pantokrator Monastery, Ms. Gr. 61, Mount Athos, Greece. Used with permission.

Figure 8.9. Bristol Psalter, folio 21v, on Psalm 12:5 (NRSV). British Museum, Add MS 4073. © The British Library Board. Used with permission.

Figure 8.10. Pantokrator Psalter, folio 83r, on Psalm 68:6 (NRSV). © Pantokrator Monastery, Ms. Gr. 61, Mount Athos, Greece. Used with permission.

Figure 8.11. Khludov Psalter, folio 100v, on Psalm 102:13 (NRSV). © State Historical Museum of Russia, Moscow, Cod Gr D 129. Used with permission.

Figure 8.12. Barberini Psalter, folio 171r, on Psalm 102:13 (NRSV). BAV Barb. Gr. 372. © 2015. Used with permission of Biblioteca Apostolica Vaticana, with all rights reserved.

Figure 9.1. Exultet roll 2. Archives of Monte Cassino Abbey, Cassino, Italy. Used with gracious permission of Monastery Archivist, Father Mariano dell'Omo, OSB.

Figure 9.2. Exultet roll 2. Archives of Monte Cassino Abbey, Cassino, Italy. Used with gracious permission of Monastery Archivist, Father Mariano dell'Omo, OSB.

Figure 9.3a. Exultet roll. San Matteo Diocesan Museum, Salerno, Italy.

Figure 9.3b. Exultet roll. San Matteo Diocesan Museum, Salerno, Italy.

Figure 9.4a. Exultet roll. Vatican Library, Vat. lat. 9820, folio 2r. © 2015. Used with permission of Biblioteca Apostolica Vaticana, with all rights reserved.

Figure 9.4b. Exultet roll. Vatican Library, Vat. lat. 9820, folio 9r. © 2015. Used with permission of Biblioteca Apostolica Vaticana, with all rights reserved.

Figure 9.5a. Exultet roll. Casanatense Library (Biblioteca Casanatense), Rome, MS 724 (B I 13) 3. © Biblioteca Casanatense, Rome. Used with permission.

Figure 9.5b. Exultet roll. Casanatense Library (Biblioteca Casanatense Rome. MS 724 (B I 13) 3. © Biblioteca Casanatense, Rome. Used with permission.

Figure 9.6. Exultet roll. Vatican Library, Barb. lat. 592. folio 2r. © 2015. Used with permission of Biblioteca Apostolica Vaticana, with all rights reserved.

Figure 10.1a. Exultet roll. The John Rylands Library of the University of Manchester. Latin MS 2 (JRL021498tr). © University of Manchester. Used with permission.

Figure 10.1b. Exultet roll. The John Rylands Library of the University of Manchester. Latin MS 2 (JRL021499tr). © University of Manchester. Used with permission.

Figure 10.2a. Exultet roll, Troia 3. Cathedral Treasury Museum, Troia, Italy.

Figure 10.2b. Exultet roll, Troia 3. Cathedral Treasury Museum, Troia, Italy.

Figure 10.2c. Exultet roll, Troia 3. Cathedral Treasury Museum, Troia, Italy.

Figure 10.3. Stuttgart Psalter, folio 29v. Württembergische Landesbibliothek, Stuttgart, Germany, Cod. bib. lat. fol.23. Used with permission of the Württemberg State Library.

Figure 10.4. Nicholas of Verdun, altarpiece. Chapel of St. Leopold, Augustinian Monastery, Klosterneuburg, Austria. Courtesy of Lessing Archive.

Figure 10.5. Jean de Joinville's *Credo*, folio 6r. Bibliothèque nationale de France, Paris, NAF MS 4509. © BnF. Used with permission.

Figure 10.6. Andrea di Bonaiuto da Firenze, north wall of Spanish Chapel. Santa Maria Novella, Florence.

Figure 10.7a. Easter Candlestick. Basilica Cathedral of Gaeta, Italy. © Professor Nino Zchomelidse. Used with gracious permission.

Figure 10.7b. Easter Candlestick. Basilica Cathedral of Gaeta, Italy. © Professor Nino Zchomelidse. Used with gracious permission.

Figure 11.1a. Gospel Lectionary. Church of the Mother of God, Hah, Tur Abdin, Turkey.

Figure 11.1b. Silver plaque on cover of Gospel Lectionary. Church of the Mother of God, Hah, Tur Abdin, Turkey.

Figure 11.2. Icon in upstairs chapel. Panagia tis Amasgou Monastery, Monagri, Cyprus, Greece.

Figure 11.3. Mosaic in north transept. Cathedral of Mary's Assumption, Monreale, Sicily.

Figure 11.4. Anastasis Fresco. Virgin Hodegetria Church, Patriarchate of Peć, Kosovo.

Figure 11.5. Icon. Church of the Descent of the Holy Spirit, Dragomirna Monastery, Suceava, Romania.

Figure 11.6. Reconstructed Anastasis from *Musterbuch*. Herzog August Library, Wolfenbütell, Germany, Cod. Guelf. 61.2 Aug. 8°, folios 90r, 90v, & 92v. © Herzog August Bibliothek. Used with permission.

Figure 11.7. Barberini Psalter, Folio 187r. Vatican Library, Barb. Gr. 372. © 2015. Used with permission of Biblioteca Apostolica Vaticana, with all rights reserved.

Figure 12.1. Icon with combined Eastern Universal (center) and Western Individual (bottom right) Resurrection Traditions. Museum of the Holy, Royal and Stavropegic Monastery of Kykkos, Cyprus, Greece. Courtesy of Director Athanassoulas and Father Agathonikos.

Figure 13.1. Sign for national strike (*apergia*), 20 May 2010. Athens, Greece.

Figure 13.2. Narthex lunette. Monastic Church of Hosios Loukas, near Distomo, Greece.

Figure 13.3. Modern village of Distomo, Greece, 2010.

Figure 13.4. Memorial Mausoleum of Distomo Massacre, 10 June 1944, Distomo, Greece.

Figure 13.5. One panel of eight naming those murdered, Memorial Mausoleum of Distomo Massacre. Distomo, Greece.

Figure 13.6. Anniversary Parade (1945–2015). Red Square, Moscow, Saturday, 9 May 2015. © Reuters.

Figure 13.7. Anastasis between arches of Resurrection Gate, facing to inside of Red Square. Moscow.

Scripture Index

Subject Index

Page references followed by *fig* indicate an illustration or photograph.

Ceccopieri, Isabella, 134

"Chaereas and Callirhoe" (Chariton of Aphrodisias), 171

"Chapel of the Spaniards," 38*fig*–39

Chariton of Aphrodisias, 171

Chi-Rho monogram (Pio Cristiano sarcophagus), 26*fig*, 29

Chora Church (Church of the Holy Savior), 20*fig*–22*fig*, 23, 165

"The Chora of the Living" [Church of the Holy Savior], 21

Christianity. *See* Eastern Christianity Easter (Anastasis); Western Christianity Easter

Christian Judaism: closer to universal than individual resurrection tradition, 175; Enoch, Elijah, and Moses tradition in, 169–71, 172

Christ's arrest images: Cathedral Crypt sarcophagus (Sicilian Palermo), 29–30; sarcophagus (Museo Pio Cristiano), 27*fig*, 29

Christ's Resurrection: Anastasis as the Greek word for, 14–15, 16; comparing Jewish tradition on the afterlife to, 170–71; comparing pre-Christian Jewish tradition of Resurrection to, 173–75; direct and indirect portrayals of, 2–5; examining credibility as humanity's liberation from death, 4–5; never directly described in the Gospels, 1–2

Christ's Resurrection tradition: comparing Jewish tradition on the afterlife to, 170–71; empty-tomb, 2, 51–53*fig*, 57, 81, 82*fig*, 128*fig*–30*fig*, 158–60; guarded-tomb, 3, 39–41, 53*fi*, 57, 65–68, 87, 105–11, 118*fig*–20*fig*; organizational diagram of the, 3–4; risen-vision, 2, 105–11, 172–73. *See also* individual resurrection tradition; universal resurrection tradition

Christ's tomb: empty-tomb tradition, 2, 51–53*fig*, 57, 81, 82*fig*, 128*fig*–30*fig*, 158–60; guarded-tomb tradition, 3, 39–41, 53*fi*, 57, 65–68, 87, 105–11, 118*fig*–20*fig*; increased individual resurrection imagery and Islamic control over, 124–25; Maskell Ivories, 50*fig*–51; moving from Symbolic to Emerging Resurrection, 42–43; questions regarding details of the, 42; Reider Panel (Reidersche Tafel) Tree of Life, 49*fig*–50, 52.

See also Church of the Holy Sepulchre (Jerusalem); Women at the Tomb images

Church of St. George of the Voronet Monastery, 92*fig*–93*fig*, 100

Church of St. Ignatius Loyola, 134

Church of the Holy Savior (Chora Church), 20*fig*–22*fig*, 23, 165

Church of the Holy Sepulchre (Jerusalem): Anastasis Rotunda at west end of, 55, 56*fig*, 57, 106; anonymous pilgrim's description of oil flasks blessed at, 55; destroyed in 1009, 46; diagram of the, 46*fig*; Easter Banner, Tomb edicule, 59*fig*; *Egeria's Pilgrimage* on the, 47–48; Islam's Dome of the Rock built to compete with, 123–24; model of the Constantine edicule in, 46–47*fig*; moving toward Physical Resurrection, 48–49; Psalter images of Christ's Resurrection representing, 122. *See also* Christ's tomb; Jerusalem

Church of the Mother of God (Tur Abdin), 155*fig*–56

Church of the Santa Maria Antique (Roman Forum), 62*fig*, 66*fig*, 73, 84

Church of the Savior (Chorea), 20*fig*–21

Clonmacnoise Cross of the Scriptures (Ireland), 30–31*fig*, 32

coin images: Constants I, 98–99*fig*; as source of Trampling Down and Leading Out, 98–100. *See also* medallion images

Constantine the Great: "Cross of light" battle standard of, 25–26; medallion of Constantius Chlorus, father of, 93–94*fig*; mother Helena's travel to Jerusalem, 45

Constantinople: destruction on April 13, 1204, during Fourth (Pseudo-) Crusade, 164, 166; increased individual resurrection imagery (later 840s) in, 125; monks fleeing from Islamic Jerusalem received in, 124; Theodore Metochites of, 21. *See also* Eastern Orthodox Church

Constantius Chlorus medallion, 93–94*fig*

Constants I coin, 98–99*fig*

Credo, folio 7v (Jean de Joinville), 34, 35*fig*

Trampling Down, Raising Up/Leading Out, Facing Viewer (Type 3): Gospel Lectionary example of, 155*fig*–56; icon in upstairs chapel (Panagia tis Amasgou Monastery) example of, 156–58*fig*; introduction to the, 154

Transfiguration, 2

Travel Diary (Bell), 154

Tree of Life (Reider Panel, Reidersche Tafel), 49*fig*–50, 52

Troia 1 Exultet roll, 142

Troia 2 Exultet roll, 142

Troia 3 Exultet roll, 142*fig*–45

Tur Abdin (Turkey), 154–56

Twelve Magi story, 156

typologies. *See* individual resurrection typologies; universal resurrection typologies

UNESCO World Heritage sites, 12

universal resurrection images: Buckle Church, 16–20, 23; Byzantine artistic influence in papal Rome on, 97; Cappadocian cave church (1050), 15*fig*, 97; Cathedral of Santa Maria Assunta, 100, 101*fig*; Church of St. George, 92*fig*–93*fig*, 100; Church of the Holy Savior (Chora Church), 20*fig*–22*fig*, 23; Church of the Santa Maria Antique (Roman Forum), 62*fig*, 66*fig*, 73, 84; Constans I coin as source of, 98–99*fig*; Dark Church (Karanlik Kilise), 13*fig*–16, 17, 20, 23; Easter Banner, Tomb edicule (Church of the Holy Sepulchre), 59*fig*; emerging in late 600s is the divergent physical and, 58–59; first dated David and Solomon images in, 84–85*fig*; medallion victory images as source of, 93–97; Oratory of Pope John VII, 76–84; Oratory of the Forty Martyrs (Roman Forum), 62*fig*, 63*fig*–64, 63*fig*–65*fig*, 84; of Russian era combining individual and, 9, 10*fig*; San Zeno Chapel (Rome), 84–85*fig*; silver relic casket depiction of, 97*fig*–99, 100

universal resurrection tradition: Christ, Hades, Adam, and Eve as core figures in, 73; Christian Judaism in harmony with, 173–75; on Christ raising humanity from death, 3; conformity with New Testament, 4; as East Christianity icon, 9; examining through modern lens, 184–86; Exultet liturgy development into individual from, 150–51; first appearance by year 700, 3; *Gospel of Nicodemus* textual basis for, 68–71, 87, 89–91; as image of God's Peace and Reconciliation Commission, 9; individual resurrection tradition's absorption (since 700) of the, 145–51; Matthew's Gospel and a possible connection to, 87; Paul's argument for the, 174–75; Paul's textual basis for both individual and, 67; Pseudo-Epiphanius homilies on Hades role in the, 71–72; renaming it as West's Hovering Resurrection (Type 4), 149; Troia Exultet 1, 2, 3 rolls replacing individual resurrection with, 142–45. *See also* Christ's Resurrection tradition; Eastern Christianity Easter (Anastasis)

universal resurrection typologies: always combined until Salerno Exultet roll's Split Anastasis, 130*fig*–32; Trampling Down and Leading Out (Universe Type 2), 15*fig*, 92–101*fig*, 97, 153–54; Trampling Down and Raising Up (Universe Type 1) images, 3, 92*fig*–101, 128*fig*–30*fig*, 153–54; Trampling Down, Raising Up/Leading Out, but Grasping Both (Type 5), 160–66; Trampling Down, Raising Up/Leading Out, but Not Touching (Type 4), 158–60; Trampling Down, Raising Up/Leading Out, Facing Viewer (Type 3), 154–58*fig*. *See also* Eastern Christianity Easter (Anastasis); Split Anastasis images

Vatican City: Pio Cristiano Museum of Christian Antiquities sarcophagus, 26*fig*–30; St. Peter's Basilica, 75–84; Sancta Sanctorum (Holy of Holies) [pope's private chapel, Lateran Palace], 54, 97–98; Vatican Museums of, 132

Vatican Library: Exultet roll (Barb. lat. 592, folio 2r), 136*fig*–37; Exultet roll (Vat. lat. 9820), 132–34*fig*; fourteenth-century manuscript stolen from (1987), 132; renovations (2007 to 2010) of the, 132; Ripoll Bible in the, 35–36*fig*

victory images: Constantius Chlorus medallion, 93–95*fig*; Constans I coin, 98–99*fig*; as source of rising Adam and trampling down of Hades, 95*fig*–97; Theodosius I medallion, 95*fig*–96*fig*

Virgil, 5

Virgin Hodegetria Church, 162*fig*

Vissarion, Father, 115, 118, 122

Western Christianity Easter: Descent into Hell images as Split Anastasis solution, 145*fig*–46*fig*; guarded-tomb tradition becoming basis of, 3, 39–40, 41, 65–68; how the universal resurrection tradition is absorbed (since 700) into the, 145–51; individual resurrection tradition of, 3–4*fig*, 9; renaming of universal resurrection image as "Descent into Hell," 146–50*fig*; reviewing observed differences between Eastern and, 22–23.

See also individual resurrection tradition; individual resurrection typologies; Roman Catholic Church

"Wolfenbüttel Master Book" folios, 164*fig*–65

Women at the Tomb images: Maskell Ivories, 50*fig*, 51; Matthew's Gospel on the, 172; Monte Cassino Exultet roll images in, 128*fig*–30*fig*; Oratory of Pope John VII life-of-Christ mosaic image of, 82, 83*fig*; Pantokrator Psalter, 119, 120*fig*; pilgrim oil flask, 57*fig*; Rabbula Gospels, 53*fig*, 57. *See also* Christ's tomb; Mary Magdalene

World War II Distomo massacre (1944), 179–82

Wright, Ronald, 183

Zchomelidse, Nino, 127

Zenobius, 45